LIFE

FACES OF GROUND ZERO

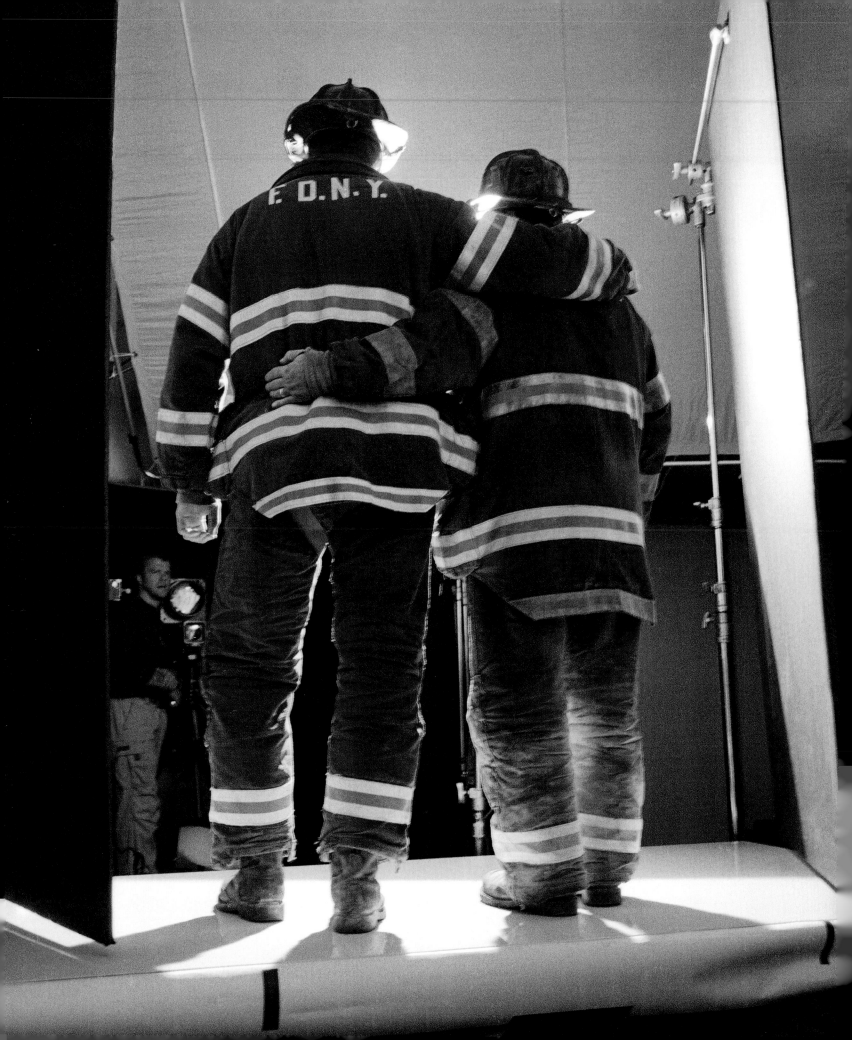

LIFE

FACES OF GROUND ZERO

Portraits of the Heroes of September 11, 2001

Photographs by Joe McNally

Little, Brown and Company 1837 **Boston New York London**

LIFE

Editor Robert Sullivan
Creative Director Ian Denning
Picture Editor Barbara Baker Burrows
Senior Editor Robert Andreas
Associate Picture Editor Christina Lieberman
Copy Chief J.C. Choi
Production Manager Michael Roseman
Picture Research Lauren Steel
Photo Assistant Joshua Colow

Publisher Andrew Blau
Director of Business Development Marta Bialek
Finance Director Camille Sanabria
Assistant Finance Manager Karen Tortora

Additional staff for this book
Project Director Nina Russo
Senior Writer Melissa Stanton
Writer/Reporters Hildegard Anderson, Loren Mooney
Studio Manager Lynn DelMastro
Production Meghan Milkowski

Editorial Operations
Richard K. Prue (Director), Richard Shaffer (Manager), Brian Fellows,
Stanley E. Moyse (Supervisors), Keith Aurelio, Gregg Baker,
Charlotte Coco, Scott Dvorin, Raphael Joa, Rosalie Khan, Po Fung Ng,
Barry Pribula, David Spatz, Sara Wasilausky, David Weiner

This project was the labor of many. Heartfelt thanks to John Huey and
Dick Stolley, who believed in it from the start; to Dan Okrent for his
friendship and wisdom; to Mark Sobczak and Laurel Parker, who kept the
camera running; to Andy Blau for his energy and dedication; to Steve
Cambron and Kathy Petersen, who worked tirelessly; to Ronnie Davis and
Rita Perrault for their kind hearts and wise counsel; to Lynn DelMastro,
who kept everything together; to my field sponsors Jeff Hirsch of Fotocare,
Ian Lederman of Mamiya America, Briss Prashad of U.S. Color, and
Dorian Romer of Kodak; to my family, who have put up with my being a
photographer for many years; and, finally, to Nina Russo, without whose
efforts and friendship nothing would have been possible. —Joe McNally

Published by AOL Time Warner Book Group
Chairman, AOL Time Warner Book Group Laurence J. Kirshbaum
Publisher, Little, Brown and Company Michael Pietsch
Executive Editor Geoff Shandler

INTRODUCTION

By Joe McNally

The people represented on the pages of this book are, by and large, ordinary people. They go to work, to school, to church. On an average day in New York City (if there is such a thing) you would pass hundreds of people just like these. They live their lives. They do their jobs.

That is what they would tell you of their involvement in the tragedy called 9/11: They did their jobs. They did what they were supposed to do—as human beings, as citizens, as New Yorkers.

When they came to the Polaroid studio, they did not come seeking celebrity or any kind of special recognition for their actions during the momentous days of the waning weeks of 2001—actions that they uniformly described in the simplest of terms. They came only with the intention of participating in a project, telling their story, and sharing in the telling of others.

They were asked to come because they represent the best of us, the quiet capacity for heroism that resides within the human spirit. Asking someone to take time to be photographed on something other than a wedding day can be perceived as time-consuming and unnecessary or, worse, frivolous. Certainly in the days after the attacks, with the nation grieving and in shock, it might have seemed obscenely so. But that is what I do. I'm a photographer, not a firefighter or a cop or an ironworker. This, I felt, is all that I can offer.

I knew about this camera and its ability to render a subject with astonishing clarity, power and detail. Originally conceived in the 1970s by Polaroid's Dr. Edwin H. Land as a copy camera, and used through the years primarily in a museum context, it had come to reside in the Bowery district of Manhattan, not far from Ground Zero. Its lens is from a U-2 spy plane, and the exposure it makes is on an eight-foot-tall piece of film; the huge picture is not, then, a blowup, and the lack of grain in the image lends immediacy and intimacy. Because of the complexity of the operation, a subject coming before this camera is, typically, given only one chance to tell his story—and this also creates a heightened intensity because it is not a typical "shoot," where the best of 50 or a hundred images will be selected.

The way to understand this camera is to think of it as a room-size instrument. The room goes completely dark, and the flash fills the whole room at the critical moment. As might be imagined, the camera is not transportable: The subject must come to the camera. This, too, made approaching these people, who were intimately involved with the horrific events of 9/11, more difficult. But as I continued to read accounts of these people's

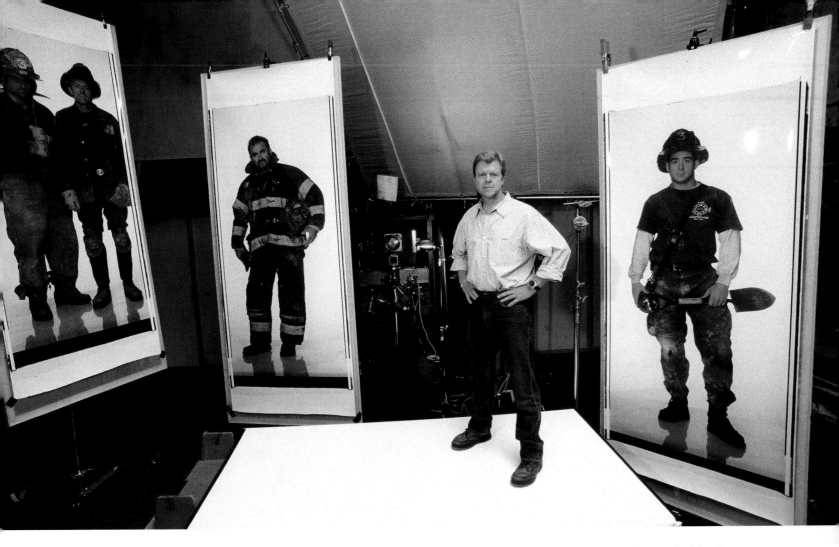

actions—what they had done on the infamous date and in the days thereafter—my thoughts kept returning to this camera. In the crucible, these ordinary people had risen up and become giants. They had reached out, risked their lives, helped total strangers and become a source of light within an immensely dark cloud. Several of them rescued people who would otherwise have been lost that day, and in the process, they rescued an entire city's sense of self.

This unusual camera, which took larger-than-life pictures, might, I felt, be a suitable, even worthy medium for telling these people's stories. So I made the phone calls. I'm still unsure what the people heard in my voice, or what interested them about being a part of this project. But they started to arrive at the studio on East 2nd Street—slowly at first, then in a torrent. They came in fire trucks, police cars, rescue vehicles, ambulances, taxis and on the subway. They came on foot, walking over from their firehouse or from their apartment. They came alone in their own vehicles, or as a group in a ladder truck, or in a Suburban with a security detail, as the mayor did.

The studio was awash in emotion: sadness, loss, recovery, relief. It was also filled with questions: Why did this happen? Why did I survive when so many others did not? There were, of course, no answers.

Speaking for myself, it was a privilege and a blessing to meet the people who bore these questions and emotions. Jason Cascone, the young firefighter who received absolution from a priest on the way to his first day of work. Jan Demczur, a window washer who, armed only with his squeegee, fought his way out of the trap of an elevator and rescued five others in the process. Barry Crumbley of the Red Cross, who volunteered all day long on 9/11, helping people, not knowing until six p.m. that his wife had made it safely out of the towers. Louie Cacchioli, a firefighter who easily could have perished but kept moving and never gave up, saving many lives.

As I met and worked with these people, listening to quiet descriptions of what had happened to them on 9/11 and in the aftermath, it became clear to me that, no matter how big a camera might have existed on the planet—no matter how huge a camera I might have dreamed up—they would have filled the lens. In the tragedy, they gave an enormous gift to all Americans, as their grace and courage reminded us about the best in mankind, even as we stared at the worst. In coming to the studio and standing in front of this singular camera, they have given us all another gift: their images and their stories of that day.

The subjects demanded the use of this heroic photographic instrument, for they truly were—and are—larger than life.

THE STRENGTH OF THESE FACES

The reality is that the way New York and America dealt with the horrible attack of these evil people was with strength and character. I believe that these pictures capture that strength and character in a very beautiful, effective and powerful way. Just as the perverse ideologues of the past found out, this strength and character is something they cannot match. It is the strength and character of a free people—people who live in freedom, who decide and elect to live in freedom. These photographs capture the strength and character of such people.

Sometimes we take our strength for granted when we are not challenged or attacked. That's probably human and understandable. But when we are attacked, there's nothing stronger in the world than the character of people who live in a democracy with freedom of religion, political freedom, economic freedom. You can see in the faces of each and every one of these people a sense of determination that probably would not have been there the day before this horrible attack. That's what our enemies didn't count on. They attacked us to destroy our spirit, and instead they created a city and a country that are more united, more determined, and with a more profound understanding of what we are all about as Americans.

I congratulate you, Joe, for your ability to capture that in a very powerful way. This is a wonderful contribution to the healing and restoration of confidence in our country. As this exhibit travels across the country and around the world, people will see, as many of us saw even on the first day, that America will be stronger as a result of this horrible and terrible attack.

Thank you. God bless you.

—**Rudolph W. Giuliani,** on the opening of the *Faces of Ground Zero* exhibit, Grand Central Terminal, New York City, January 7, 2002

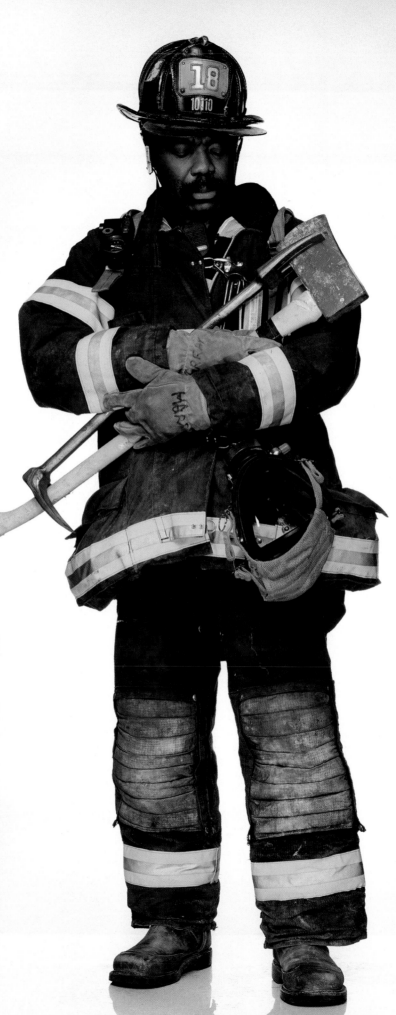

Harry Davis
Firefighter, Squad 18, FDNY

Davis, one of the squad's drivers, was on his way home when he heard news of the attacks on his car radio. Squad 18's rig was found crushed under rubble from Tower 1, and seven members' bodies were found in the tower's remnants.

❝ We tried not to think about our guys when we were searching for survivors, but I still hoped to see them walking around the corner any second. I don't feel lucky to be alive. I just wonder why the others had to go. It's not fair. Why them? ❞

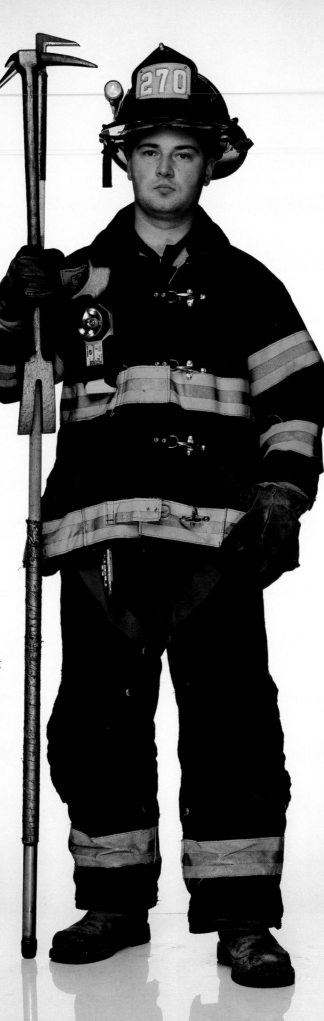

John J. Cassidy
Firefighter, Squad 270, FDNY

He was driving home from a work detail at Squad 288/Hazardous Materials Company 1 on September 11, ready to start vacation. Hearing of the attacks, he drove to his own firehouse, where his squad was awaiting orders. Because the company was held in reserve until the afternoon, all survived. (Eight men from Squad 288 and 11 men from Haz Mat did not.)

❝ Throughout all the chaos, one of my biggest fears was that my son, who's two and a half, would see it all on TV. He's at an age that he doesn't need to know firemen can die. ❞

Ron Marden
Kathleen Jones
Peter Hernandez
**Officers, Port Authority
Police Department**

These officers, who were assigned to regular security detail at the World Trade Center, were off-duty Tuesday but came to the scene to help locate missing co-workers. After the attacks, they assisted with body recoveries and Ground Zero security.

❝ We spent every day at those buildings," said Hernandez. "Every day, the same people would say good morning to me when they were heading to their offices. Now I picture their faces and wonder if they're alive. ❞

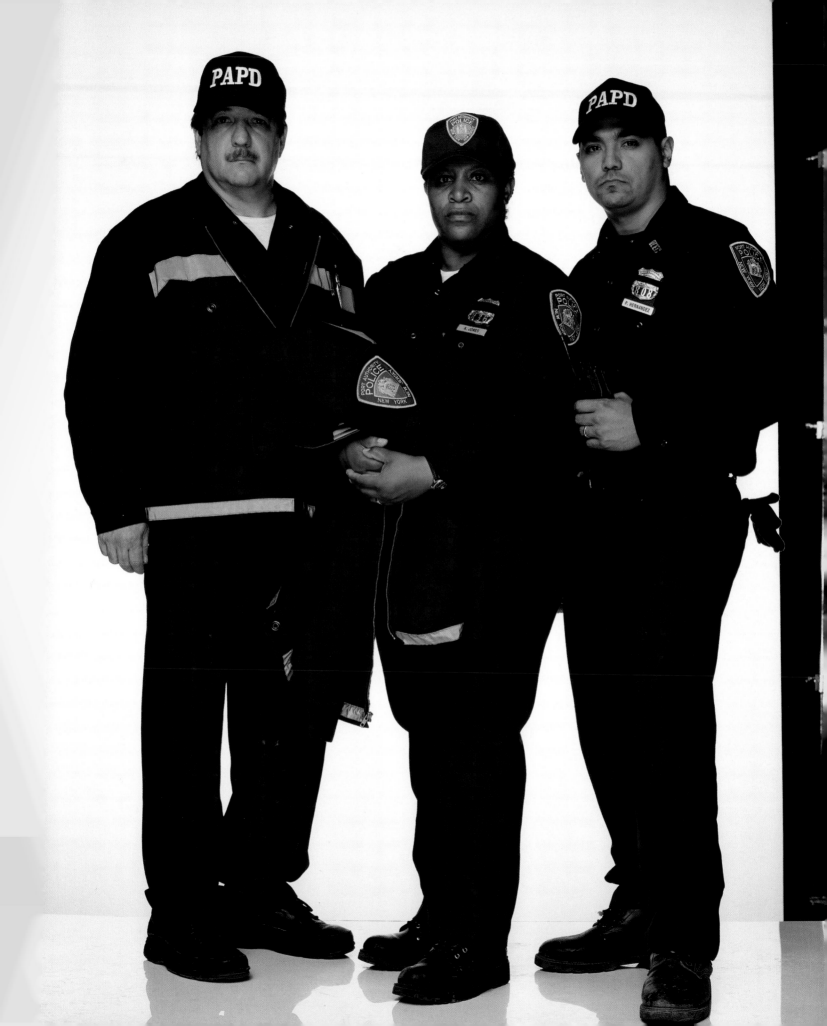

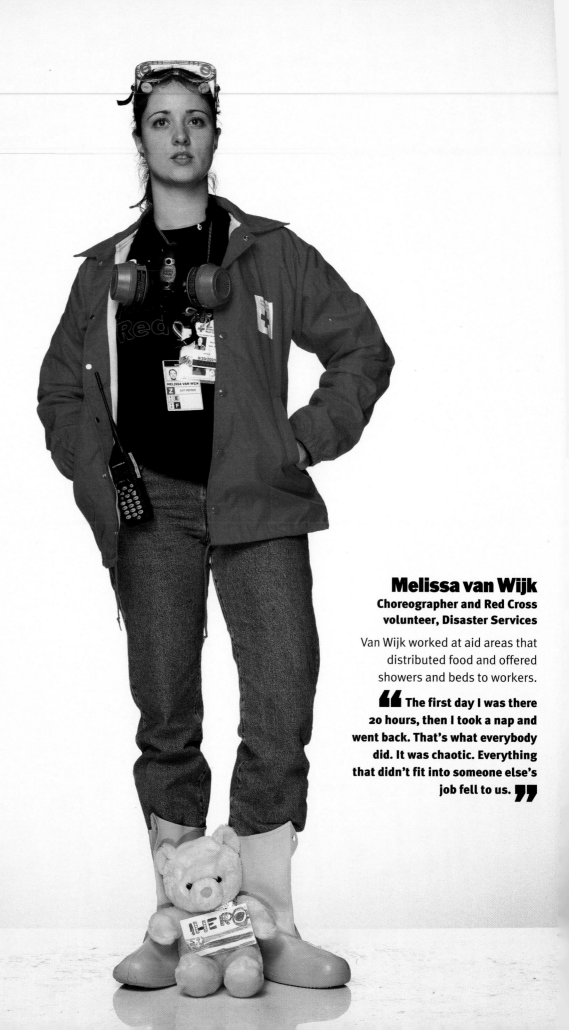

Melissa van Wijk
Choreographer and Red Cross volunteer, Disaster Services

Van Wijk worked at aid areas that distributed food and offered showers and beds to workers.

❝ The first day I was there 20 hours, then I took a nap and went back. That's what everybody did. It was chaotic. Everything that didn't fit into someone else's job fell to us. ❞

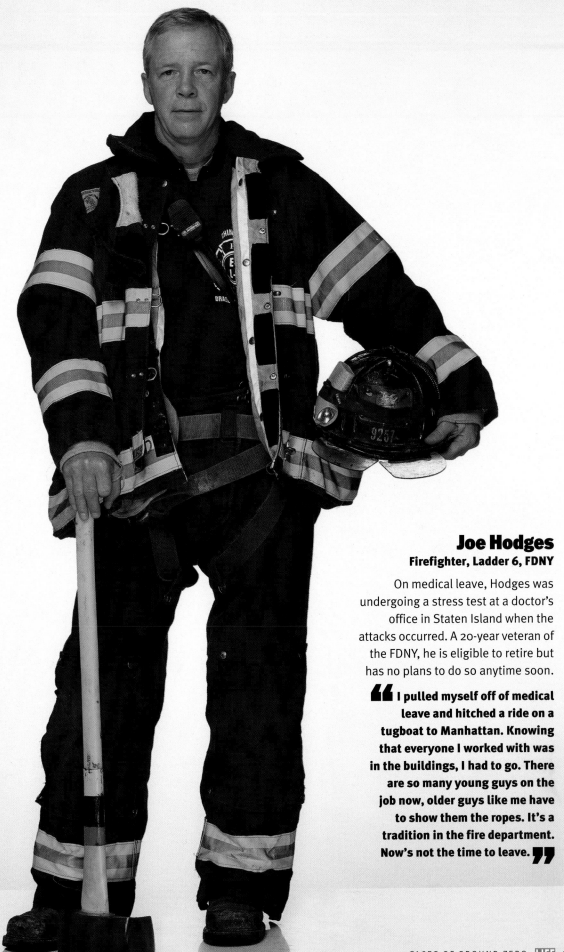

Joe Hodges
Firefighter, Ladder 6, FDNY

On medical leave, Hodges was undergoing a stress test at a doctor's office in Staten Island when the attacks occurred. A 20-year veteran of the FDNY, he is eligible to retire but has no plans to do so anytime soon.

" I pulled myself off of medical leave and hitched a ride on a tugboat to Manhattan. Knowing that everyone I worked with was in the buildings, I had to go. There are so many young guys on the job now, older guys like me have to show them the ropes. It's a tradition in the fire department. Now's not the time to leave. "

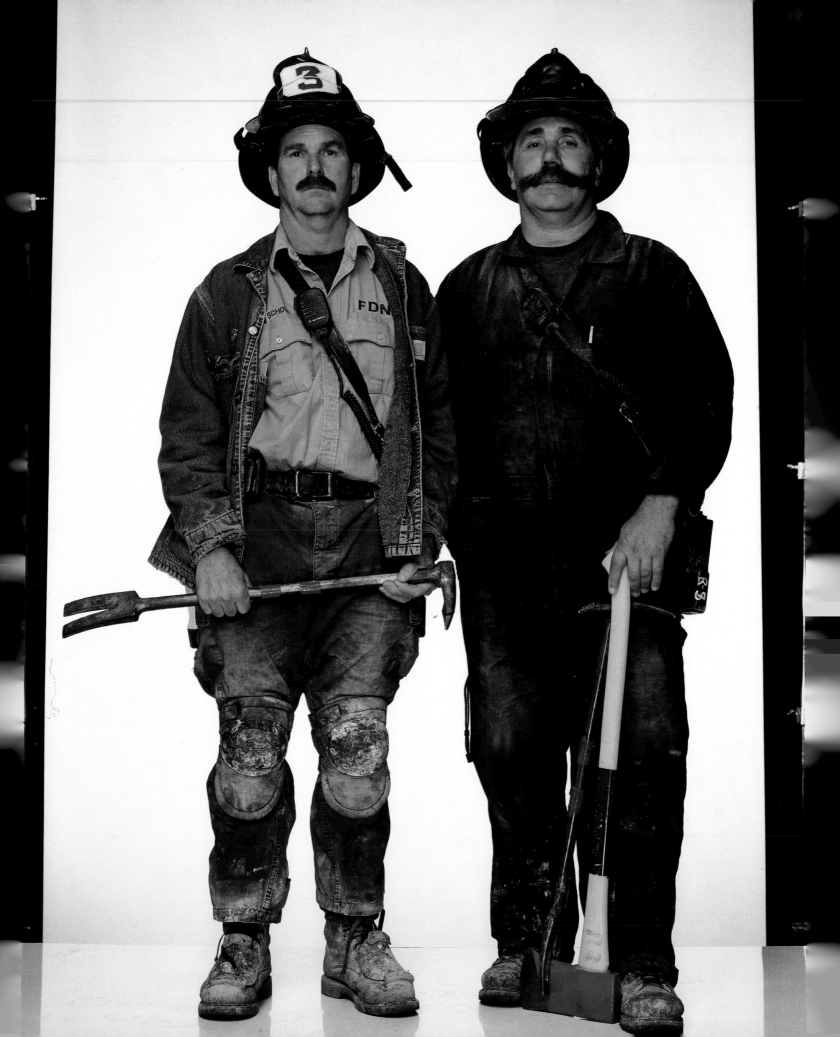

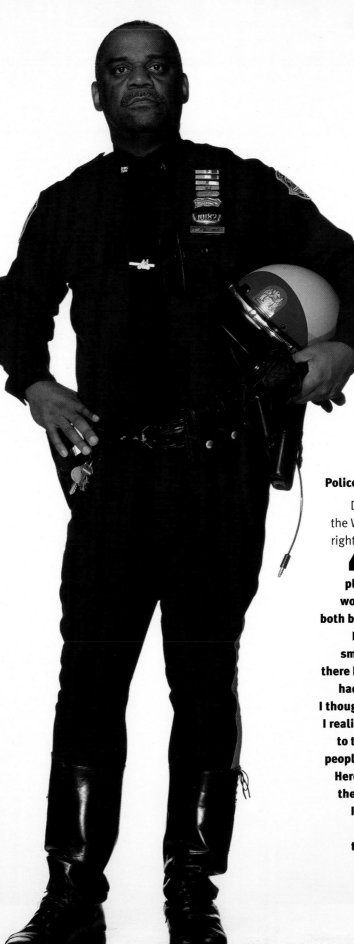

Fred Scholl
Nick Giordano
Lieutenant and Firefighter, Rescue 3, FDNY

After a few days, their Kevlar flame-resistant gear became so grungy and cumbersome that some rescuers switched to more practical attire. But the lighter clothing didn't make the work any easier to cope with.

**" I was numb to it at first,"
said Scholl. "But it hit me when
we found eight firefighters
together in a stairway void.
They were still holding their
tools, still had their helmets on.
Seeing mourners is tough too.
At the Ground Zero family
service, a little kid asked me to
get him a rock from the pile, and
my knees buckled. "**

Melvin Doby
Police Officer, Highway 4, NYPD

Doby went by motorcycle to the World Trade Center, arriving right after the second plane hit.

**" I didn't see the second
plane, so I'm standing there
wondering how one plane hit
both buildings. In the confusion,
I didn't even know that the
smoke cloud and debris were
there because an entire building
had fallen down. At one point
I thought I heard gunshots. Then
I realized it was bodies crashing
to the ground. I was watching
people jumping out of windows.
Here I am, a police officer, and
there was absolutely nothing
I could do for those people.
That hurt so much. Being
there was like one big case
of helplessness. "**

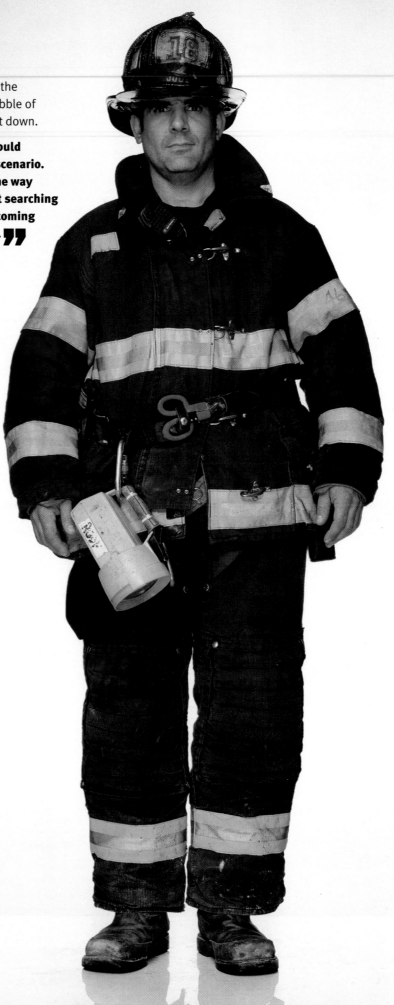

John Ceriello
Firefighter, Squad 18, FDNY

Ceriello was outside the north tower when the south tower fell, and was working in the rubble of the south tower when the north tower went down.

"We knew the tops of the buildings would eventually fall. That was the worst-case scenario. We didn't expect the towers to collapse the way they did. After the first tower fell, we kept searching for people. Was I wary of the second one coming down? Yes. But we don't abandon people."

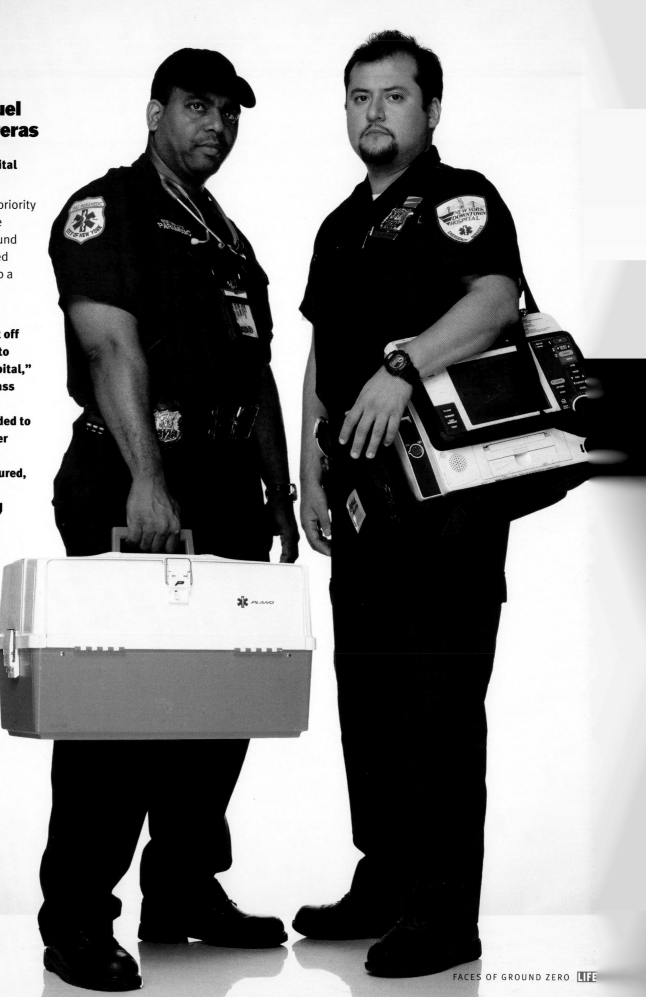

Kenrick Samuel
George Contreras
Paramedics,
NYU Downtown Hospital

Emergency medical personnel received a priority call to the World Trade Center, where they found so many people injured that they had to set up a triage system.

"People who had lacerations were sent off as walking wounded to find a ride to the hospital," said Samuel. **"The mass of casualties was horrendous. I responded to the World Trade Center bombing in '93, when 1,000 people were injured, and that was nothing compared to this. "**

Kerry McGinnis
Kennel Manager, Humane Society of New York

In the week after the attack she escorted evacuees to their apartments to retrieve pets.

❝ Some said, 'Why bother? There's more important work.' But these animals are parts of families. People would call their children on cell phones to let them know the cat was safe. Many had lost neighbors and colleagues. They didn't need to lose family, too. ❞

Bob LaRocco
Lieutenant, Ladder 9, FDNY

"Rocky" was off-duty when the first plane hit, but immediately headed to his firehouse. He had escaped from the rubble of the first fallen tower when the second came down.

❝ As the collapse started to outrun me, I dove behind a fire truck. It's funny what you think, your last thoughts. I actually laughed, and I thought, 'Death, I just cheated you and now you're gonna come for the payoff.' ❞

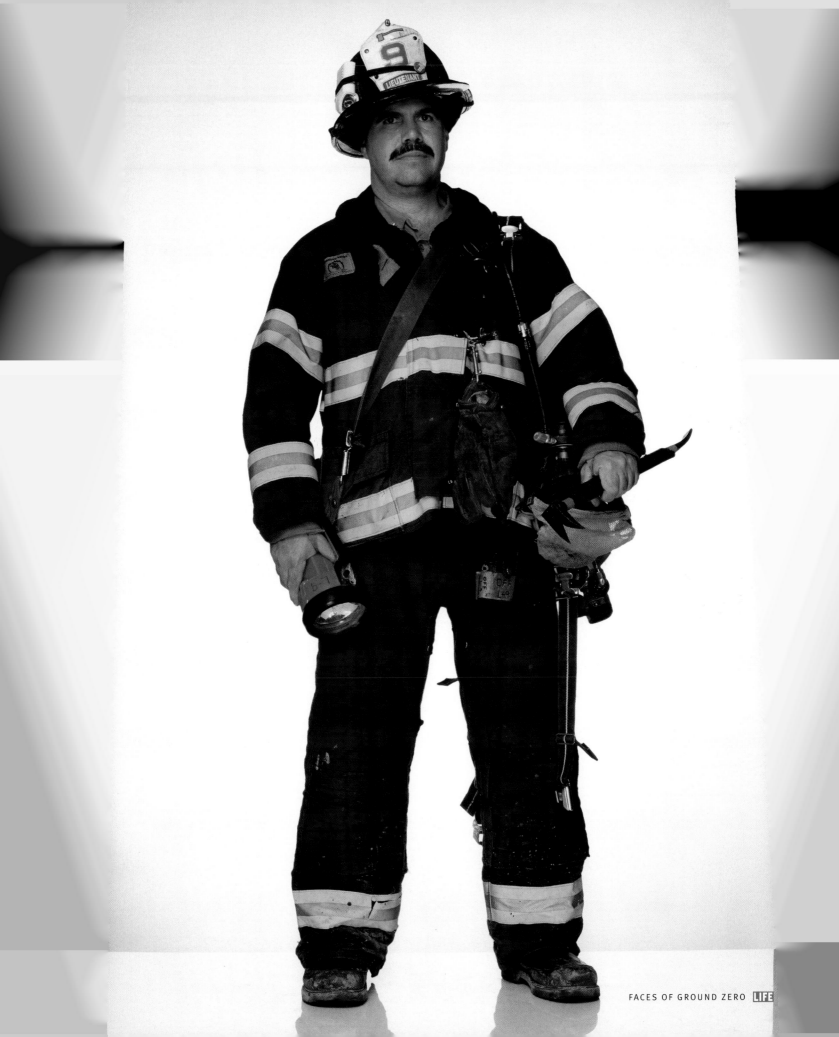

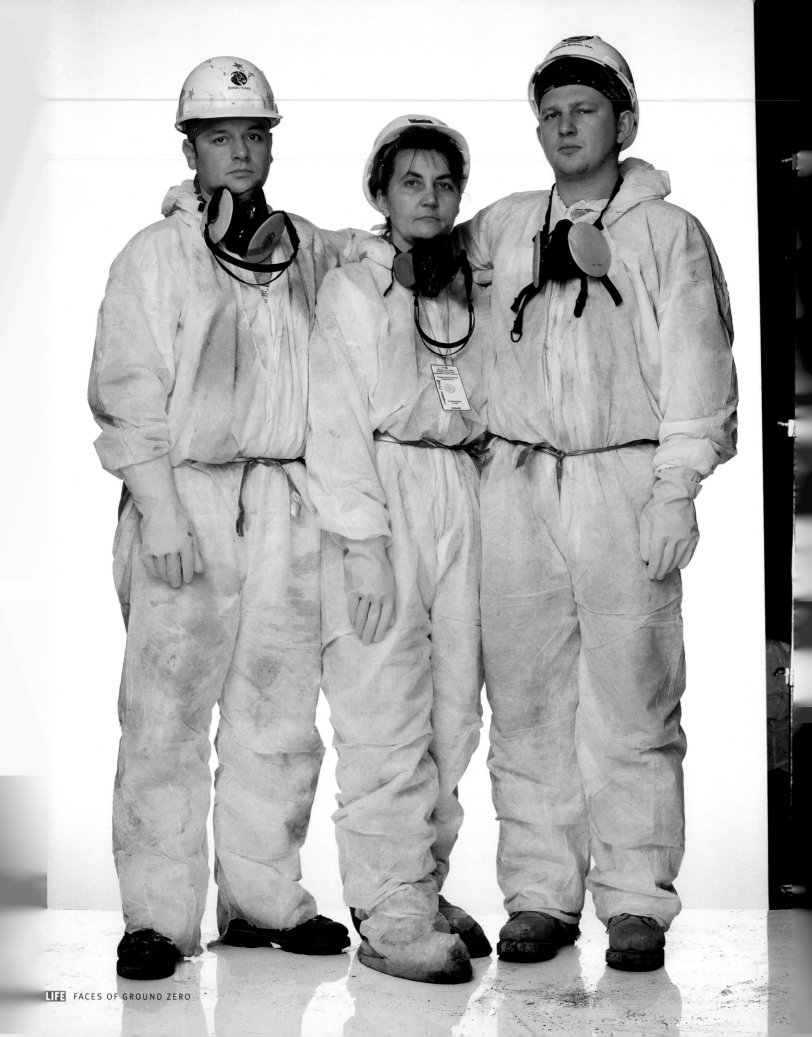

Andrzej Nowak
Larysa Prokhna
Pawel Choinski
Asbestos handlers

For nearly three months, Nowak, Prokhna and Choinski—immigrants from, respectively, Poland, the Ukraine and Poland—cleaned asbestos from buildings adjacent to Ground Zero. The dust on some surfaces was eight inches high.

❝ I wanted to help," said Choinski. Added Nowak: "The work made me feel like I'm part of history." On September 11, Prokhna feared that a war had begun and more attacks were coming: "I knew what had happened was a big problem, not only for the American people but for everyone in the world. ❞

Michael Wernick
Firefighter, Ladder 9, FDNY

A 23-year veteran of the department, Wernick had responded to the Trade Center bombing in 1993 and was in the first rush of firefighters to arrive on September 11.

❝ We were on the 27th floor of the north tower when the building shook—the south tower collapsing. When terrorists attack, they often do something after rescuers arrive, so we thought another plane had hit. In '93, you always felt more [bombs] were going to go off. The fear of what will happen next is a tremendous fear. We didn't run from the 27th floor, we just filtered down. Seconds after I got to the street the tower fell and I was blown off my feet. I was choking. Some guys picked me up. I went to the hospital. My lungs were filled with all that stuff. Three guys in our company did not make it out. ❞

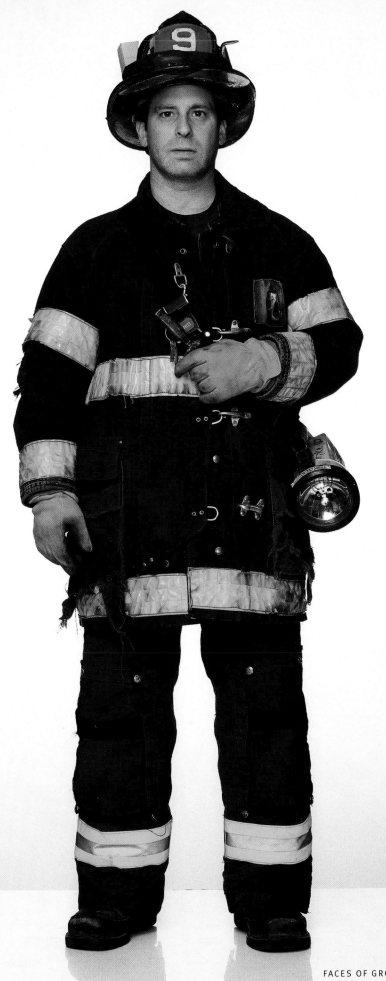

Omar Rivera

**Senior Systems Designer,
Port Authority of New York
and New Jersey**

With one hand on the arm
of his co-worker, Donna Enright,
and the other on the harness of
his guide dog, Salty, Rivera
descended 71 floors in Tower No. 1.

**❝ Salty was nervous, but
he was very concentrated on
his duty. He and Donna
were my angels that day.
Many people saw what
happened, but I heard it.
The sounds of walls
cracking, pipes popping,
people screaming—
it still echoes in
my ears. ❞**

Dave Simms
Carmine Jichetti Jr.

**Lieutenant and Firefighter,
Ladder 20, FDNY**

Both would have been among
the first rescuers on the scene,
but Simms had switched shifts
and Jichetti was attending an off-
site training seminar. Both men
worked at Ground Zero later that
day. Ladder 20 lost every
firefighter who rushed to the
burning towers. Jichetti also lost
his lifelong best friend, Gregory
Saucedo of Ladder 5.

**❝ If there was any way he'd
want to go out, it would be doing
his job, helping people," said
Jichetti. "It's such a strange
twist that I wasn't there. I think
about it every day." Said Simms:
"Lt. John Fischer, who worked
for me, leaves a wife and three
kids." Of working at Ground
Zero on the 11th, he felt: "This is
what hell must look like. ❞**

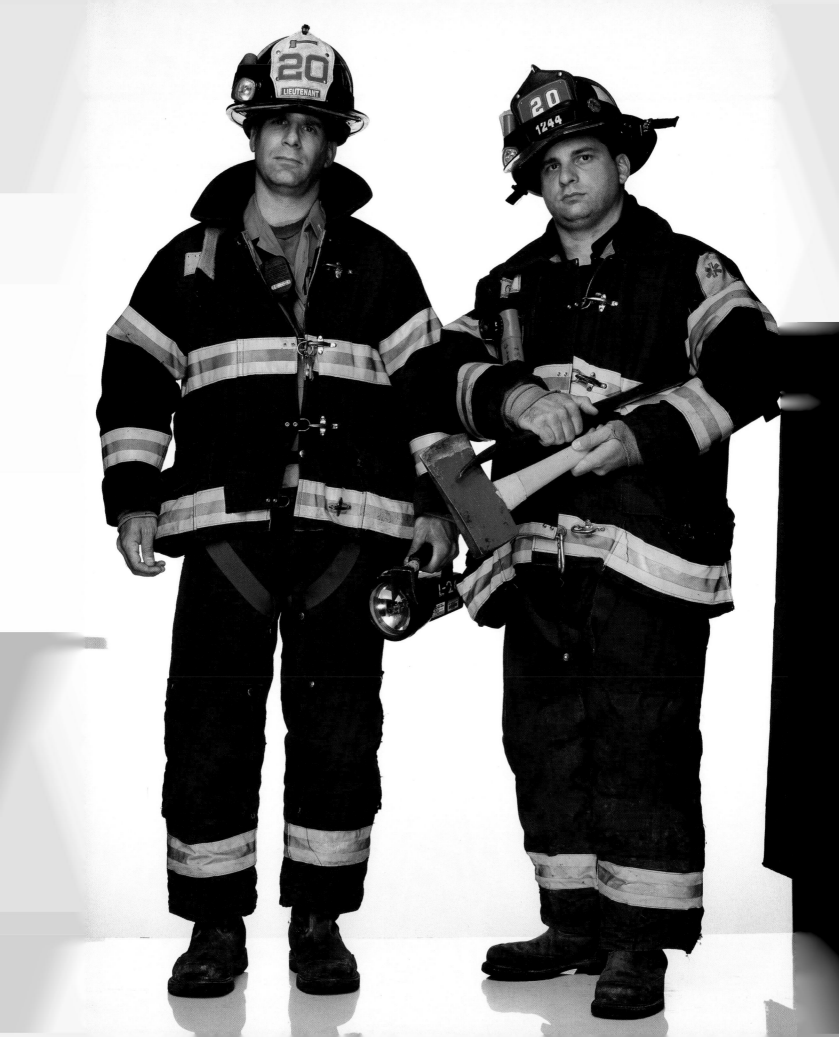

Peter Mueller
Firefighter, Ladder 6, FDNY

Mueller sped to his firehouse when he heard the news and went with others who were off-duty to the site. When the second tower collapsed, he ducked into a building lobby and called to those in the street to join him.

"I waved my flashlight and told people to go towards the light. When it cleared a little, we put out fires and searched buildings. Fire trucks were smashed and there was an ambulance upside down with its lights still flashing. I felt like I was in a battle in a foreign country."

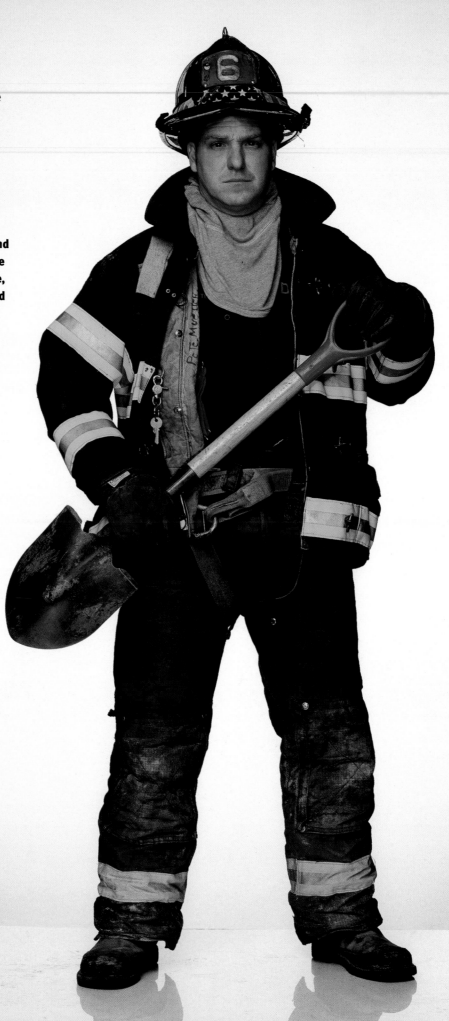

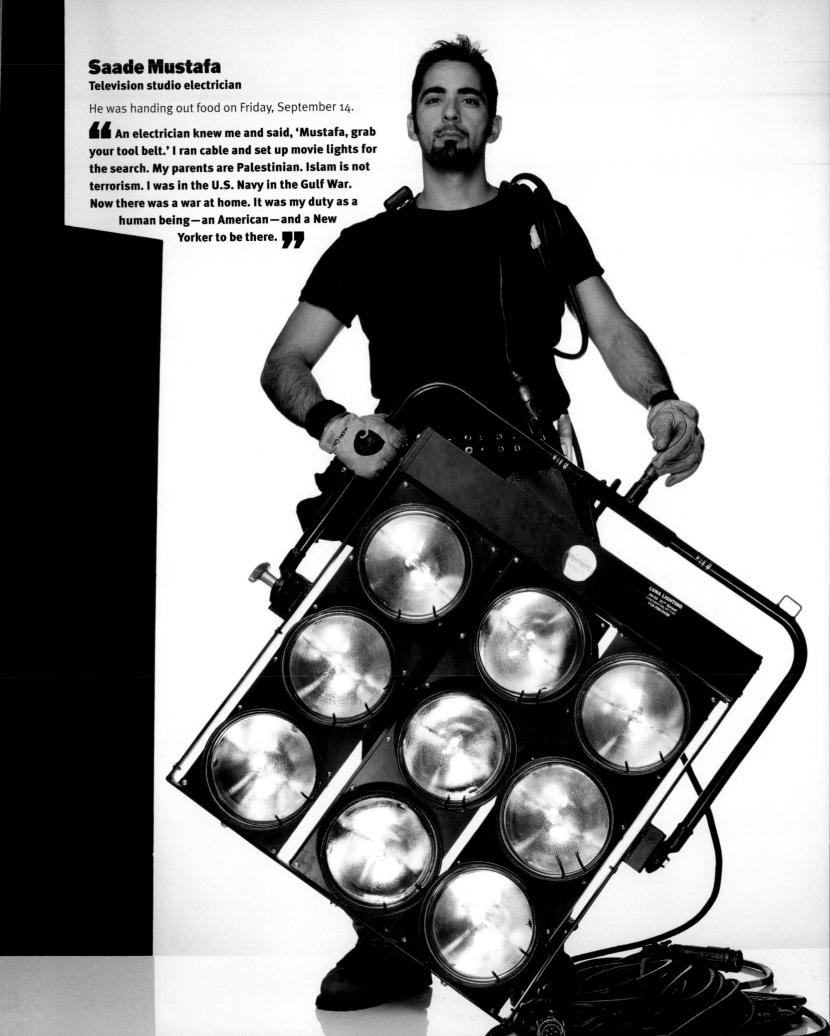

Saade Mustafa
Television studio electrician

He was handing out food on Friday, September 14.

" An electrician knew me and said, 'Mustafa, grab your tool belt.' I ran cable and set up movie lights for the search. My parents are Palestinian. Islam is not terrorism. I was in the U.S. Navy in the Gulf War. Now there was a war at home. It was my duty as a human being—an American—and a New Yorker to be there. "

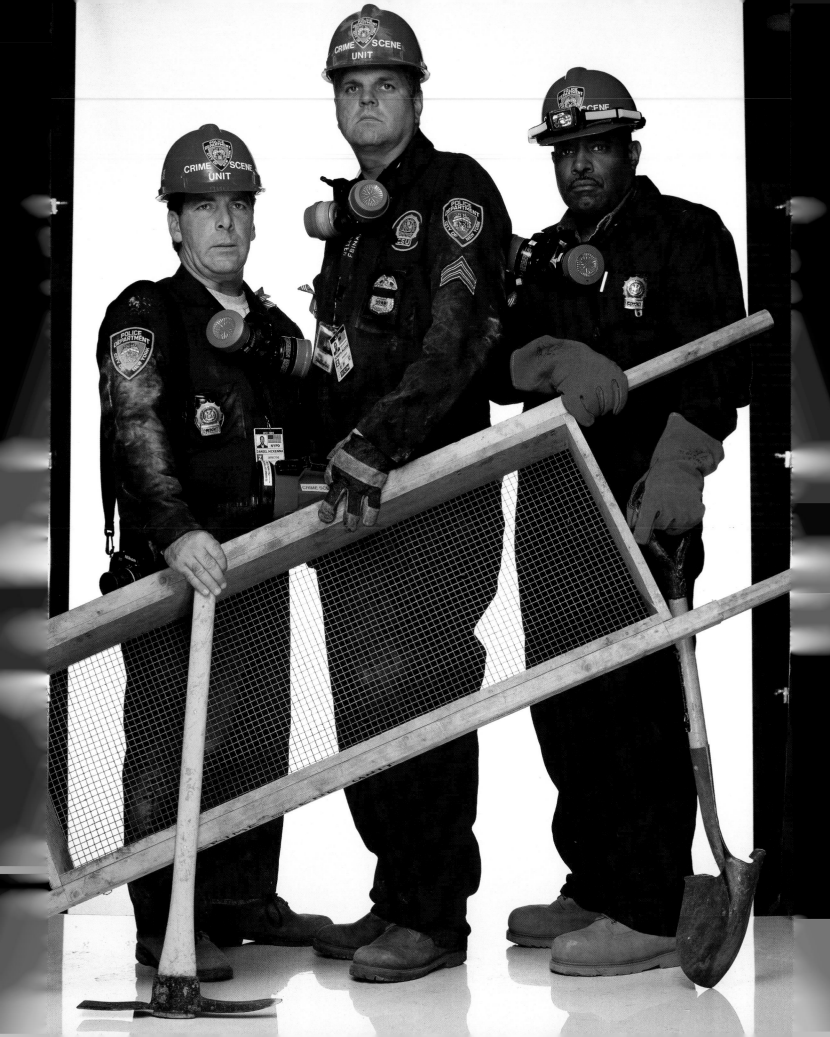

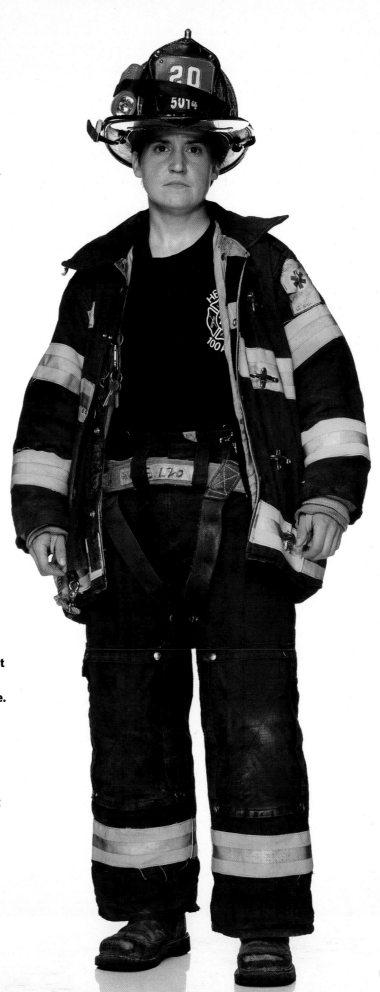

Daniel McKenna
Joseph Blozis
Kurtis Harris
Detectives and Detective Sergeant (Blozis), NYPD Crime Scene Unit

Using pickaxes, shovels and sifters, the detectives searched Ground Zero, for evidence that could further the case but mostly for personal effects of the victims.

"We're trying to provide some sense of closure to families," said Blozis. "For some, it means the world to them to have a wedding band or a piece of a wallet from their loved one."

Adrienne Walsh
Firefighter, Ladder 20, FDNY

To get to work after the attacks, Walsh ran to the Brooklyn Bridge from her apartment a few miles away, hitched a ride with a Manhattan-bound fire truck, then ran to her Lafayette St. firehouse to gather her gear. She arrived just before the second tower fell.

"The sky was gone. You couldn't see it because everything was so dark. But there was fire everywhere. We were trying to put out fires and were digging and digging. I never found a soul, never found evidence of anybody. It was like people just disappeared. I got into a void once, about 50 feet deep, and I'm looking around but there was no sign of humanity. I'm thinking, 'There should be something here.' All we found were a few postcards and a tiny stuffed bear."

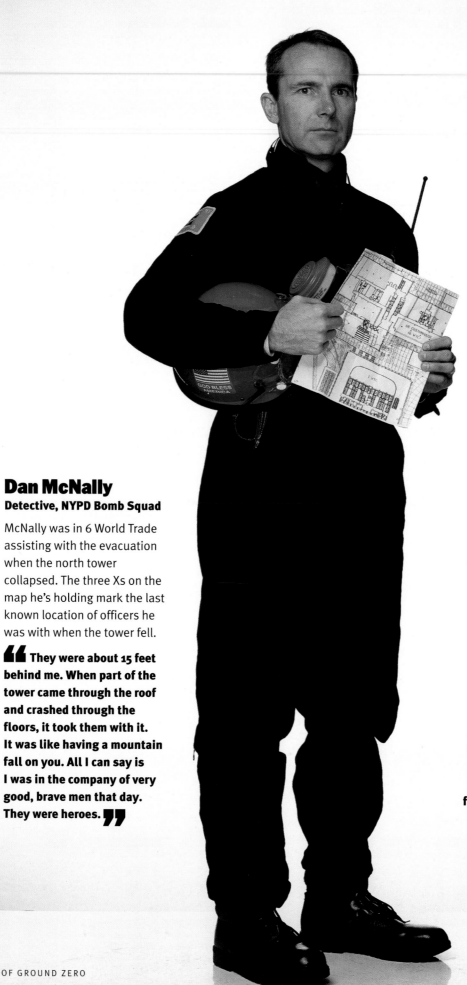

Dan McNally
Detective, NYPD Bomb Squad

McNally was in 6 World Trade assisting with the evacuation when the north tower collapsed. The three Xs on the map he's holding mark the last known location of officers he was with when the tower fell.

They were about 15 feet behind me. When part of the tower came through the roof and crashed through the floors, it took them with it. It was like having a mountain fall on you. All I can say is I was in the company of very good, brave men that day. They were heroes.

Michael Culen
James McFarland
Firefighters, Engine 298 and Ladder 127, FDNY

The Queens firefighters worked at the Ladder 20 house during that unit's memorial service. Firefighters attended a steady stream of funerals for months after the attacks.

Even if your house wasn't hit hard, you're going to funerals, one after another with no end in sight," said Culen. **"Each of us knows more than a hundred firefighters — guys from the academy, guys from rotation, guys who passed through our house.**

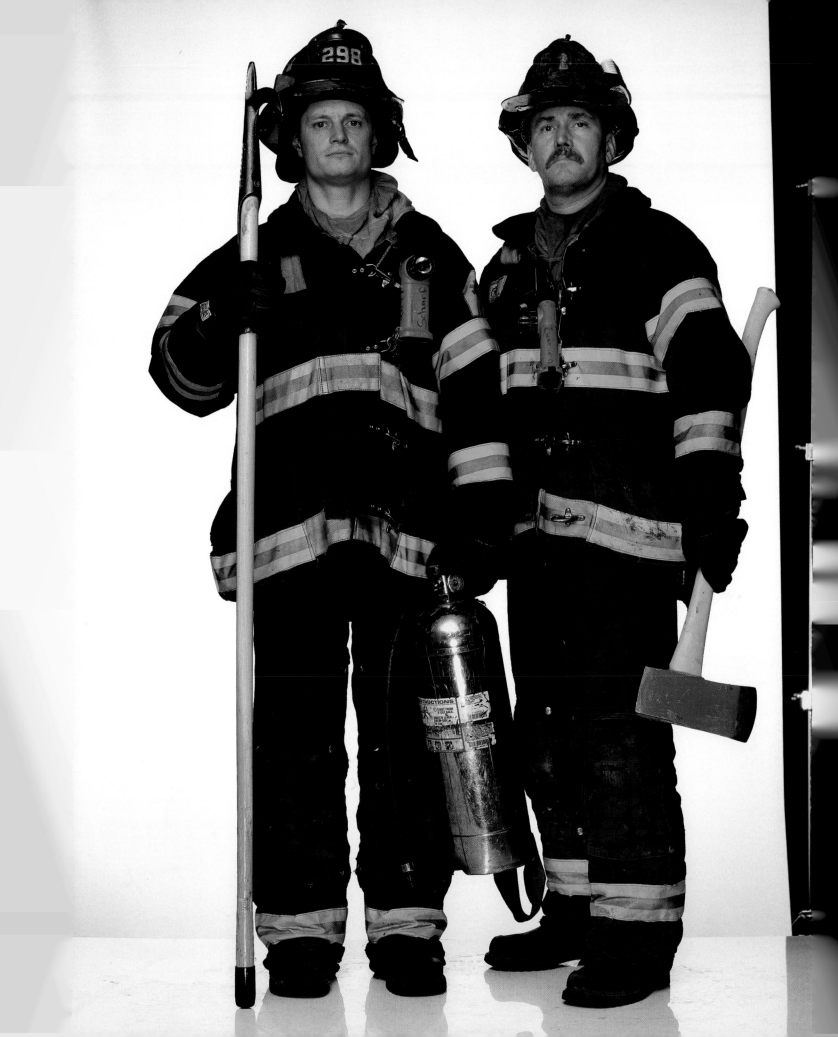

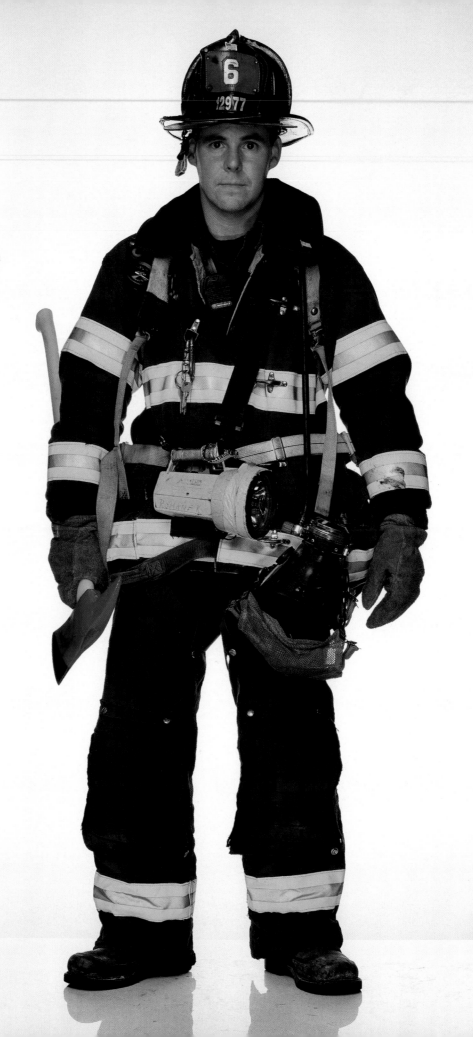

Richard Romanek
Firefighter, Ladder 6, FDNY

As his firehouse colleagues in Manhattan were on their way to a burning Tower 1, Romanek was in his car driving to a training course in Staten Island.

❝ I had a clear view of the first tower smoking. In Staten Island we organized a recall of all off-duty firemen to come back into service. By the time I made it to the Staten Island Ferry, both towers were down and it was a smoking mess. ❞

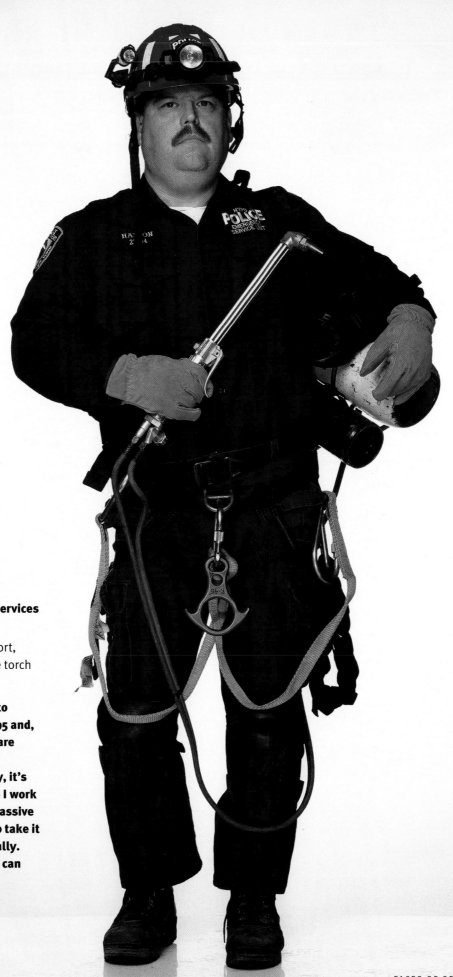

Mike Hanson
**Officer, Emergency Services
Unit, Truck 1, NYPD**

During the rescue effort,
he used his acetylene torch
to cut through steel.

**❝ I was deployed to
Oklahoma City in 1995 and,
well, you can't compare
them. This is just so
massive. Emotionally, it's
taken a toll. Just like I work
in small sectors of massive
destruction, I have to take it
in little pieces mentally.
That's the only way I can
manage it. ❞**

Peter Regan
United States Marine

He was stationed at Camp Pendleton in California when the towers were hit and his father, Donald, a New York City firefighter with Rescue 3, rushed to the scene. Peter flew east and joined in recovery efforts at Ground Zero, searching for his dad.

" If the roles were reversed, I know he would do the same thing. I just want something of his. I would prefer to bring something back. "

Marek Truskolaski
Raul Pala
Julio Jalil
Asbestos handlers, Laborers International Union of North America, Local 78

They began cleanup efforts at Ground Zero on September 15.

" When I first got there, I was crying, thinking about the people who died and their families," said Truskolaski. Said Pala: "This is so painful for anyone who is human." And Jalil: "When I saw it, I thought, 'It would take the devil to kill so many people.' "

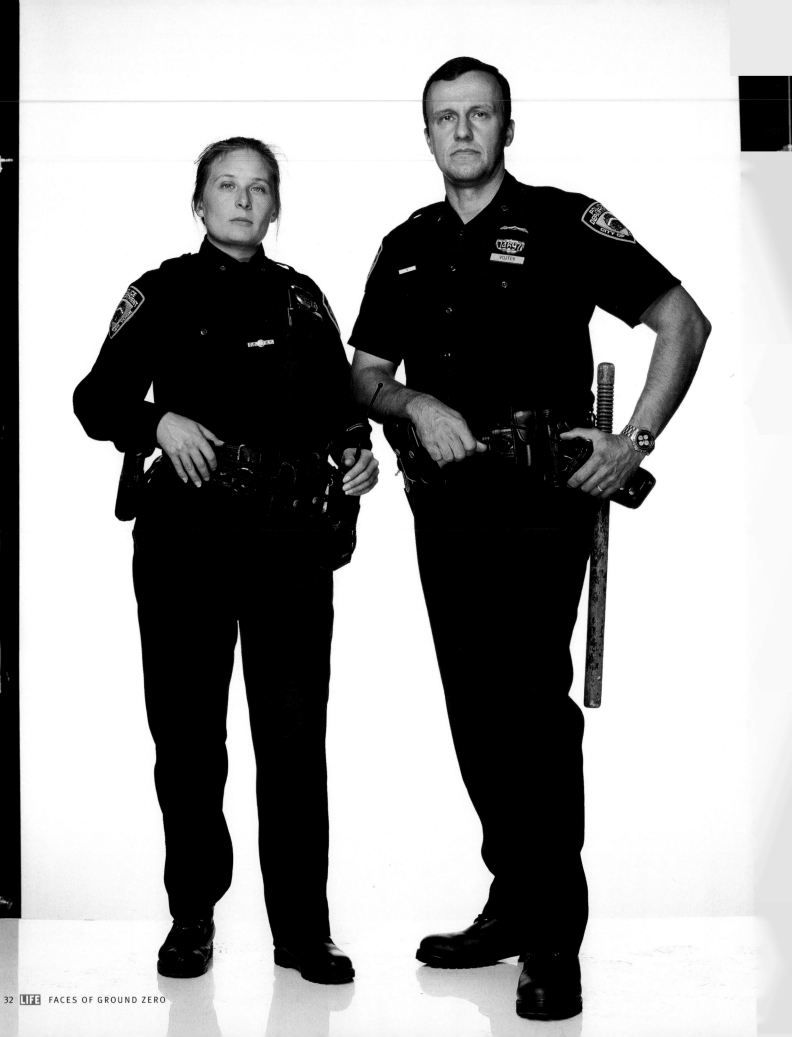

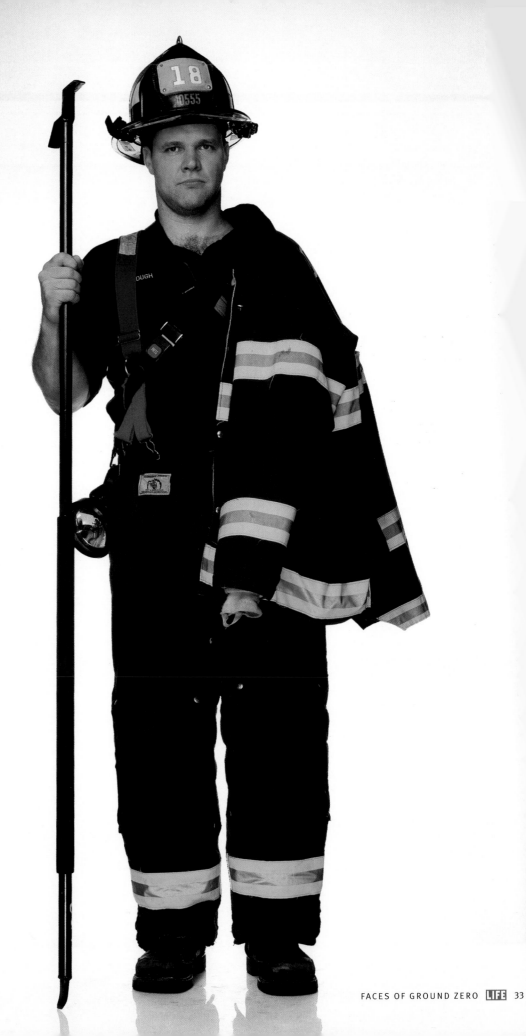

Caroline M. Jones
Miroslav M. Vojtek
Police Officers, 6th Precinct, NYPD

Standing at the corner of Seventh Avenue and Grove Street, Jones and Vojtek saw the first plane hit.

❝ We took the last block driving on the sidewalk to get there," said Vojtek. "We stopped at the corner of Varick and Canal and were directing traffic away from the site when the second plane hit. Later, we moved further south and were just two blocks away when the first tower came down. We were again just a few blocks away when the second building fell. We were choking and spitting and covered in dust, but we worked until about 11 p.m. ❞

George Hough
Firefighter, Squad 18, FDNY

Hough was off-duty on September 11.

❝ After the planes hit, I started driving to my firehouse in lower Manhattan, where I got a ride to the Trade Center. We had just gotten off the truck when the north tower came crashing down. The dust cloud knocked me to the ground. I didn't comprehend at the time what had just happened. Only after speaking to other firefighters did I begin to realize how many guys were missing, not only from the houses I had worked in — Squad 18/Ladder 20, Hazardous Materials Company 1/Squad 288, and Ladder 9/Engine 33 — but from so many houses. While searching the site that day, I tried to stay focused. I thought to myself: 'More guys must have gotten out, we just haven't found them yet.' ❞

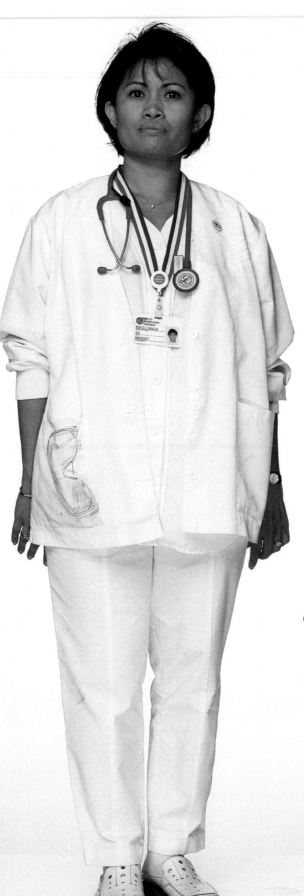

Rebecca Canalija

**Emergency Room Nurse,
NYU Downtown Hospital**

While many medical
facilities throughout the city
waited for large numbers of
wounded who never arrived,
NYU Downtown Hospital was
inundated. The E.R., which
usually handles 60 people in
a day, treated some 500 on
that Tuesday.

**❝ We didn't bother
calling in extra staff.
Everyone just came right in.
Some had to show their IDs
at police barricades to get
back into Manhattan. It still
makes me very sad, but I'm
glad our tiny hospital was
able to help so many. ❞**

Kevin Williams
Clifford Stabner

**Lieutenant and Firefighter,
Rescue 3, FDNY**

Eight men from Rescue 3
responded to alarms. None
returned. Williams and
Stabner were off-duty on the
11th, but they spent weeks at
Ground Zero working 12-hour
shifts with no days off.

**❝ It was endless
digging," said Williams.
"I was horrified at what we
had to do, but we worked
together, supported each
other and got through it.
Everyone did their part. ❞**

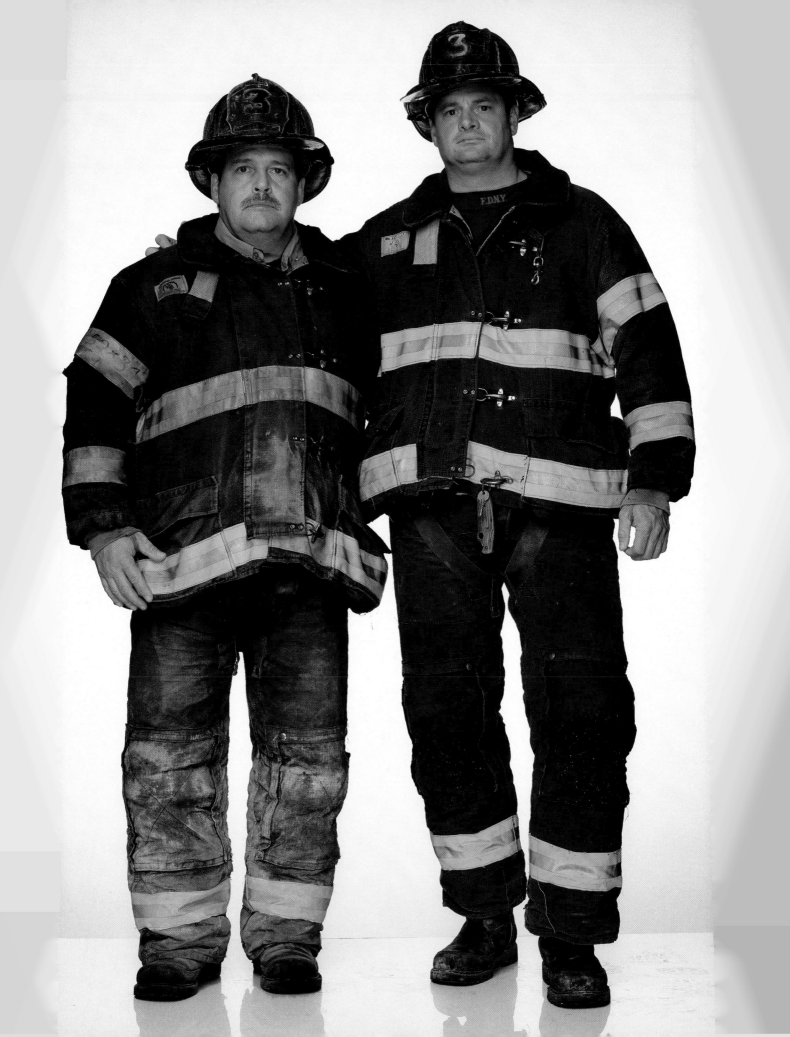

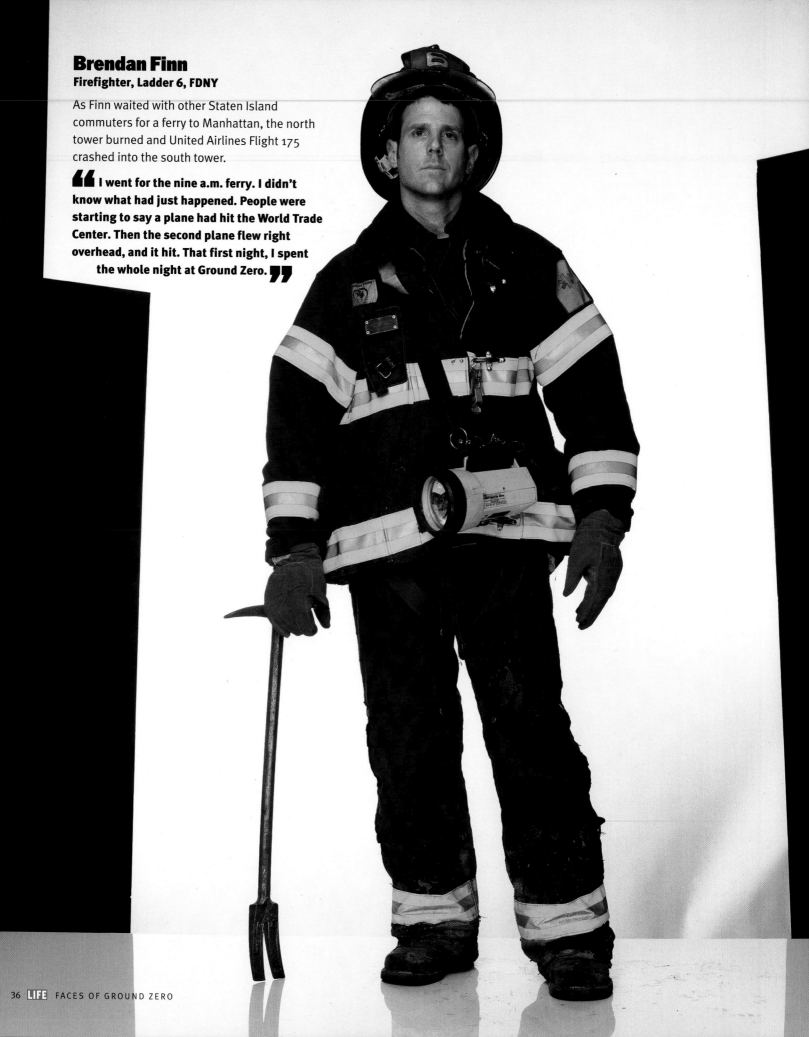

Brendan Finn
Firefighter, Ladder 6, FDNY

As Finn waited with other Staten Island commuters for a ferry to Manhattan, the north tower burned and United Airlines Flight 175 crashed into the south tower.

" I went for the nine a.m. ferry. I didn't know what had just happened. People were starting to say a plane had hit the World Trade Center. Then the second plane flew right overhead, and it hit. That first night, I spent the whole night at Ground Zero. "

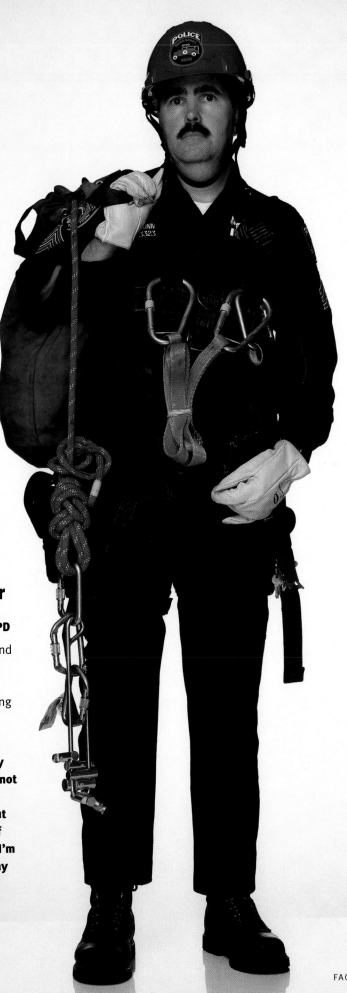

Eugene O'Connor
Sergeant, Emergency Services Unit, Truck 1, NYPD

Immediately after the second collapse, O'Connor's truck set out to find survivors. Among the dead and missing were 14 ESU officers.

" The hardest part was that this was an extremely personal situation. We're not used to being called in to rescue our own people. But you can't personalize it. If you do, you're in trouble. I'm extremely proud of the way our guys handled it. "

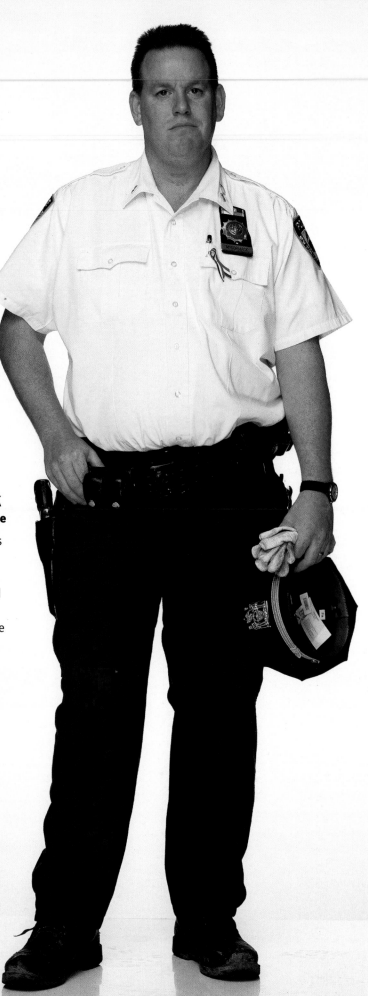

Michael McCormack
Lieutenant, NYC Sanitation Police

McCormack's crew cleared streets so emergency vehicles could access Ground Zero. Sanitation trucks hauled out debris, watered streets to minimize dust and trucked away garbage from rescue workers and local restaurants.

❝ It was tough to be there, a horrific scene, but everyone was working together. So many people from so many groups. People just said, 'Let's get in and get it done.' ❞

Joseph Wakie
Firefighter, Ladder 9, FDNY

When Wakie was working at Ground Zero, he and a colleague found the Ladder 9 truck thoroughly burned. They removed the rig's silver bell and took it back to the firehouse.

❝ The bell's a tradition, a symbol. The guys in the house were glad to have something back. Our rig's getting fixed up. It'll be back, and we'll put the bell back on. People say we're heroes. I don't feel like one. I'm just doing what others taught me. A lot of those guys aren't here anymore, so I'm just trying to live up to their example. ❞

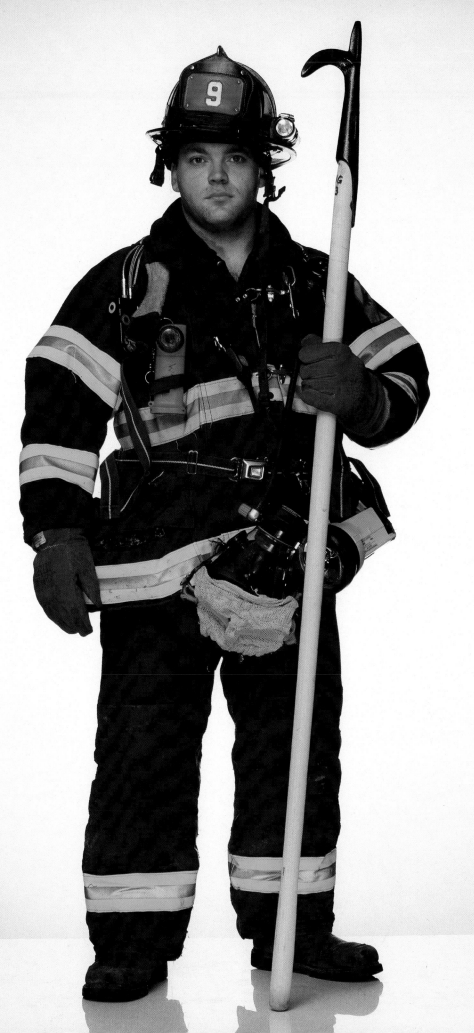

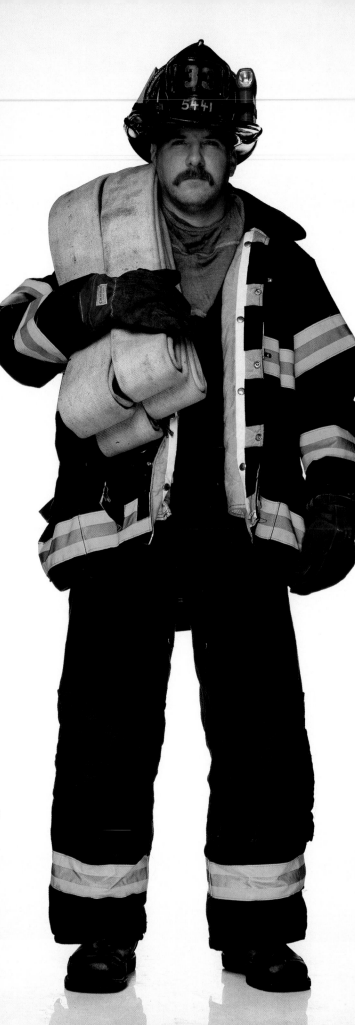

Robert Schmück
Firefighter, Engine 33, FDNY

Schmück was on jury duty the morning of the 11th. He was excused by the bailiff and went to Ground Zero. Of the seven men from Engine 33 who responded to initial alarms, only the truck's driver survived.

❝ Jury duty saved my life. I should have been there. When I finally got there late that afternoon, it looked like it was four a.m. and snowing. The workers were covered in ash. You could hear the crackling of fires. It was a war zone. ❞

David Ebert
Warren P. Curry
Steven Hoffman
**Lieutenant,
Missing Persons Squad
Captain,
Special Investigations Division
Sergeant,
Missing Persons Squad /
Morgue Supervisor, NYPD**

After the attacks, but before both buildings fell, the three responded to the World Trade Center site to help establish a temporary morgue. After September 11 they worked with the New York City Medical Examiner's office to identify victims and notify families.

❝ Shortly after the north tower collapsed, I was walking on Ann St. and was thinking it was all a dream," recalled Ebert. "How many people had just lost their lives? A fireman was cursing about news he had heard on his radio that an entire company was missing. I couldn't believe we were so vulnerable. ❞

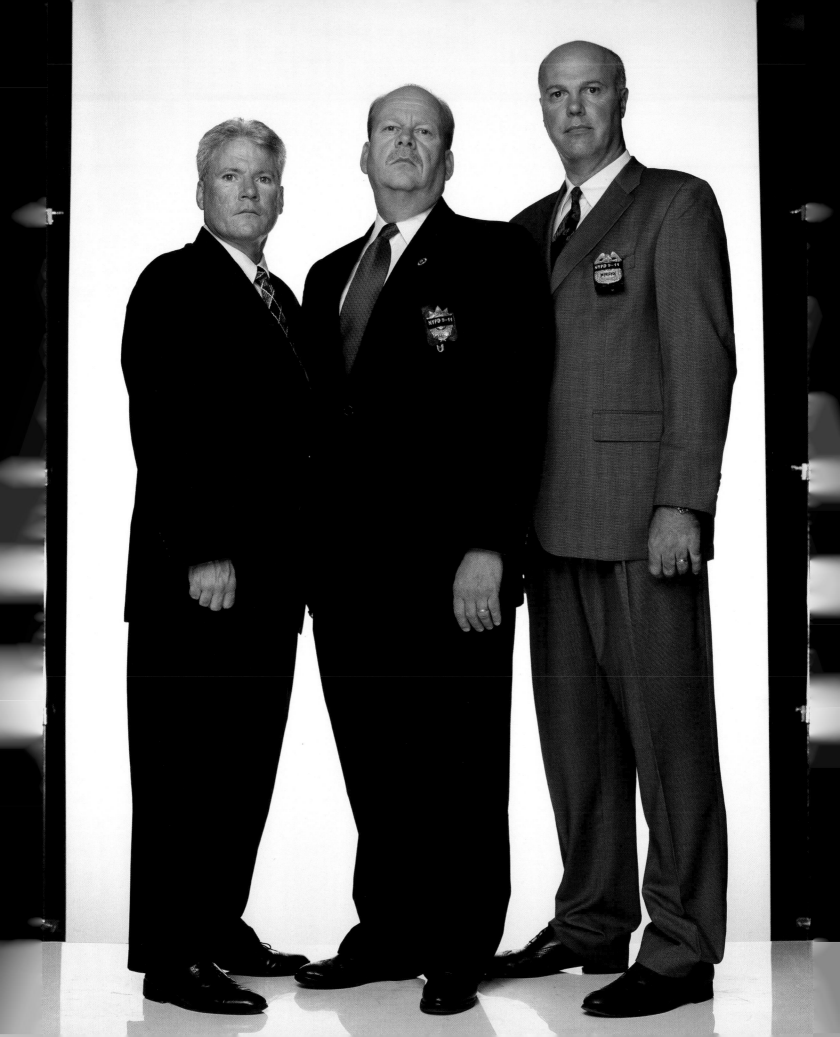

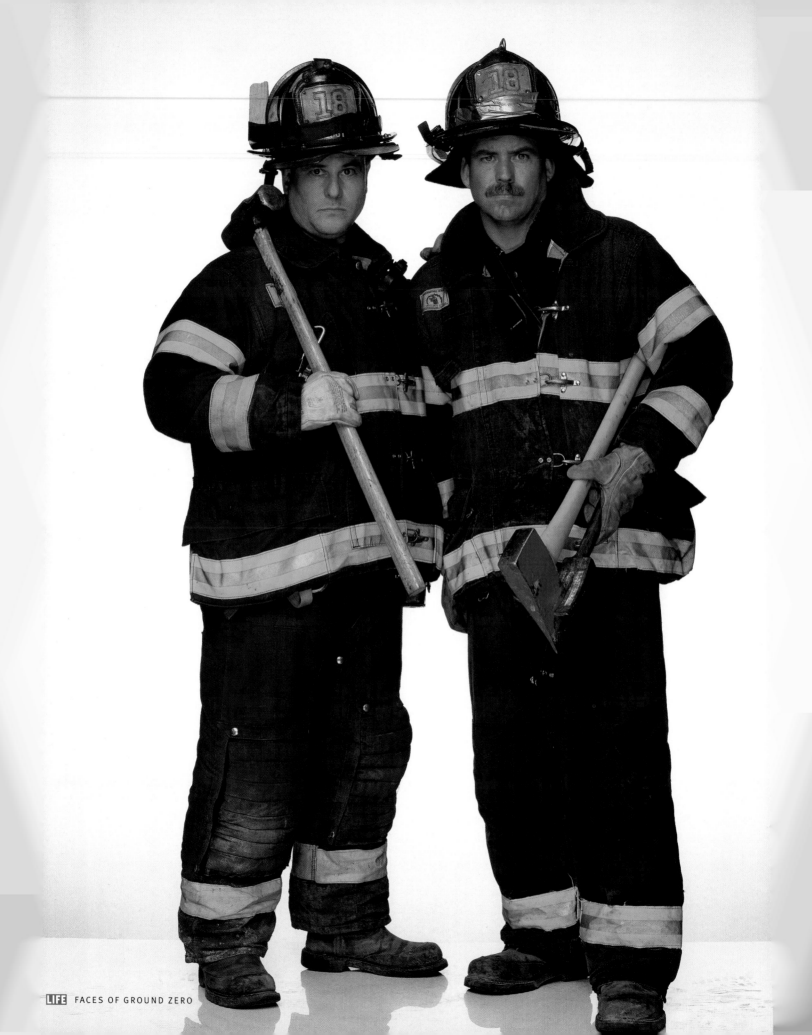

Dan Castellano
Patrick Kelly
Firefighters, Squad 18, FDNY

Castellano was off-duty but raced downtown as soon as he heard of the attacks. Kelly rode to the scene with seven from his squad, even though he had just gone off the clock. He became separated in the Tower 1 lobby and went up a stairwell with another unit. The other seven from Squad 18 perished, while Kelly narrowly escaped.

❝ I heard on someone's radio that my guys were on 33," said Kelly. "I was on 23 helping a cop carry a civilian. We dove into the Customs House when Tower 1 came down. After the air cleared a little, I looked for my guys, but I had a bad feeling. I knew they were up higher than I was. ❞

Dave Gallart
Police Officer, Highway 3, NYPD

Trapped in a dark, dust-filled subway station, Gallart and his partner, John Dadabo, finally dug themselves out after about two hours.

❝ When we got back up to the street we found a police car that wasn't completely destroyed, so we ripped open the trunk and took some tools. We figured we'd dig out anybody we found buried. Unfortunately, there was nobody to find. We found a lot of body parts. We didn't realize we were walking on them, because there was about four inches of dust and debris. ❞

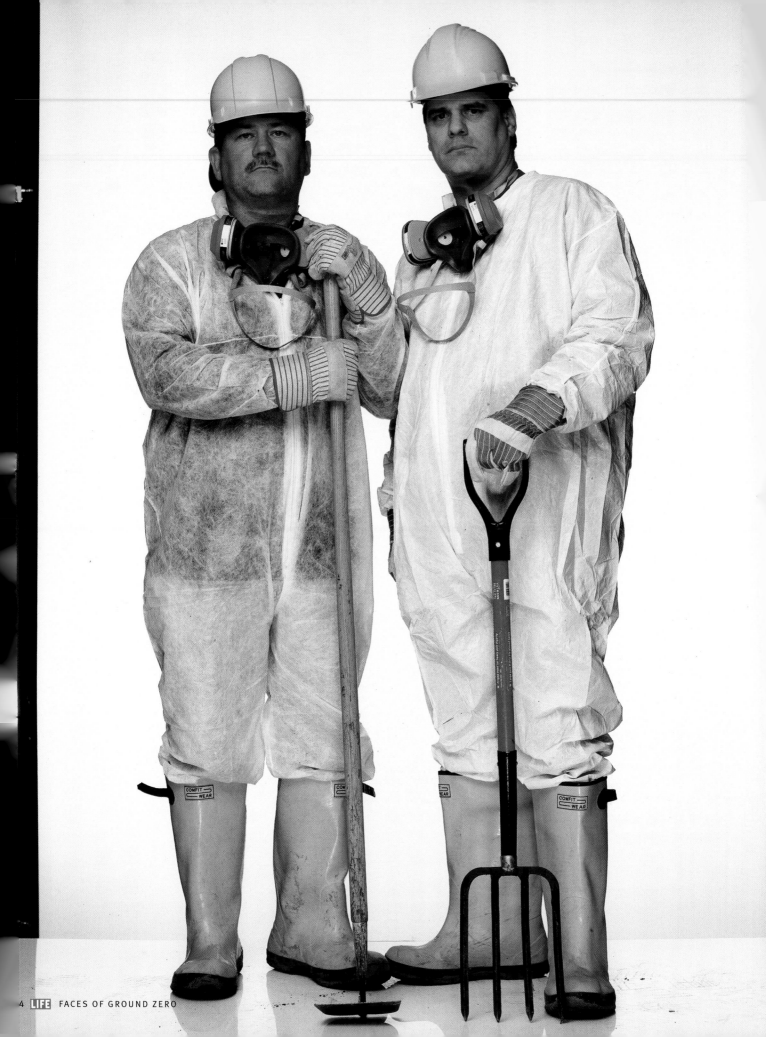

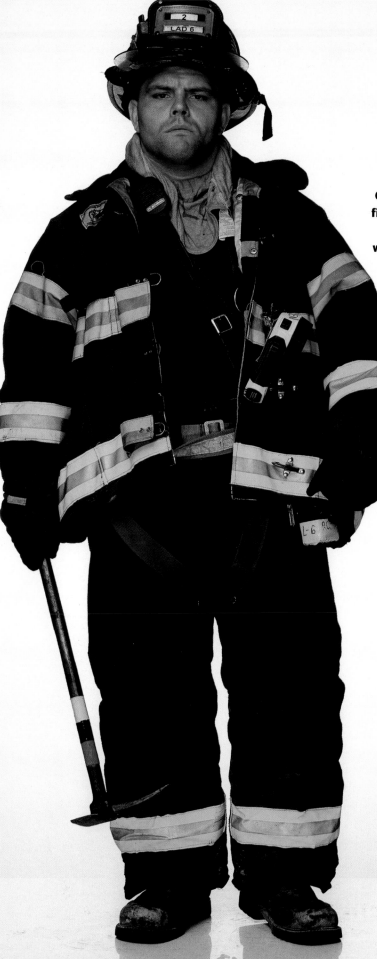

Douglas Lotten
Firefighter, Ladder 6, FDNY

On September 11, Lotten and his wife were on vacation in California. His mother-in-law called to break the news.

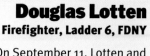 **I watched it on TV. Then I drove 100 miles per hour on Route 80 to get back home by Friday morning. I worked at Ground Zero until two a.m. that first night. I look at all the guys in a different light now. We all work together and I realize how quickly it can all change and be over. But the biggest thing that I feel is guilt that I was so far away when it happened. 🙶**

Danny Rice
Kevin McGarvey
**Detectives,
52nd Precinct, NYPD**

For nearly six months starting in September, Rice and McGarvey worked 12-hour shifts at the Fresh Kills landfill in Staten Island, searching through World Trade Center rubble for human remains and items that could help identify victims.

🙶 **It was terrible. We didn't find anybody whole," revealed Rice. "Mostly charred bones and flesh. I just kept thinking, 'How much hate is there in the world?' We also found a lot of ID cards, driver's licenses, even just regular photos that must have come off of people's desks. We found golf balls, oddly, a lot of golf balls. 🙶**

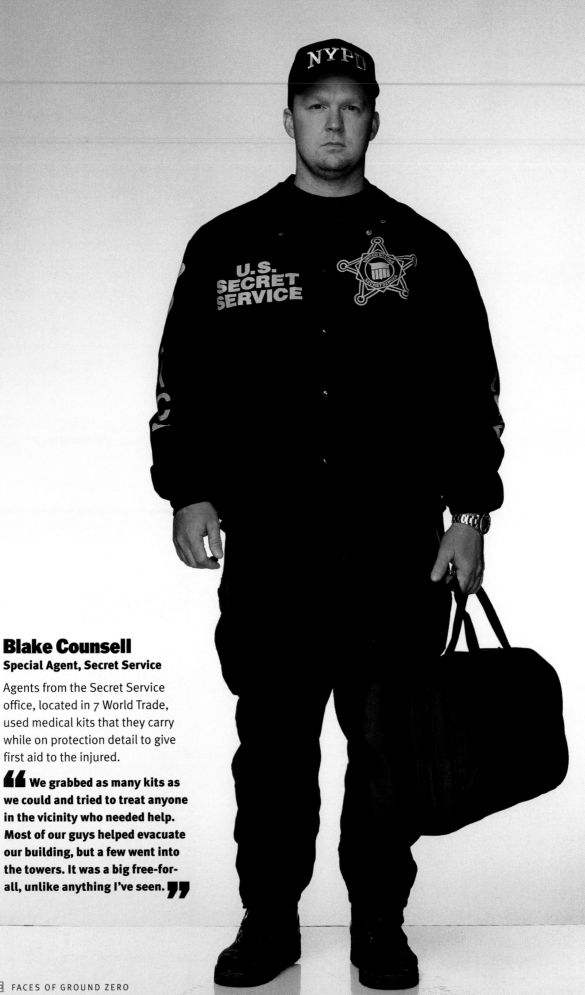

Blake Counsell
Special Agent, Secret Service

Agents from the Secret Service
office, located in 7 World Trade,
used medical kits that they carry
while on protection detail to give
first aid to the injured.

**❝ We grabbed as many kits as
we could and tried to treat anyone
in the vicinity who needed help.
Most of our guys helped evacuate
our building, but a few went into
the towers. It was a big free-for-
all, unlike anything I've seen. ❞**

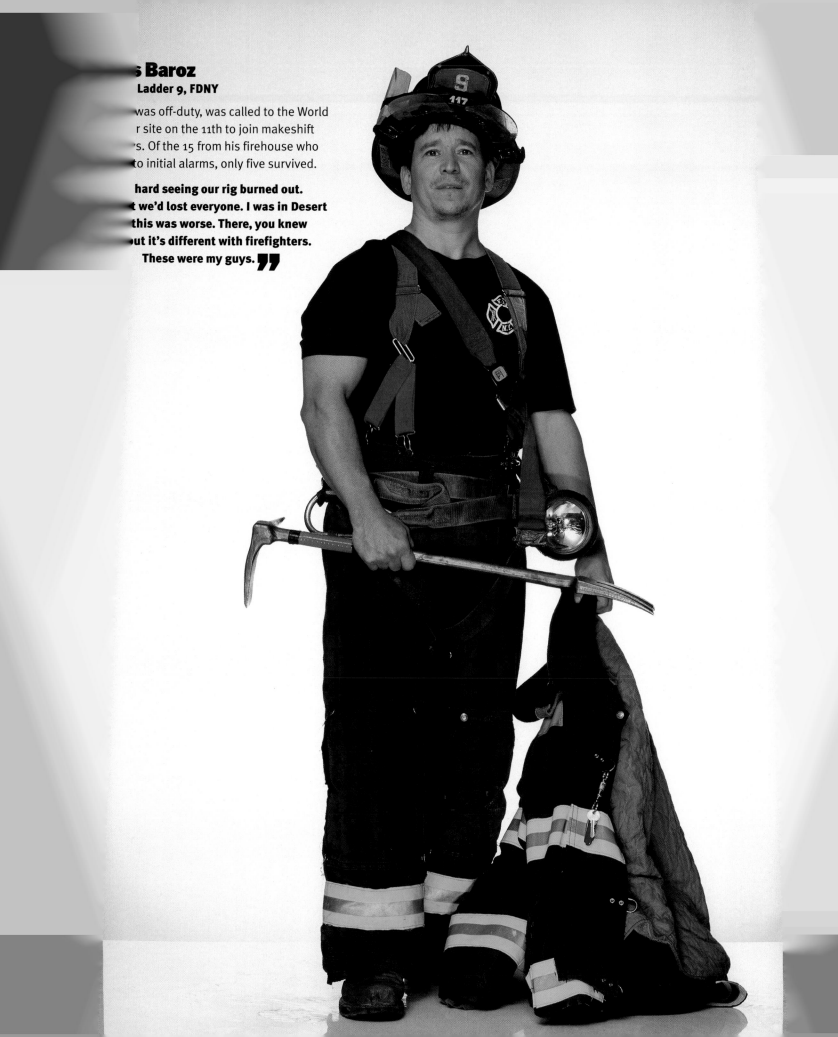

...s Baroz
...Ladder 9, FDNY

...was off-duty, was called to the World
... site on the 11th to join makeshift
...s. Of the 15 from his firehouse who
...to initial alarms, only five survived.

... hard seeing our rig burned out.
...t we'd lost everyone. I was in Desert
...this was worse. There, you knew
...ut it's different with firefighters.
These were my guys. 🙮

Evelyn Montanez
Psychiatric Social Worker and
American Red Cross volunteer

She spent several weeks counseling people at and near Ground Zero.

❝ It wasn't just the survivors and rescue workers needing help, there were a lot of immigrants and minorities working around those perimeters, cleaning the buildings and removing the asbestos. Those people weren't in Ground Zero digging out, but a lot of them had lived through civil war in their countries, especially in South America. There was a lot of retraumatization for them. They felt like, 'I left over there to have some security, and now I'm here and I'm in the middle of all this.' ❞

William Lewis
Tom Polanish
Firefighters, Ladder 134
and Ladder 127, FDNY

When a devastated firehouse holds a memorial, men from other houses cover for the bereaved unit. These Queens firefighters worked at Ladder 20, in SoHo, which lost 14 members.

❝ It's strange, I don't feel the impact from the scene down there. It doesn't seem real," said Polanish. "What's all too real are the memorial services and reading the people's stories in the newspaper. That's what makes it sink in. ❞

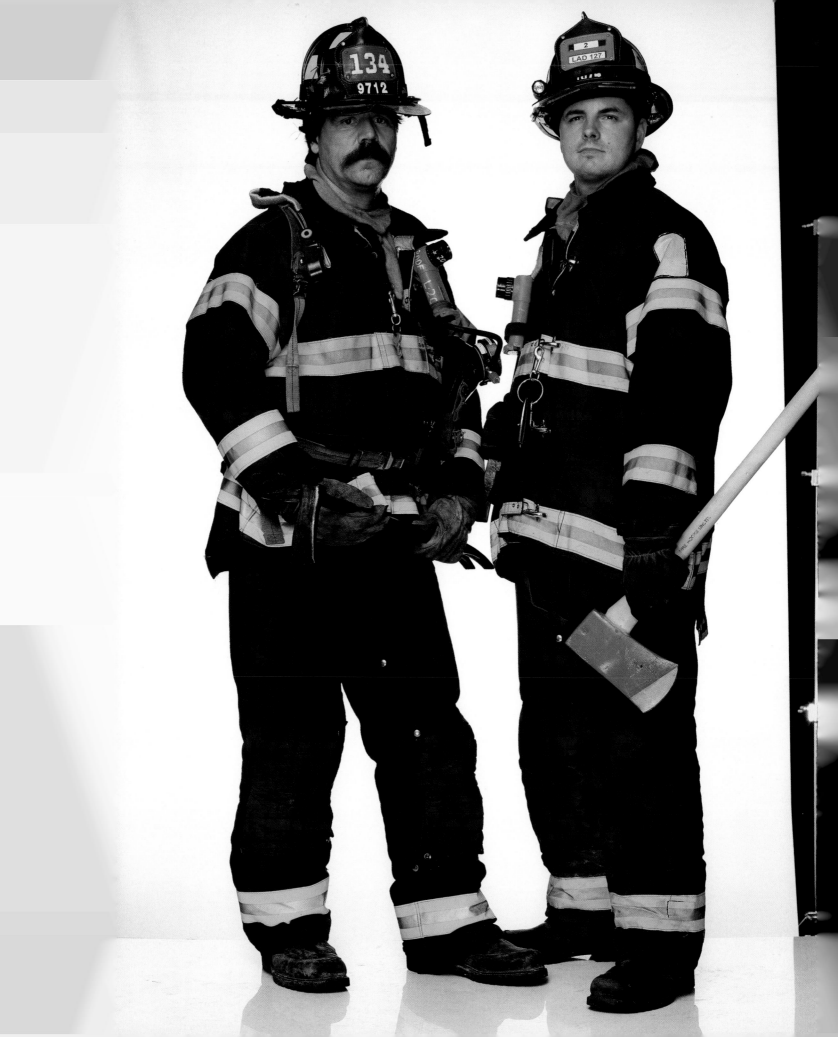

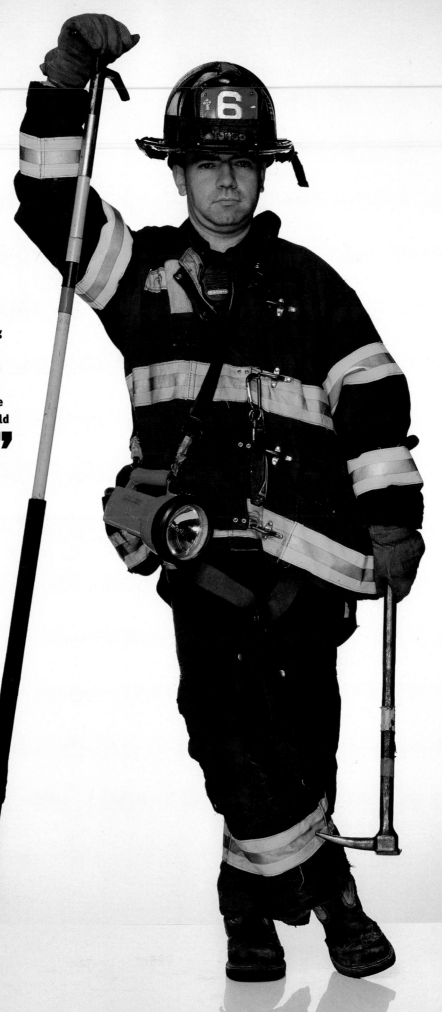

Bill Leahy
Firefighter, Ladder 6, FDNY

Miraculously, everyone from the Engine 9/Ladder 6 house survived. In the aftermath, they filled in at fire companies that had been hit hard, and worked at Ground Zero.

❝ There was so much going on that my brain didn't really process what I was doing, the horror of the scene. It was frustrating work, like we were trying to move the entire World Trade Center with a bucket. ❞

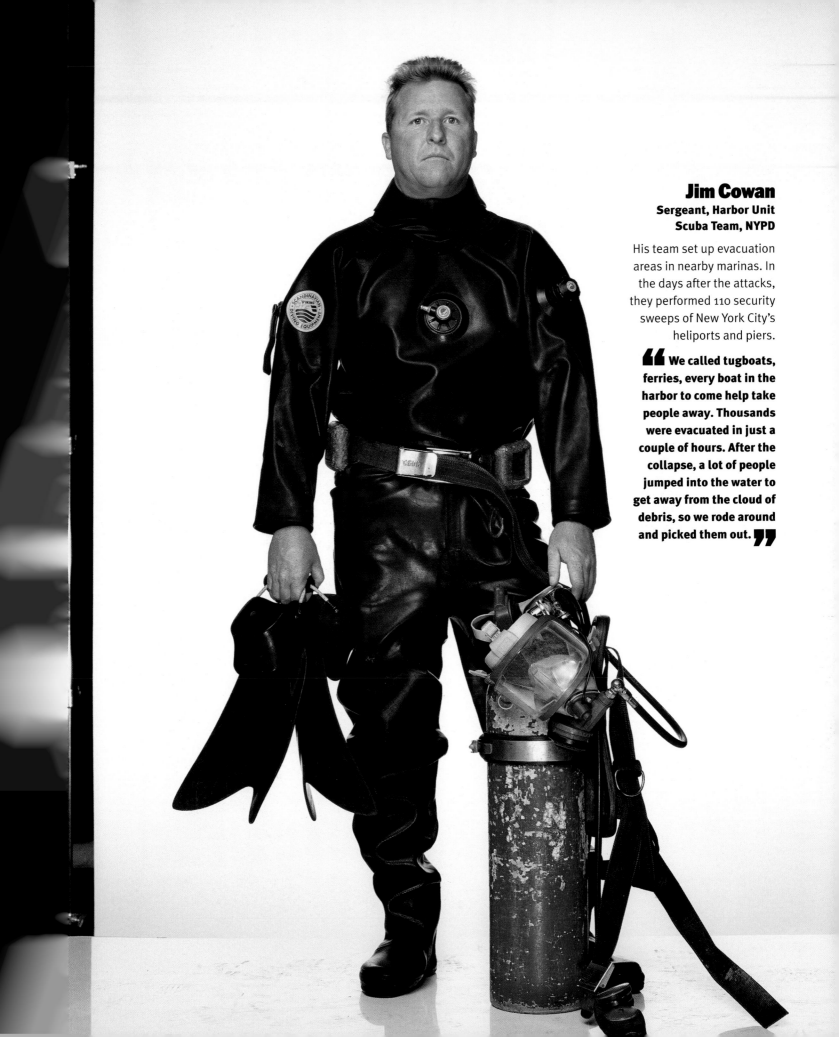

Jim Cowan
**Sergeant, Harbor Unit
Scuba Team, NYPD**

His team set up evacuation
areas in nearby marinas. In
the days after the attacks,
they performed 110 security
sweeps of New York City's
heliports and piers.

**❝ We called tugboats,
ferries, every boat in the
harbor to come help take
people away. Thousands
were evacuated in just a
couple of hours. After the
collapse, a lot of people
jumped into the water to
get away from the cloud of
debris, so we rode around
and picked them out. ❞**

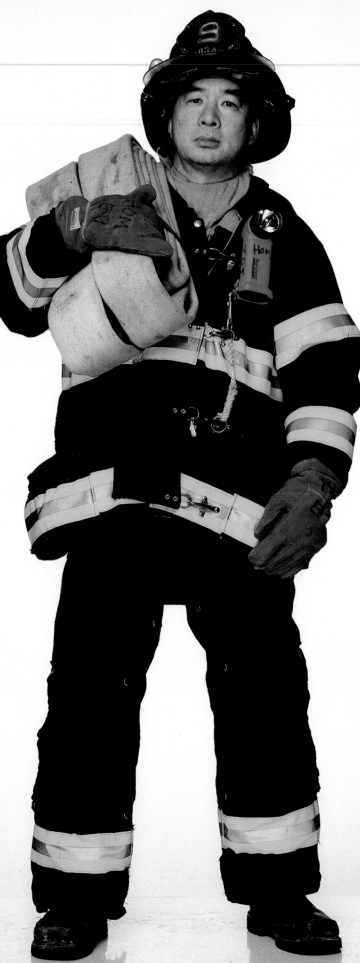

Benny Hom
Firefighter, Engine 9, FDNY

Hom arrived at Ground Zero after both towers had fallen.

❝ You couldn't see well, but you could hear real well. Someone said to me, 'I think there's somebody right here hurt.' Four of us started digging and we saw an arm. We called on the walkie, 'We have a Lieutenant Fuentes but we don't know where we are.' The fireboat radioed back, 'Listen for our horn and head to the water.' We made it to the water. Things were really crazy, people in shock walking in circles. There was a firefighter walking around holding a leg. I told him to sit down, but he kept saying, 'No, but I got a leg.' We heard guys on the walkie saying, 'Come get us.' We'd hear someone else say, 'I'm hurt, please help me.' Then nothing. When our guys got out, all of them sat in a huddle, crying like children. ❞

Tim Mullally
Tom Norden
Mullally owns a John Deere dealership in Jefferson, N.Y. Norden is his brother-in-law, a Manhattan resident.

Mullally asked John Deere to donate their Gator Utility Vehicle to the rescue efforts. The company sent 46 of them to Ground Zero.

❝ We gave them to anyone who needed one," said Mullally. "When people saw what they could do, they became pretty popular. We were driving up and down stairs and over sharp objects. I just feel lucky that we were able to do something to help. ❞

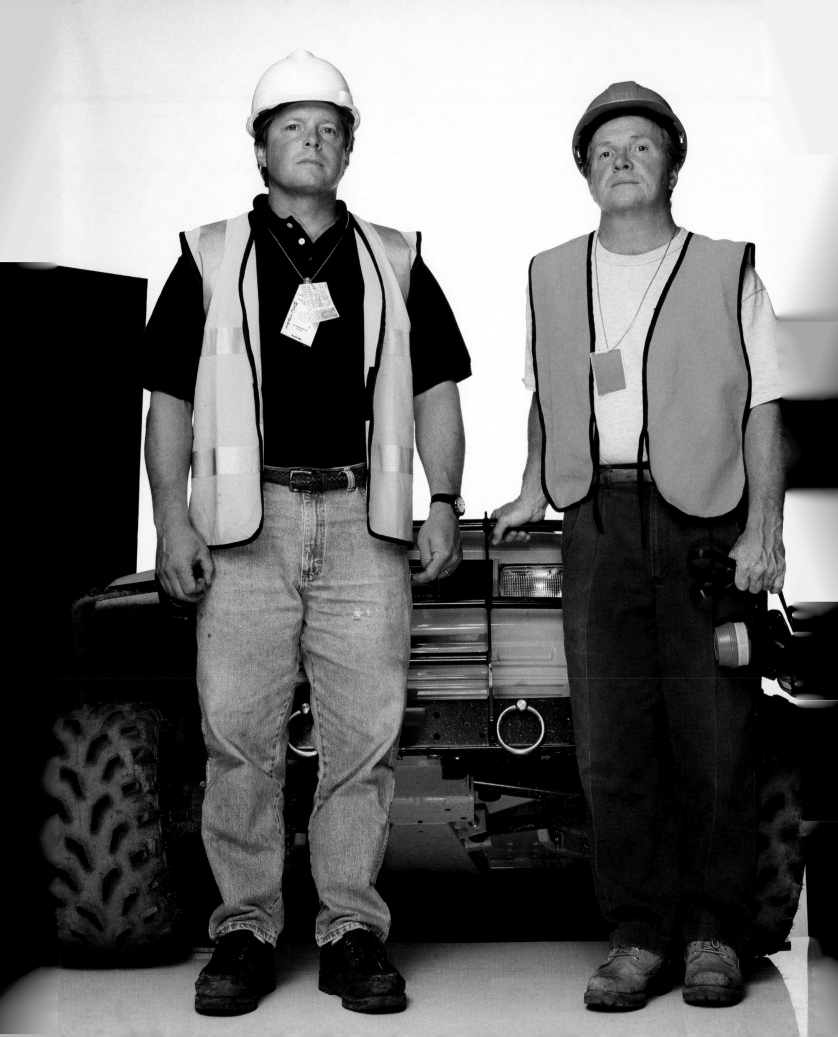

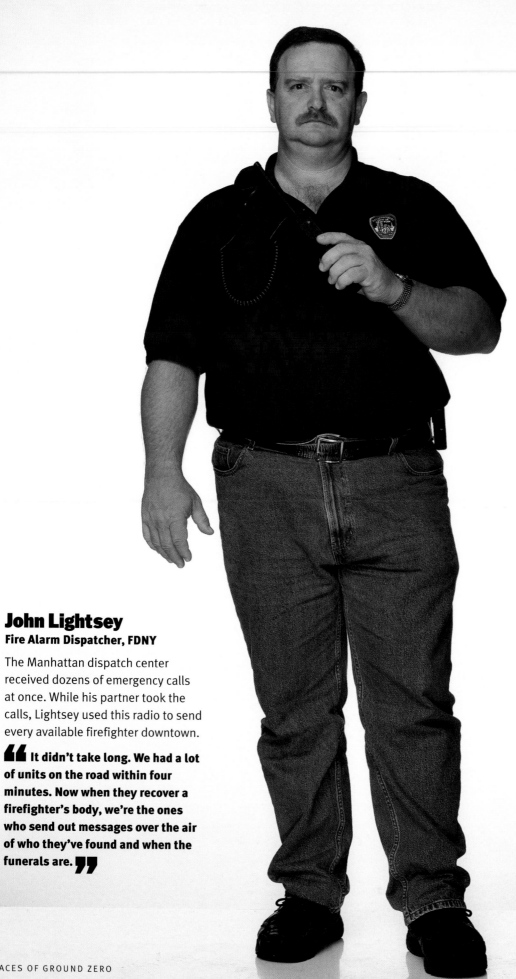

John Lightsey
Fire Alarm Dispatcher, FDNY

The Manhattan dispatch center received dozens of emergency calls at once. While his partner took the calls, Lightsey used this radio to send every available firefighter downtown.

" It didn't take long. We had a lot of units on the road within four minutes. Now when they recover a firefighter's body, we're the ones who send out messages over the air of who they've found and when the funerals are. "

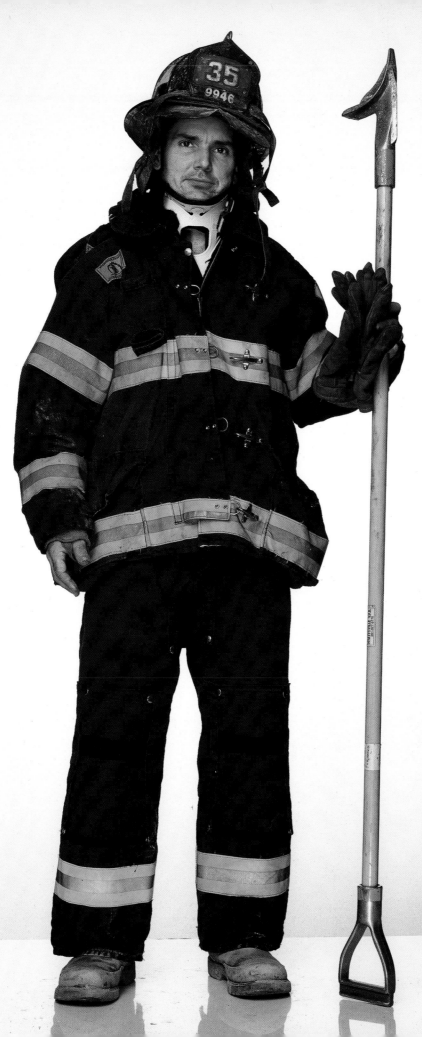

Kevin Shea
Firefighter, Ladder 35, FDNY

Shea had just gone off-duty but he jumped on Ladder 35 when the alarm sounded. The last thing he remembers is greeting a firefighter friend in the lobby of the south tower. After the building collapsed, rescuers found him lying in six inches of ash on Albany St., two blocks away. He suffered a broken neck, multiple traumas and loss of part of a thumb. Of the 12 firefighters from his house who responded to the call, he's the only survivor. He has since dedicated his time to the Fallen Brothers Foundation, a charity he started with his brother in 1999.

❝ For the first three days I was listed as 'unaccounted for.' Now that I'm alive, I'm working 100 percent for the families of my fallen brothers. It's part of my healing process. ❞

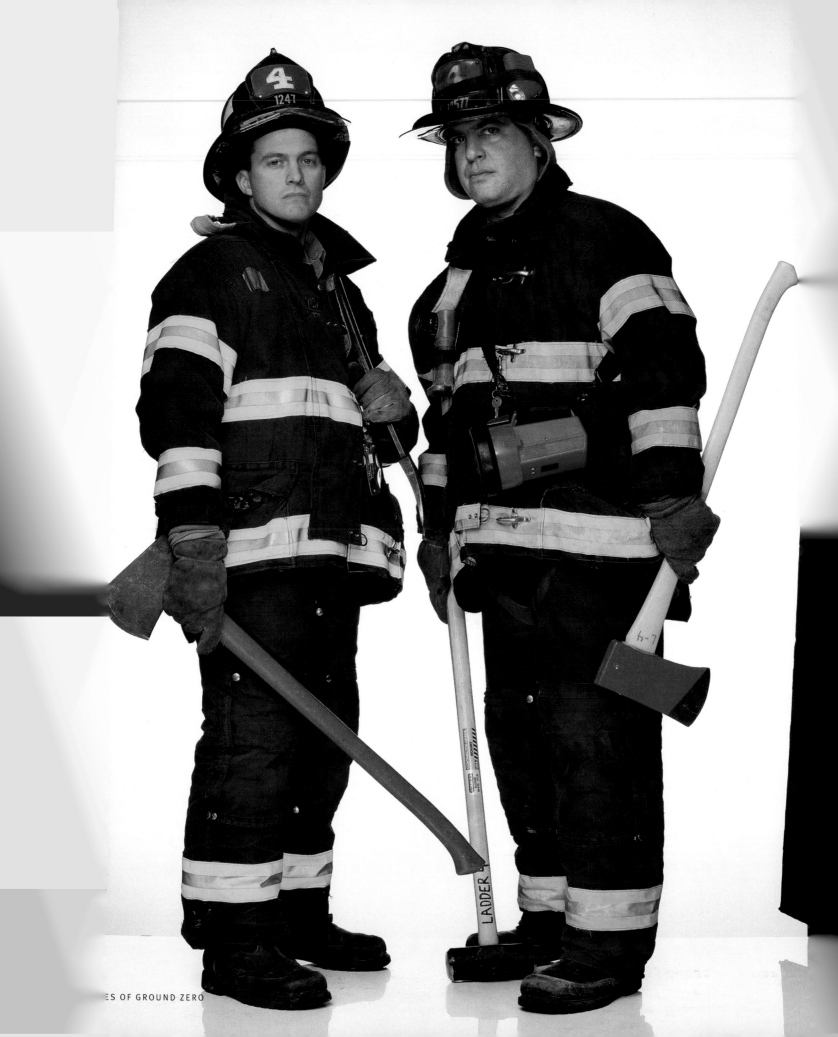

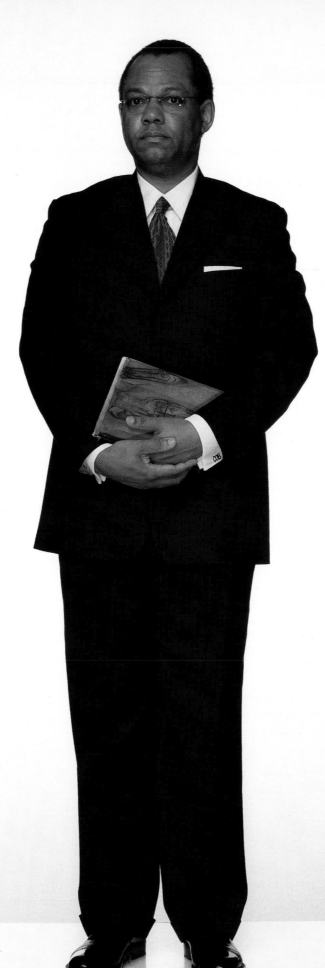

The Reverend Dr. Calvin O. Butts III

Pastor, Abyssinian Baptist Church, New York City

The reverend is on the board of the September 11th Fund. On the Sunday after the attacks he delivered a sermon urging Americans not to live in fear.

❝ Never before in some of our lifetimes has tragedy visited our shores. But thanks be to God that we have a country, that even though we've come face to face with terror, we are still able to pull together and thank God for beautiful skies, and amber waves of grain. Thank God for our liberties that we enjoy, thank God for our Constitution and the resolve of all Americans to pull together for the sake of our nation. ❞

Daniel Squire
Joseph Ceravolo

Firefighters, Ladder 4, FDNY

Squire and Ceravolo, off-duty on the 11th, were bused to Ground Zero from their midtown firehouse, which lost all 15 firefighters who responded to alarms.

❝ We went down there thinking we would do some good, so it was very disappointing to find nothing but devastation," said Squire. **"It's been hard, but we've received so much support. We had firemen from Boston, Chicago and Vancouver helping out at our house. We got letters from kindergarten classes around the country. Our neighbors brought candles and flowers, wanted to give money, and asked how they could help. ❞**

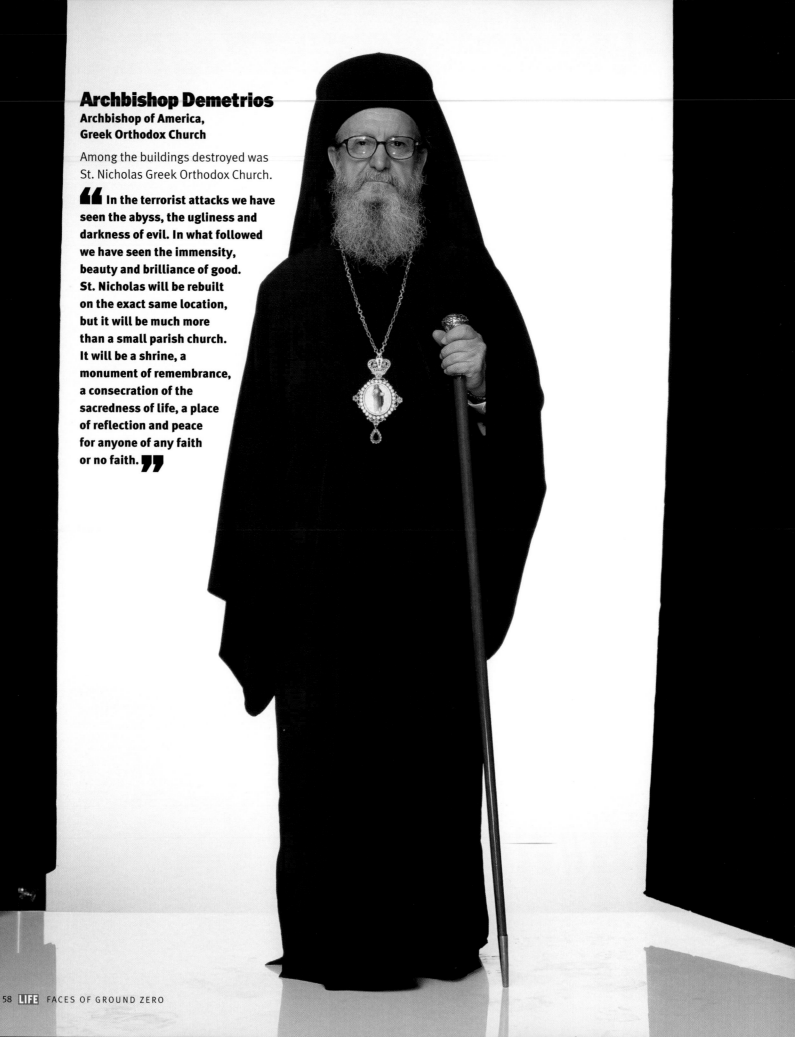

Archbishop Demetrios
**Archbishop of America,
Greek Orthodox Church**

Among the buildings destroyed was
St. Nicholas Greek Orthodox Church.

**❝ In the terrorist attacks we have
seen the abyss, the ugliness and
darkness of evil. In what followed
we have seen the immensity,
beauty and brilliance of good.
St. Nicholas will be rebuilt
on the exact same location,
but it will be much more
than a small parish church.
It will be a shrine, a
monument of remembrance,
a consecration of the
sacredness of life, a place
of reflection and peace
for anyone of any faith
or no faith. ❞**

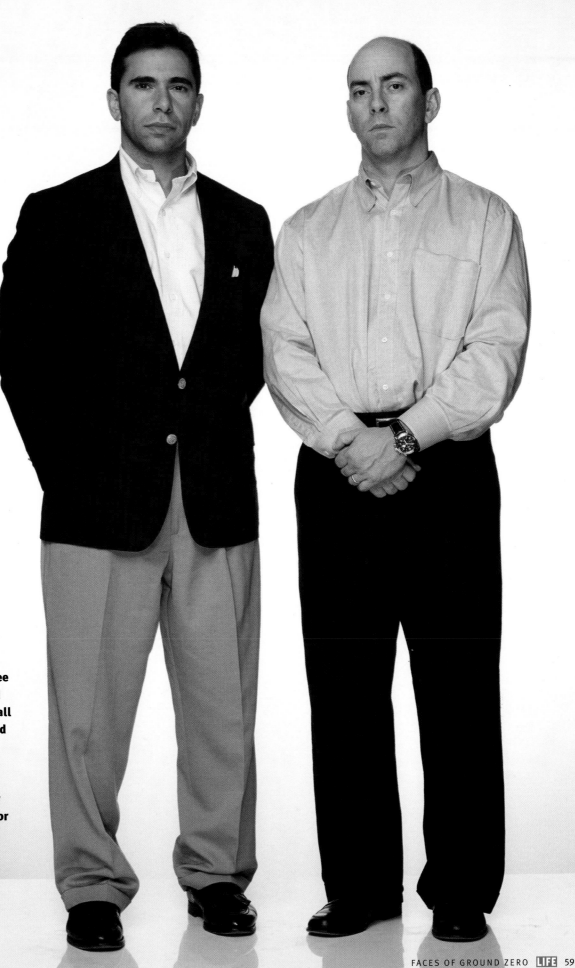

Christopher Pepe
David Kravette

**Salesman and Managing
Director, Cantor Fitzgerald**

They were called from their
offices just before the attack.

**❝ The guy said he had to see
me, so I left Tower 1 at around
8:20 to go to Broad St. That call
saved my life,"** said Pepe. Said
Kravette: **"My assistant was
seven months pregnant, so I
offered to go down and meet
our guests. I was in the lobby
when it hit. No one from Cantor
Fitzgerald made it down. ❞**

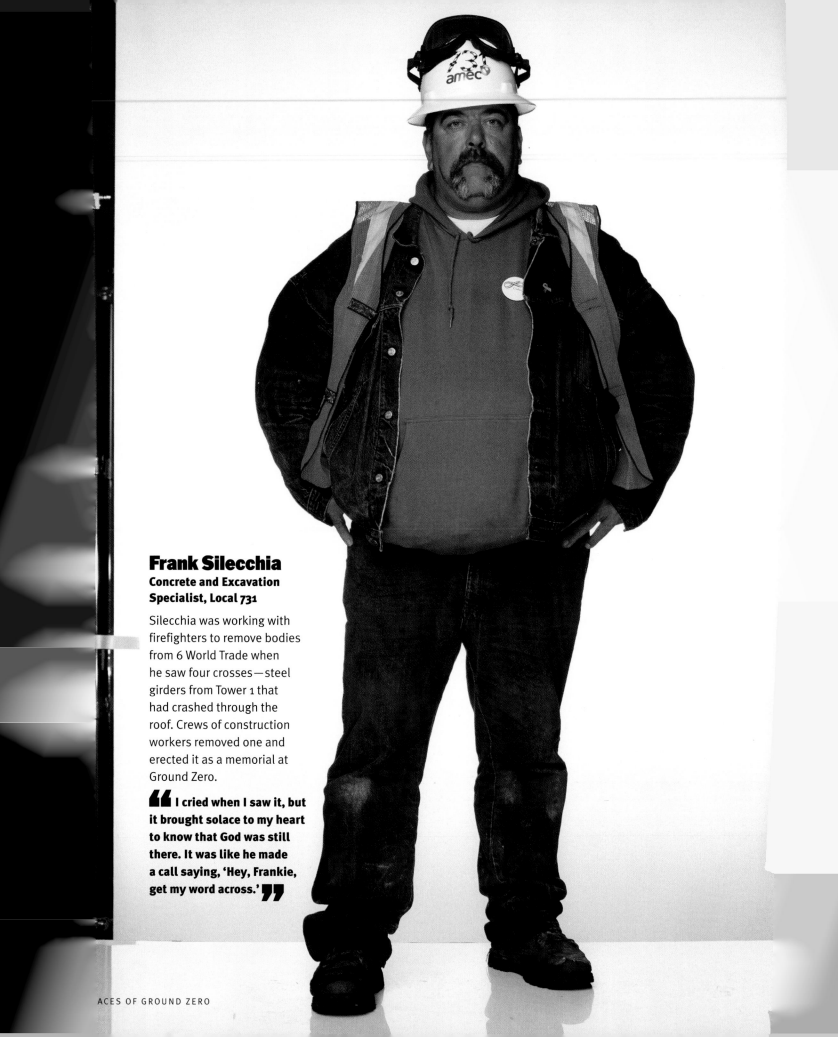

Frank Silecchia
Concrete and Excavation Specialist, Local 731

Silecchia was working with firefighters to remove bodies from 6 World Trade when he saw four crosses—steel girders from Tower 1 that had crashed through the roof. Crews of construction workers removed one and erected it as a memorial at Ground Zero.

" I cried when I saw it, but it brought solace to my heart to know that God was still there. It was like he made a call saying, 'Hey, Frankie, get my word across.' "

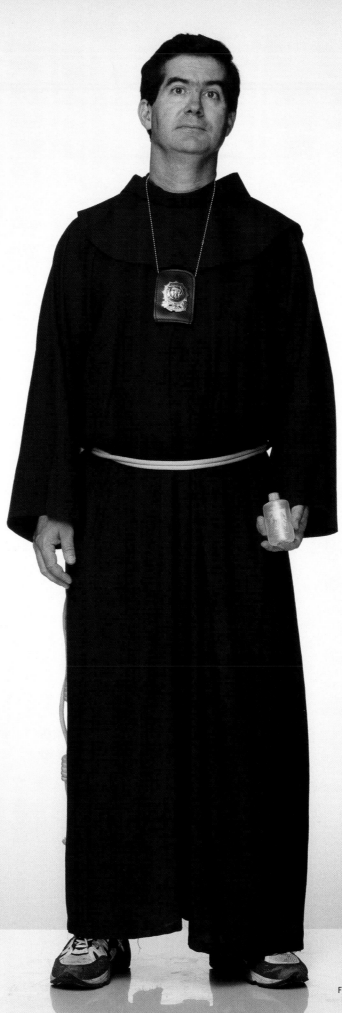

Father Brian Jordan
Friar, Church of St. Francis of Assisi, midtown Manhattan

In the days and weeks after the attacks, Father Jordan, who succeeded his fallen friend, Father Mychal Judge, as FDNY Chaplain, ministered to workers at Ground Zero. In a special ceremony, he rode a crane bucket up to where welders had mounted the cross-shaped girder from Tower 1, then blessed the impromptu monument.

❝ We have seen evil at its worst, but goodness at its best. I worked to provide hope and healing—to give comfort to the living and bless the dead. ❞

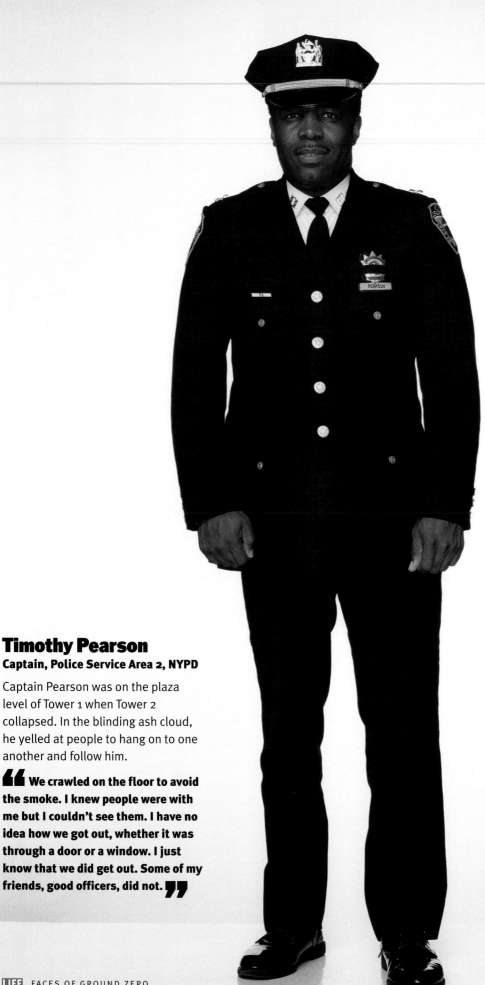

Timothy Pearson
Captain, Police Service Area 2, NYPD

Captain Pearson was on the plaza level of Tower 1 when Tower 2 collapsed. In the blinding ash cloud, he yelled at people to hang on to one another and follow him.

We crawled on the floor to avoid the smoke. I knew people were with me but I couldn't see them. I have no idea how we got out, whether it was through a door or a window. I just know that we did get out. Some of my friends, good officers, did not.

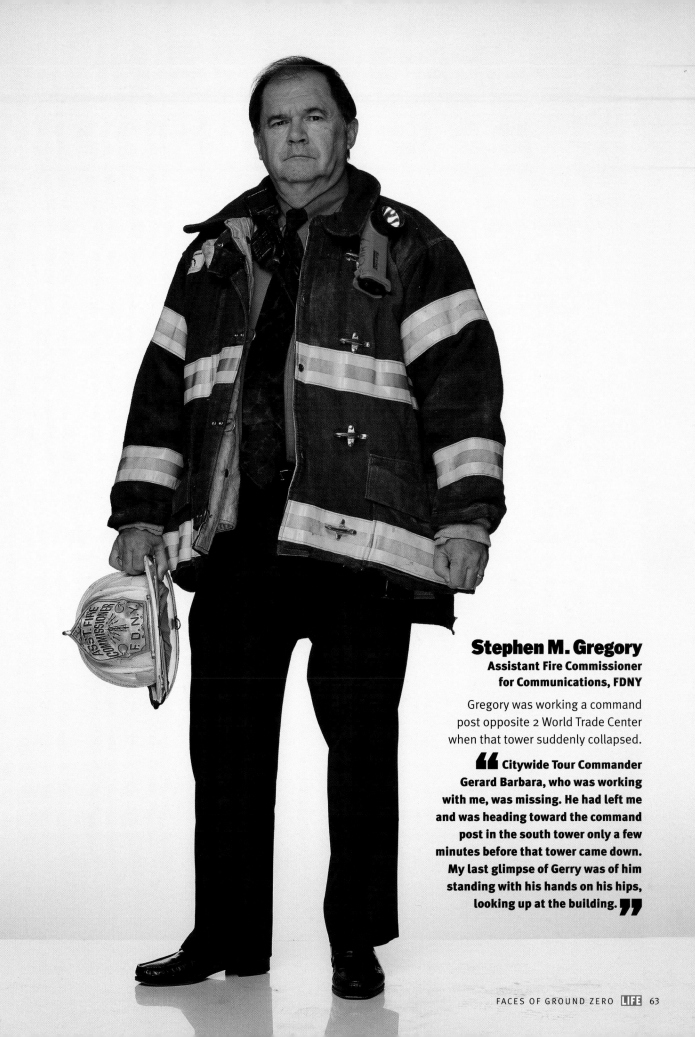

Stephen M. Gregory
**Assistant Fire Commissioner
for Communications, FDNY**

Gregory was working a command post opposite 2 World Trade Center when that tower suddenly collapsed.

❝ Citywide Tour Commander Gerard Barbara, who was working with me, was missing. He had left me and was heading toward the command post in the south tower only a few minutes before that tower came down. My last glimpse of Gerry was of him standing with his hands on his hips, looking up at the building. ❞

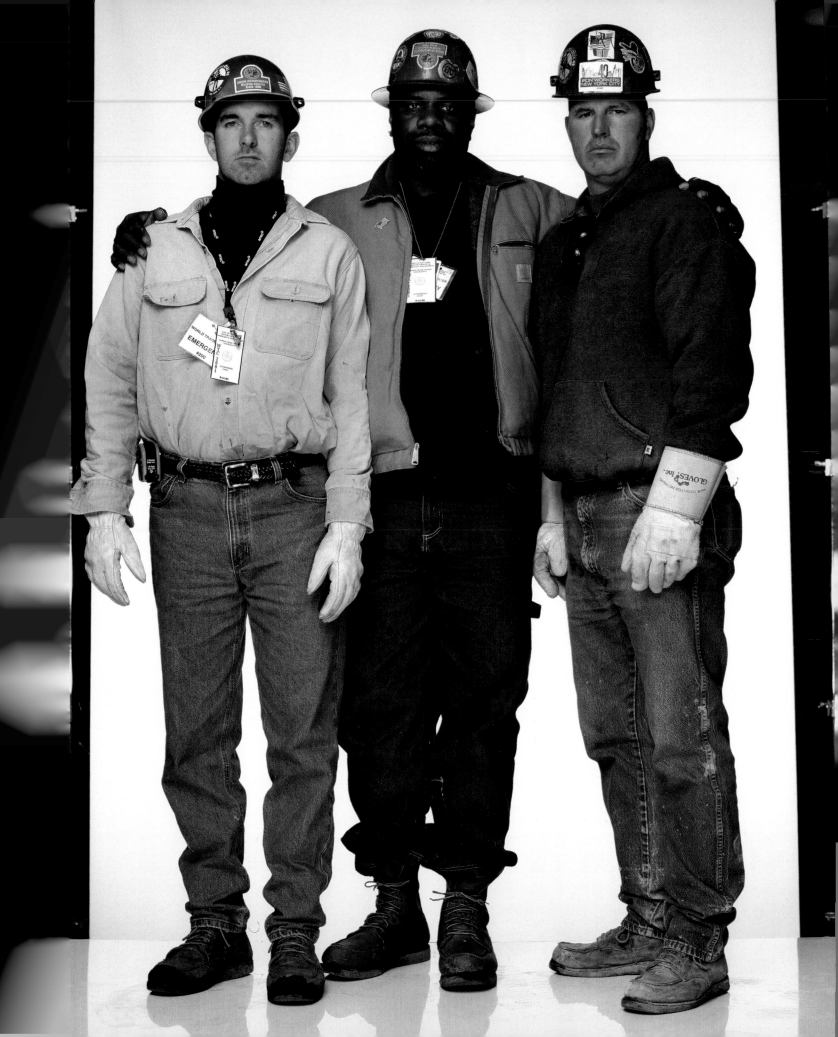

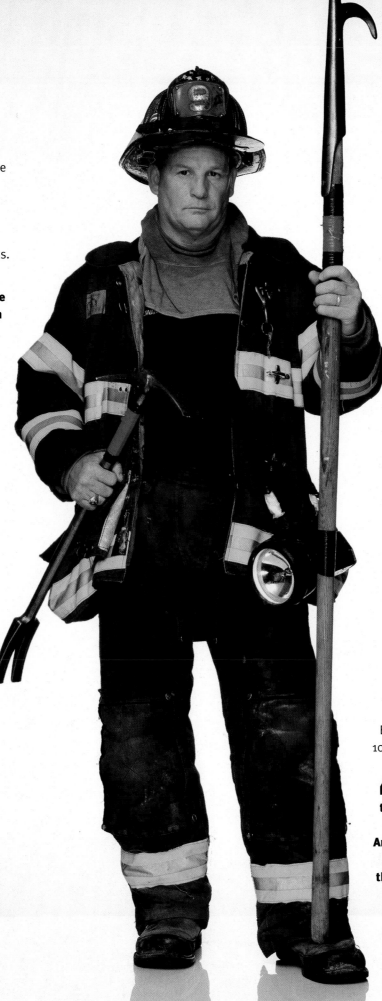

Bryan Brady II
Charlie Lyons
Daniel Doyle
Ironworkers, Local 40

The steel beams in the wreckage, which often weighed tons, had to be measured and stabilized before being cut, to avoid collapse and injury. In many cases, the ironworkers needed to remove large pieces before recovery workers could access search areas.

❝ We're on the front lines. We have to do our jobs before the firefighters can get in there with their picks and shovels," said Lyons. **"It's heart-wrenching, sorrowful. But we're glad that we can help in some way. ❞**

Dan Rowan
Firefighter, Ladder 9, FDNY

Rowan arrived at Ground Zero two hours after the towers collapsed. During hours of digging and searching, he decided he wanted to express his gratitude for the nation's support for New York City firefighters. On November 11, Rowan and four others from Engine 33/Ladder 9, which lost 10 members, began a 2,757-mile bicycle ride across America.

❝ I'm riding for 10 men. And to personally say thank you to every person I can—the American people and especially the firefighters from all over the world who assisted us. ❞

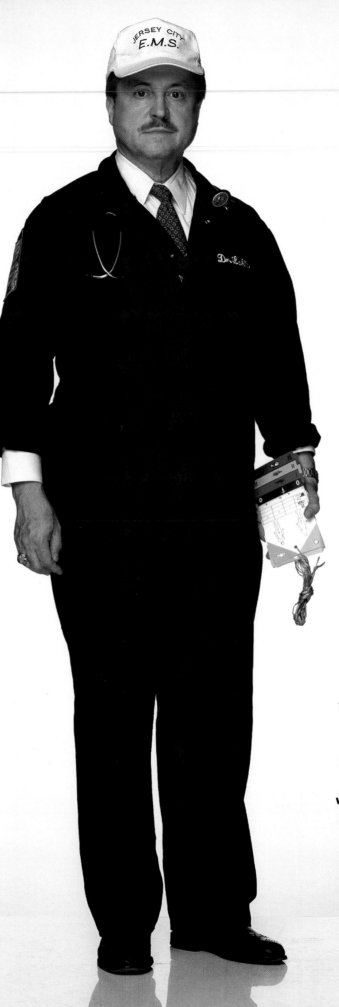

Dr. Robert G. Lahita
**Mobile Intensive Care Unit
Medical Director of Hudson
County, N.J., and
Jersey City Medical Center**

Police told Lahita he was needed at the Jersey City pier where victims were being transported.

❝ I set up a field hospital. I had two paramedics and four EMTs, nobody else for over an hour. We had no stretchers, no ambulances. Workers were coming out of the nearby buildings with rolling office chairs for us to use to transport victims off the boats. We put I.V.s in and I started deputizing civilians to hold I.V. bottles and help with CPR. We triaged and triaged and triaged. A lot were walking wounded or just hysterical. ❞

Sherwin Chow
Victor Harris
**Firefighter, Engine 9 and
Lieutenant, Engine 15, FDNY**

Firefighters experienced varying degrees of trauma, whether they narrowly escaped or—like these two—were off-duty and belong to firehouses that remain intact.

❝ It was hard searching, digging and crying," said Harris. **"But the guys who were there when the towers came down have it tougher. It's burned in their brains. You have to talk it out or your thoughts turn bad. This reminds me of when the 18-year-olds went off to Vietnam. ❞**

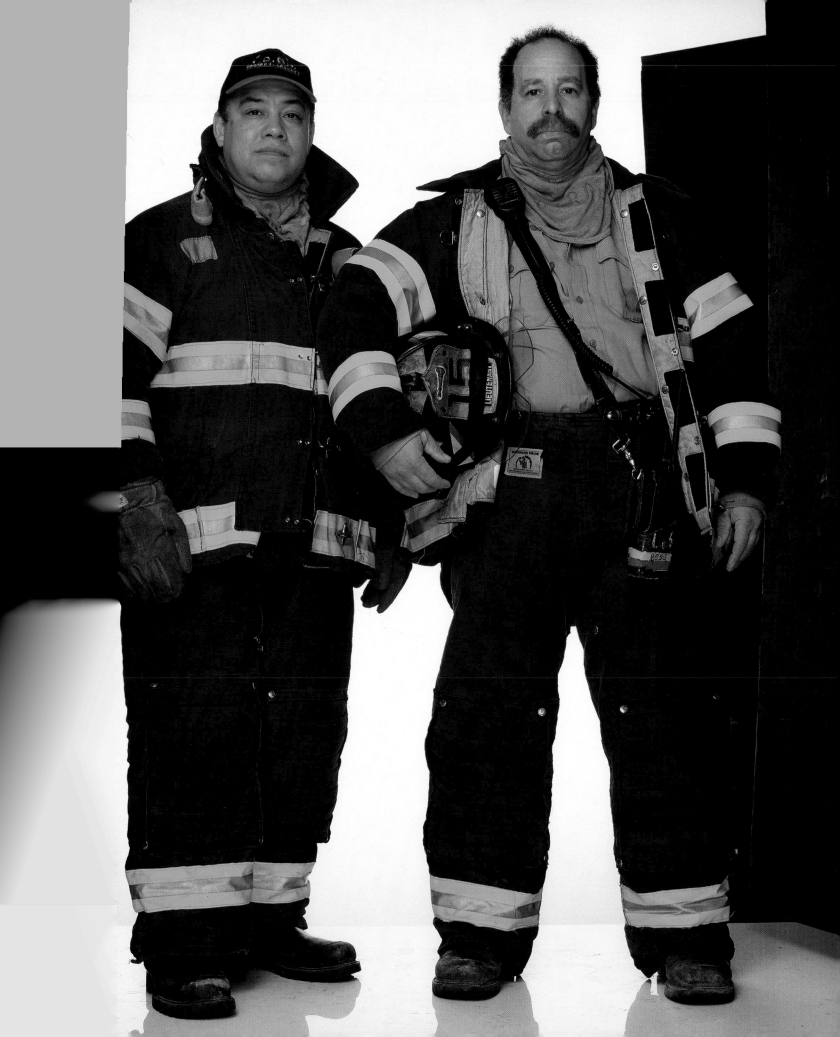

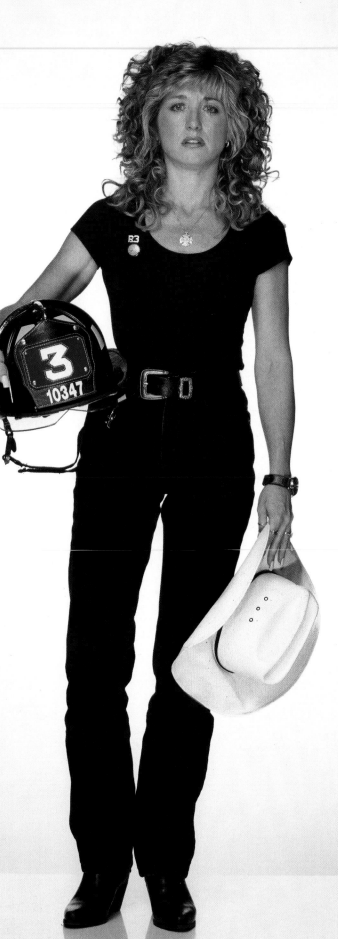

Joanne Gross
**Sister of the late Tommy Foley,
Rescue 3, FDNY**

She waited as her husband,
K.C., a Mount Vernon, N.Y.,
firefighter, went on the 11th to
find both Tommy and Danny.

" He found Danny. They
called me and said Tommy was
missing. I said, 'No! He's
helping.' They went every day
to search for him. Every
morning it was like sending
them off to war. This is his
cowboy hat. He loved it, loved
rodeos. Tommy lived life. "

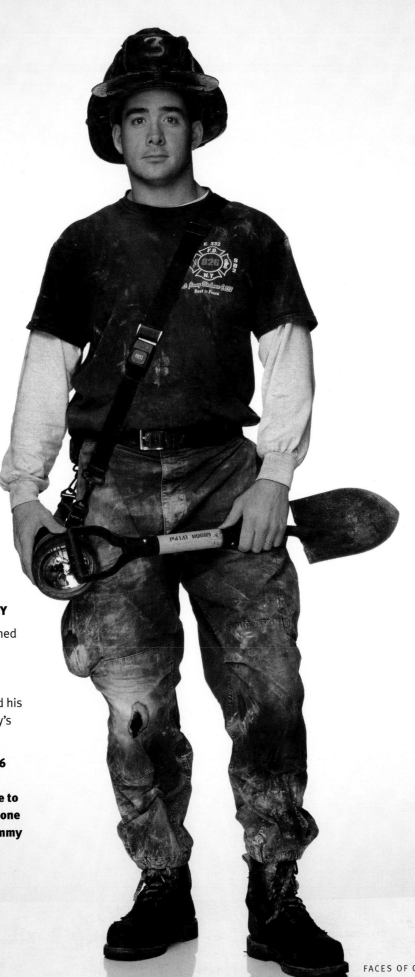

Danny Foley
Firefighter, Engine 68, FDNY

Off-duty on the 11th, he rushed
to the Rescue 3 firehouse
where his brother, Tommy,
worked. He searched that
day—and thereafter. He and his
brother-in-law found Tommy's
body on September 21.

**❝ First day, I searched 36
hours. I had a hard time
calling home. When I spoke to
my father, I promised him, one
way or another, I'd find Tommy
and bring him home. ❞**

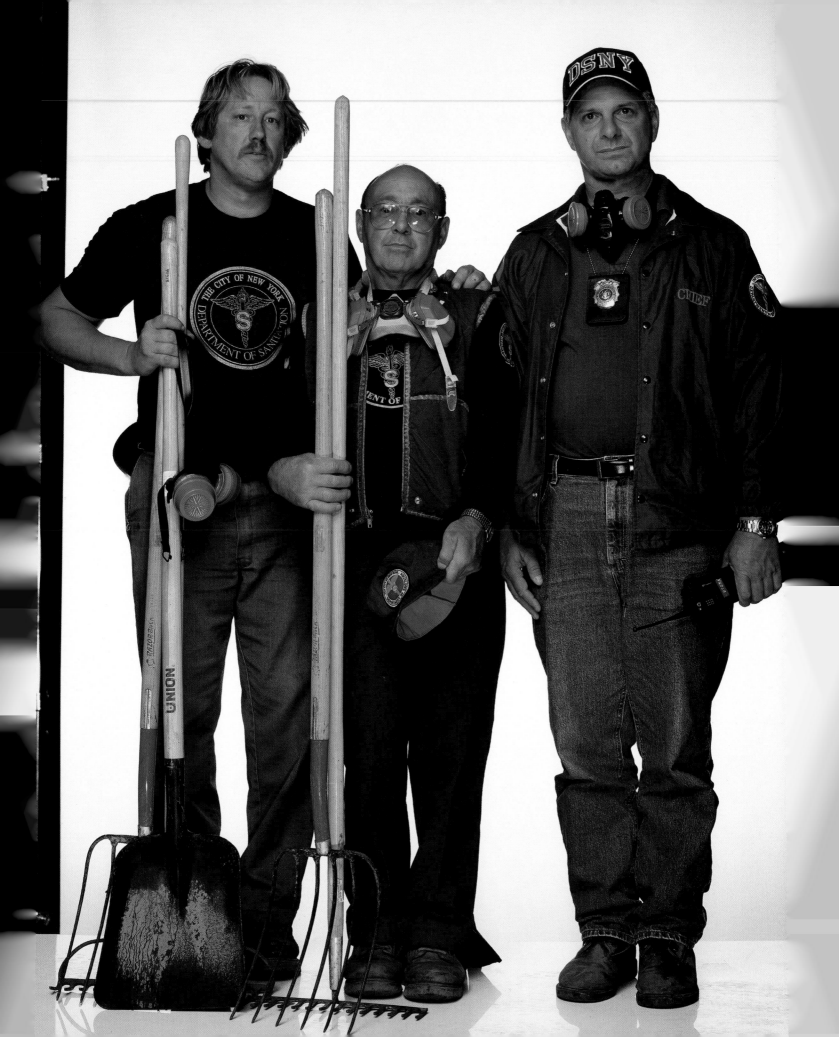

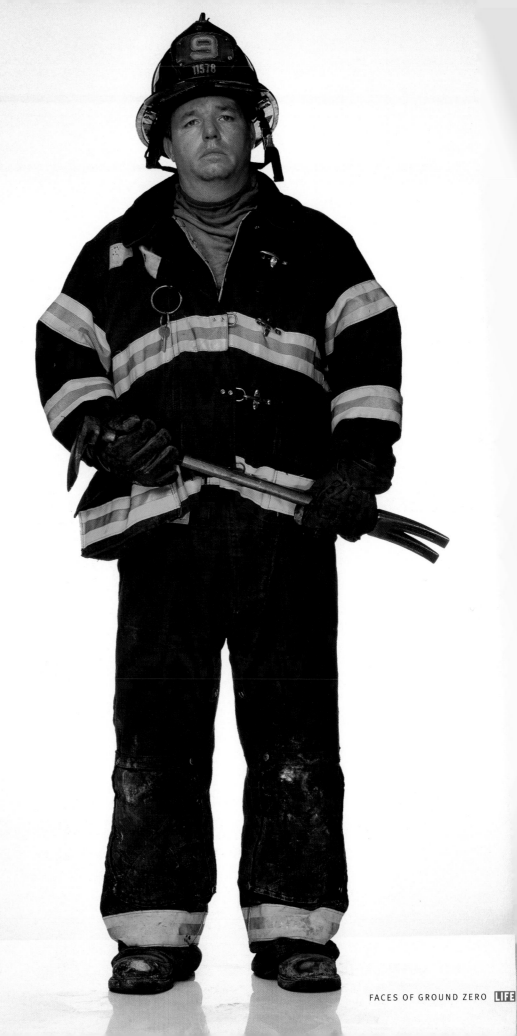

Kenneth Taylor
George Snyder
Michael Mucci
**Sanitation Workers and Director
of Fresh Kills landfill (Mucci)**

Fresh Kills, which had been closed
since March 2001, was designated
as the delivery site for World
Trade Center debris. More than
100 sanitation workers per shift
transported and removed debris
that detectives sifted through for
personal effects.

**❝ We've been working since
the first truck arrived at 2:30 a.m.
on September 12," said Mucci.
"We're trying to find anything we
can to help bring closure to those
who lost loved ones. ❞**

Don Casey
Firefighter, Ladder 9, FDNY

Casey responded to initial alarms
for Tower 1. He had climbed to the
20th floor when the other tower
collapsed. The eight men from
Ladder 9 then received a radio call
to descend. Five made it out alive.

**❝ You had to brace yourself
or you'd be knocked over from the
building shaking. We had no
idea what it was. We didn't even
know the second tower had been
hit. When I made it out, people
were yelling, 'Run! Get away from
the building!' It came down a few
seconds later. ❞**

Michael Lombardi
Firefighter, Rescue 5, FDNY

When word of the attacks reached him, Lombardi, a member of the FDNY Special Operations Command, was about to jump into the waters beneath the city's Whitestone Bridge for a submerged-rescue refresher course.

I showed up 10 minutes after the second building fell. I couldn't believe my eyes. I called to my brother firefighters on the Handie-Talkie but they didn't answer. The radio was silent and the feeling just drained me. I'd lost my friends. As firefighters, we're so used to seeing people running out. That's second nature to us: People are running out, we're going in. But when we pulled up that morning, we didn't see anybody coming out.

Maggie Haley
Patricia Buonocore

Employees of Aon, an insurance company that occupied several top floors of Tower No. 2

On the 101st floor, they took the elevators after a plane hit Tower No. 1. They made it down safely before a second plane hit their building 15 minutes later, but 176 of their colleagues did not.

❝ We ran out," said Haley. "I've learned to act on my instincts instead of waiting for instructions. ❞

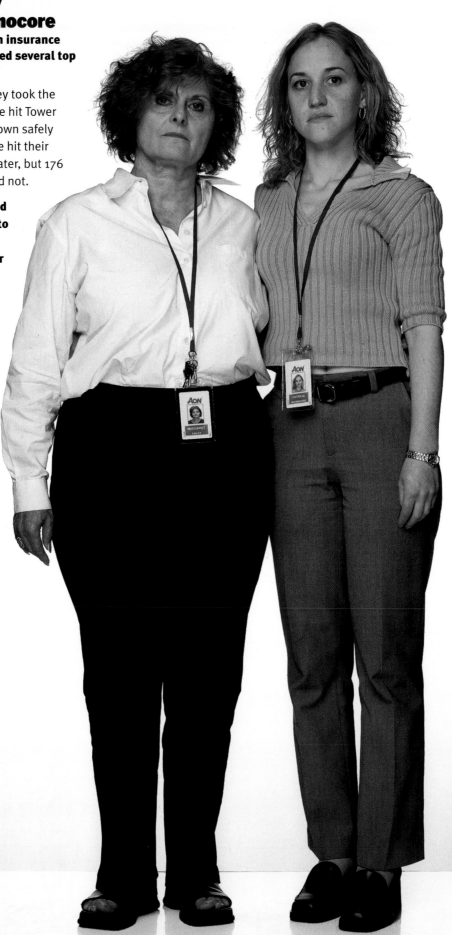

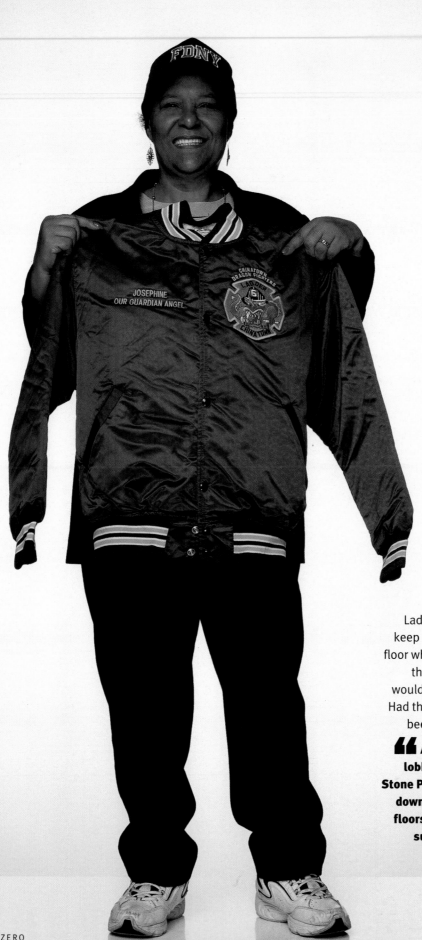

Josephine Harris
Bookkeeper, Port Authority of New York and New Jersey

Harris got to her 73rd-floor office in 1 World Trade at 8:30. After Flight 11 hit the building, she started down Stairway B. By the 20th floor, she was exhausted. Six firefighters from Ladder 6 found her and urged her to keep going. They were near the fourth floor when the building went down. Had they been going a little faster, they would have been crushed in the lobby. Had they been slower, they would have been killed by the collapsing floors.

❝ All I wanted to do was get to the lobby. I had no idea it wasn't there. Stone Phillips of NBC said, 'You walked down 70 flights of stairs and had 104 floors fall on top of you, and you still survived.' It still amazes me. ❞

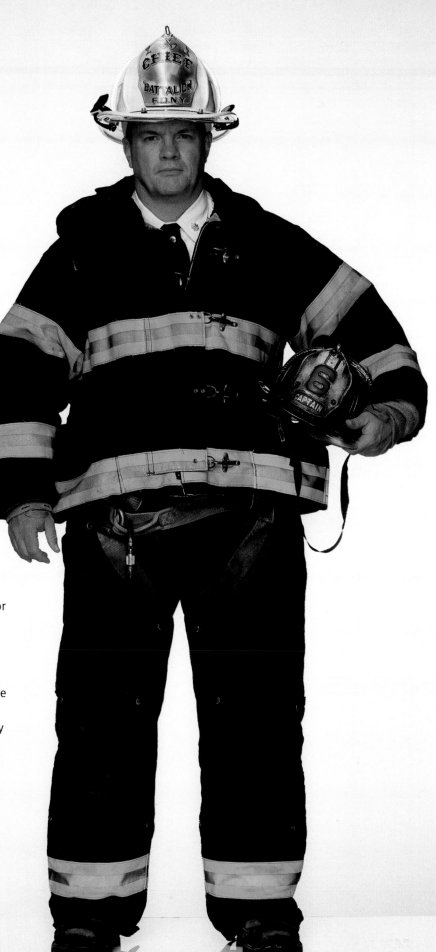

John A. Jonas
**Captain, Ladder 6, later
promoted to Battalion Chief, FDNY**

Jonas had led his crew to the 27th floor
of the north tower when they heard
and felt the other tower collapse. He
told his team, "If that one can go, this
one can go. It's time for us to get out
of here." When the north tower fell, the
six men of Ladder 6 were trapped in
Stairway B with eight other emergency
workers and Josephine Harris.

66 When those towers came down,
343 brave and heroic souls came up
through the rubble and went to
heaven. Their last act on earth was
helping their fellow man. These
firemen raised the bar for firemen
all over the world. **99**

Matt Komorowski
Firefighter, Ladder 6, FDNY

Standing in front of his firehouse having a cup of coffee, he saw the first hijacked plane heading toward lower Manhattan. By 10:30 he would be trapped with 13 other rescuers and civilian Josephine Harris for nearly four hours.

The six of us from my company were coming down the stairs. Around the fifth floor, I felt an incredible rush of air up my back and was thrown to a landing between the first and second floors. The rest of my guys were spread out between the third, fourth and fifth floors. My leg was trapped up to my knee, but I was able to free it. No one panicked— it was as though we had accepted our fate. Eventually there was a beam of light at my feet. I said to the lieutenant from Engine 39, 'Can you shut off your flashlight, it's going dim.' He said, 'It is off.' Evidently, there was a break in the smoke and dust, allowing a ray of sunlight into our stairwell. For me, it was a sign there was still hope for us.

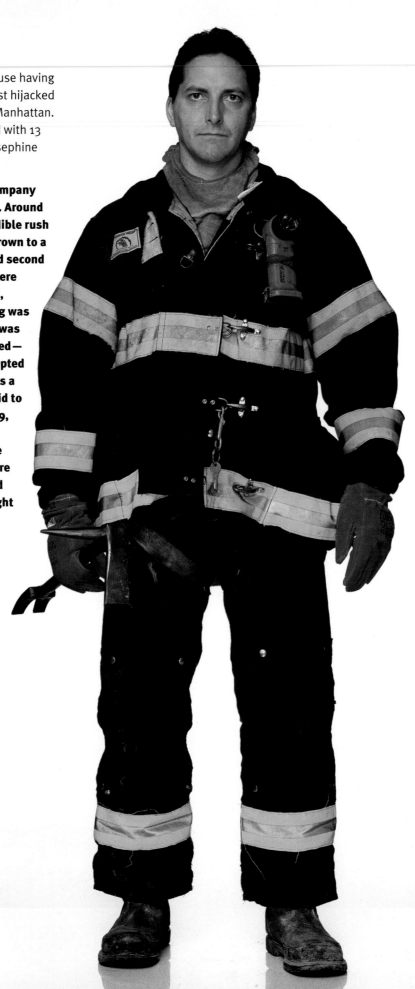

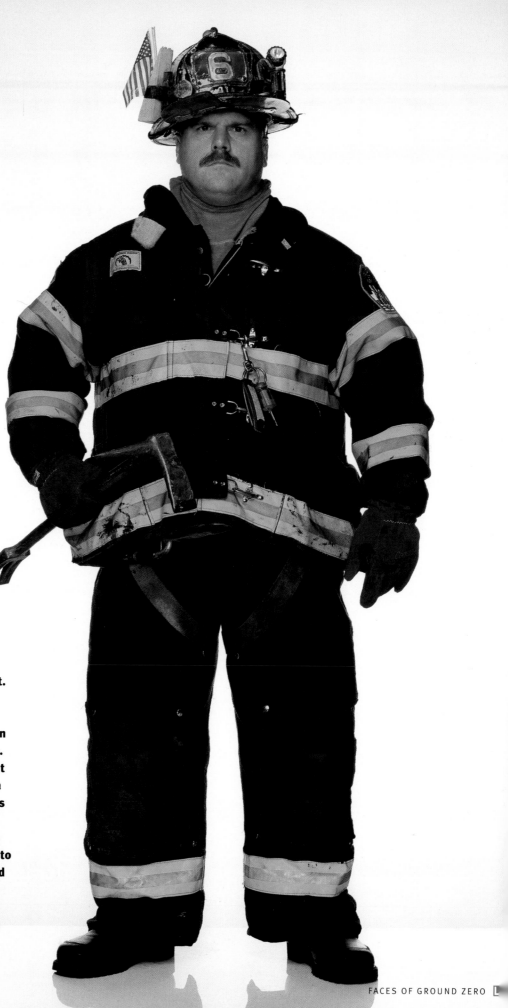

Bill Butler
Firefighter, Ladder 6, FDNY

While trapped with Harris and his ladder company in Stairwell B, Butler used a cell phone to call emergency numbers but couldn't get through. As a last effort, he called his home in Orange County, N.Y. His wife, Diane, answered.

" I just said, 'Hi, what are you doing?' I was trying to be nonchalant. She said, 'Where are you?' I said, 'We're at the World Trade Center.' She asked, 'Is everything okay?' Then I said, 'Well, we have a little problem. We're trapped in the Trade Center, but we're okay,' Then she started to cry a little bit, because she knew there was no World Trade Center. At that point I said, 'Listen, you can't cry. I have to give you some information. You have to call the firehouse or call someone and tell them where we're at.' "

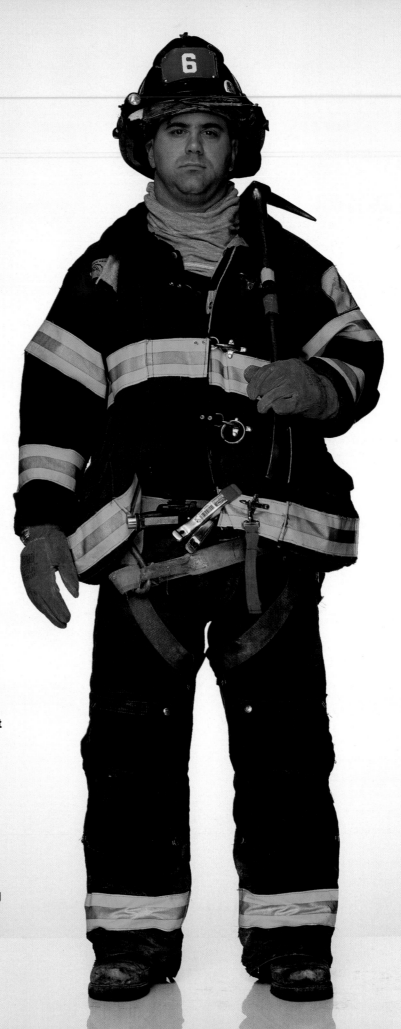

Sal D'Agostino
Firefighter, Ladder 6, FDNY

The night before the attacks, Ladder 6 had been working and didn't return to the firehouse until after midnight. That morning an exhausted D'Agostino went straight from his firehouse bed to the rig leaving for the Trade Center. He, too, wound up trapped.

❝ As the tower fell, a door in the stairwell flew open, knocking my helmet off and separating my shoulder. I said a quick little prayer, lay down on my side, covered my head and waited to get crushed. I kept saying, 'This is it, this is it.' Fortunately, it never came. We couldn't go down and there was no up, so we sat tight. Eventually we found a way out over an I beam that was about 12 inches wide, with a deep void on each side. Josephine couldn't manage that beam, so Ladder 43 came in for her with a basket. ❞

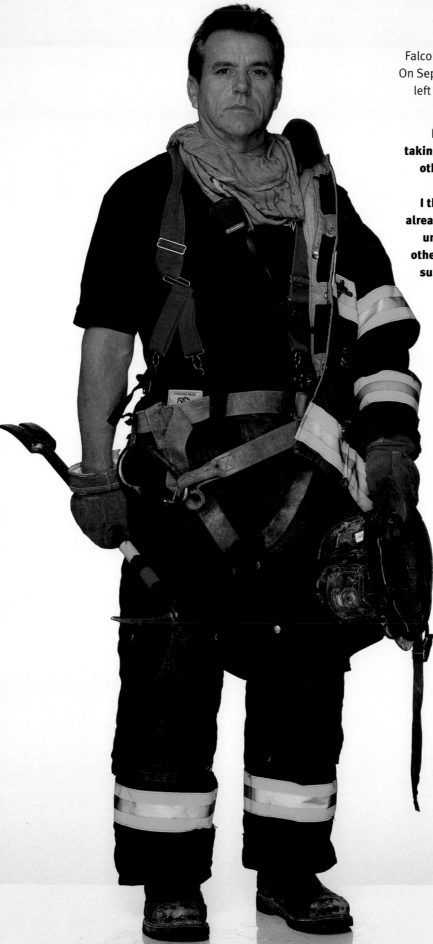

Tommy Falco
Firefighter, Ladder 6, FDNY

Falco was at the 1993 WTC bombing. On September 11 he and his company left for the north tower before they were officially dispatched.

On the 27th floor we were taking a little rest. That's when the other building went down. When they ordered us to evacuate, I thought, 'Hey, we have to leave already? We just got here.' I felt no urgency to get out. If I knew the other building had come down, for sure I would have been moving a lot faster. When our building started coming down, I heard the floors pancaking on one another: boom, boom, boom, boom, boom. I got knocked to the floor and went like a turtle, put my arms over my head. It got to a point where I felt, 'It's over.' But even then, I felt I'd be okay.

 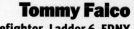

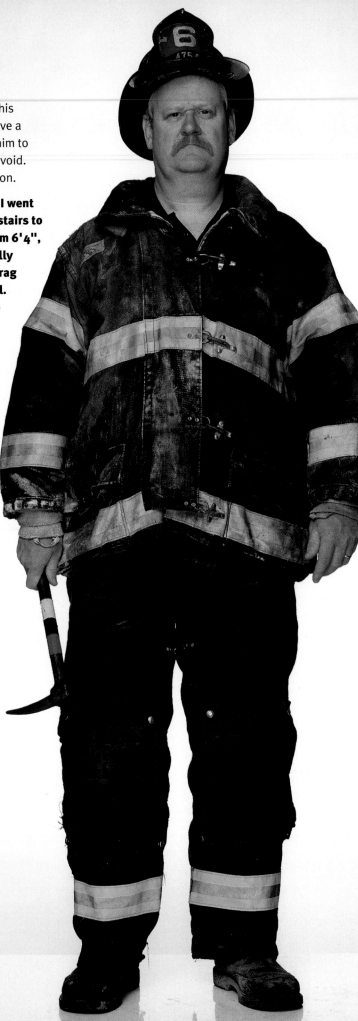

Michael Meldrum
Firefighter, Ladder 6, FDNY

Trapped in the stairway with his brethren, Meldrum helped save a firefighter who had clung to him to keep from falling into a deep void. Meldrum suffered a concussion.

❝ When the building fell, I went from being at the top of the stairs to the landing at the bottom. I'm 6'4", 250 pounds, and I was literally picked up and thrown like a rag doll and slammed into a wall. After the initial collapse, we were pulling huge globs of dirt and dust out of our mouths in order to breathe. It was three hours until the air cleared enough that we could see sky and sunlight. That's when we realized we were now at the top of the World Trade Center. ❞

Keith C. Johnson
Firefighter, Ladder 6, FDNY

When he arrived at Ground Zero soon after the second tower fell, Johnson knew that 11 men from his firehouse were missing.

❝ In our minds, they were gone. Then over the radio we hear, 'Ladder 6, repeat, what is your location? You're between the third and fourth floor in stairway B of Tower 1, is that correct, 6?' Then we hear them answer, 'Yes, we are trapped, we are in the staircase.' So now we have an idea where to go, but there's no building. If there's no fourth floor, how can they be on the fourth floor? You had to literally climb over a pile of rubble, then into a valley of rubble and back up five flights of rubble to where they dug themselves out. Everyone in our firehouse survived. We're being called The Miracle House. ❞

Andrew Walsh
Ironworker, Ironworkers Union, Local 40

After the World Trade Center bombing on February 23, 1993, Walsh worked to repair the building's destroyed basement. He was at the site again on the afternoon of September 11, 2001, removing and cutting steel beams amid the ruins of the Twin Towers.

❝ About 50 of us were working on the Williamsburg Bridge when the first plane flew over. It was so low we felt the vibration and the bridge shook a little. I got to the World Trade Center site after the second collapse. I had always thought the scene after the bombing was one of the worst things I had ever seen. But nothing will ever compare to what happened on September 11. It's a picture I will never forget. ❞

Chris, Arlene and Robert Howard
Sons and mother of Port Authority Emergency Services Officer George Howard

George rushed to the World Trade Center to help in the evacuation, even though it was his day off. His body was found buried in debris from the north tower collapse.

❝ I wasn't surprised to learn that George was there," said Arlene. "I would have been surprised if he hadn't gone. He did things like that. He is the family's beloved hero. ❞

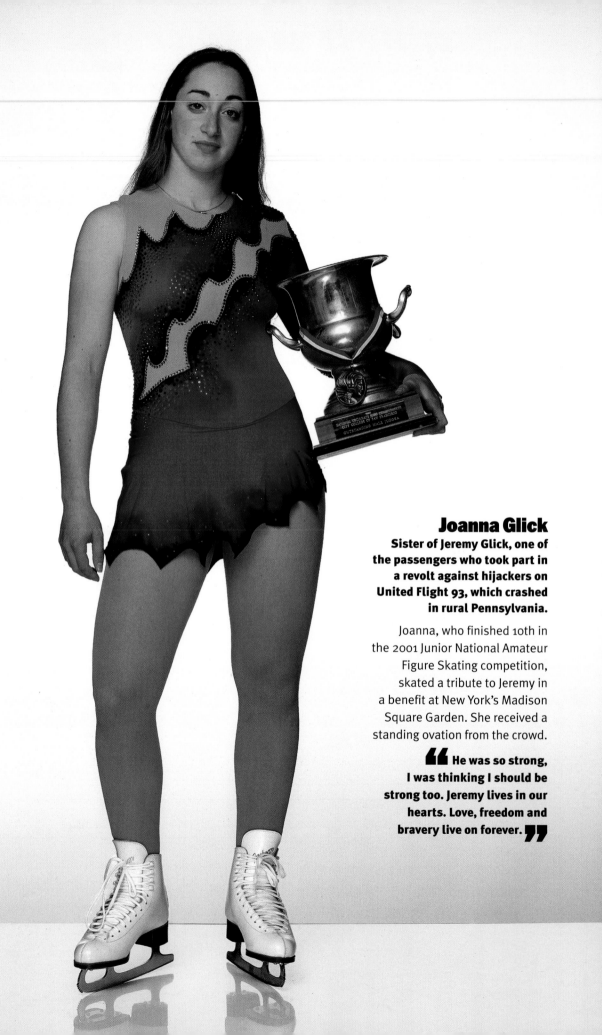

Joanna Glick

Sister of Jeremy Glick, one of the passengers who took part in a revolt against hijackers on United Flight 93, which crashed in rural Pennsylvania.

Joanna, who finished 10th in the 2001 Junior National Amateur Figure Skating competition, skated a tribute to Jeremy in a benefit at New York's Madison Square Garden. She received a standing ovation from the crowd.

" He was so strong, I was thinking I should be strong too. Jeremy lives in our hearts. Love, freedom and bravery live on forever. "

Lisa Beamer

Her husband, Todd, was on United Flight 93, which crashed in rural Pennsylvania.

Todd called a GTE Airfone operator and told her of a planned revolt against the hijackers. "Are you guys ready?" she heard Beamer ask fellow passengers. "Let's roll." The operator heard screams and a scuffle. Then the line went dead.

❝ September 11 was a day of tragedy, but we saw despair turn into hope as Americans rose up to display feats of faith, character and courage. Let us continue in their footsteps. ❞

IN THE STUDIO

Photographs by Nina Russo

Beginning on September 27, 2001, and for three weeks thereafter, scores and scores of people made their way to a little-known studio in downtown New York City to be recorded for posterity. Just a handful of days earlier, all of them had been involved in one of the most indelible moments in American history.

Some had been invited to the studio. Others had heard about it by word of mouth and asked to be included. Entire fire units came; that is why there is such a preponderance of New York's Bravest in these photos. The feeling in the studio varied according to what the different subjects had gone through on September 11, but for everyone there, it was memorable.

Most people were in the studio for about 10 minutes. Others, perhaps wanting to prolong the experience, were there for an hour. According to project director Nina Russo, the procedure was unique. "You were showing people their picture right after they were shot. A firefighter would come into the studio after spending a whole day at

Before the picture: McNally (below, with Lt. John Baldassarre) spent a little time with each subject prior to stepping into the camera. He explained the process, asked them to look directly at the lens and told them simply to be themselves. Not long after the shoot, Lisa Beamer (right) began work on a book with the working title, "Let's Roll!"

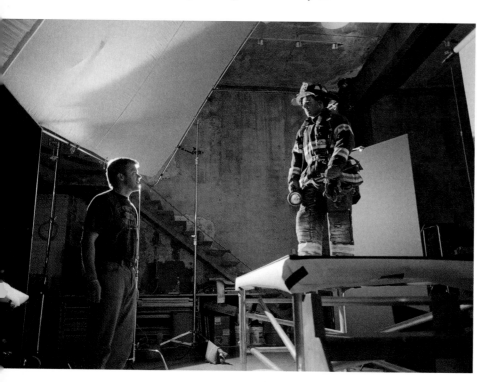

Ground Zero. He would get up on the stage, and a minute and a half later he would see his image. It was like he was getting to see himself, for the first time, in this heroic way."

Lisa Beamer, the widow of Todd Beamer, who helped lead the charge against the terrorists on Flight 93, was in the studio for about 45 minutes. She recalls that "the man behind me was the one

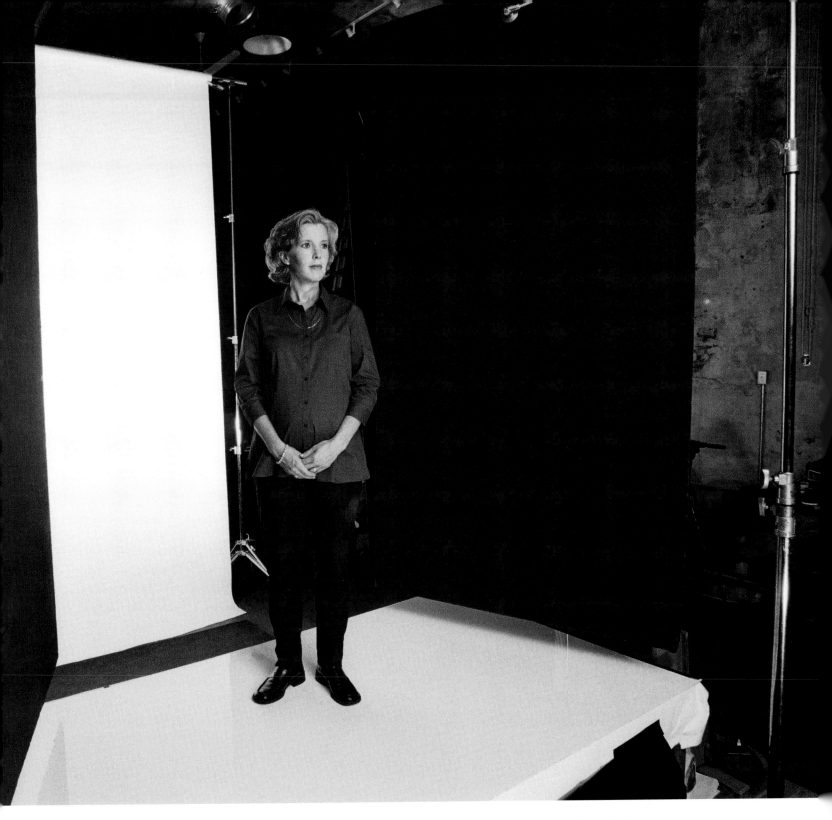

who was on the cover of *Fortune.* I noticed that he had had his suit cleaned."

Beamer says that everyone working at the studio "was very nice, very compassionate. I think Joe McNally had a real passion for his subjects and for conveying who they are to the world. I am honored to be among that company of people. Of course, I didn't do anything to be there. But when I read their

stories, I think they're heroes.

"My little kids"—David, four; Drew, two; and Morgan Kay, who was born four months after the attacks, on January 9, 2002—"are very young, and they think that police officers and firefighters are cool. But it's important for older kids, and even for grownups, to realize that police and firemen really are something to be emulated. Athletes and rock

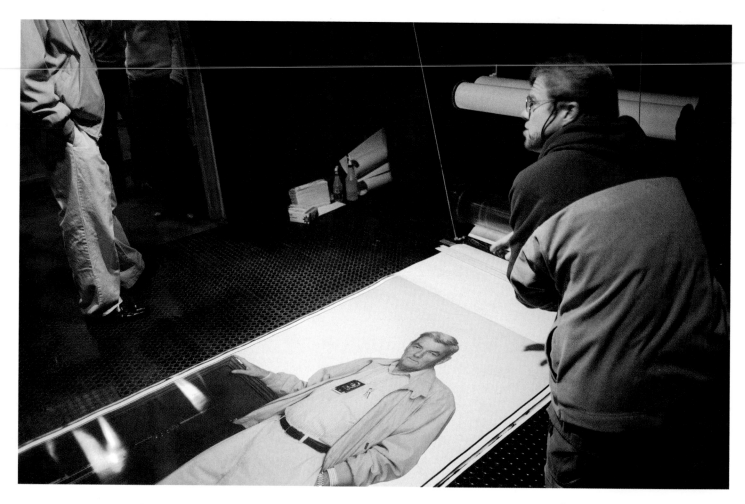

stars have a very special ability, a gift that is beyond the average person. That it can be seen how special firemen and police officers are, that they possess valuable skills and character and courage, is truly important. These people are attainable role models for the average person."

Beamer attended the original showing of McNally's photographs, at New York City's Grand Central Terminal. "It was powerful because you could see the people, and the faces, life-size," she says. "It enabled me to see their grit and their determination, what it was that enabled them to do what they did that day."

Michael Lomonaco, known to many as a host of TV cooking shows, was the executive chef at Windows on the World, a restaurant that was perched atop Tower No. 1 of the World Trade Center. He says the days following September 11 were so full and fraught, "I almost didn't get involved with the project. Then it came to me that this is important for the record, for having an accurate record.

"When I got to Joe's studio and saw some of the big photographs on the wall, I was overwhelmed with emotion. Without showing you Ground Zero, they brought you there. I got a sense of the actual humanity that was involved. It was all summed up in those photographs. It was very emotional for me because I realized the honor and privilege of being asked to be there."

Most of the subjects posed for one picture, but Lomonaco was an exception. After his first picture was taken, McNally invited him into the camera itself to see the image as it was revealed. While there, Lomonaco told the story of how he was saved because he had been downstairs getting eyeglasses. It was then decided to take a second photo, with the chef holding the fateful glasses.

Lomonaco is proud of his involvement with the project. "The entire time I was there I was thinking of what had happened, seeing everything through the prism of 9/11. Everyone there put me at ease. It wasn't about posing. Joe didn't tell me how to stand or think. He wanted to capture the real person in all of us. He had no agenda other than the work at hand. The sensitivity, the humanity of the project . . . I felt very safe within that studio."

Within the camera: After each picture, McNally invited the subjects to join him while the Polaroid film developed — about 90 seconds. Above, he chats with Alex Smirnoff, the telecommunications director for the Empire State Building. Opposite, chef Michael Lomonaco looks at his first photograph. In the background is Laurel Parker, the manager of the studio.

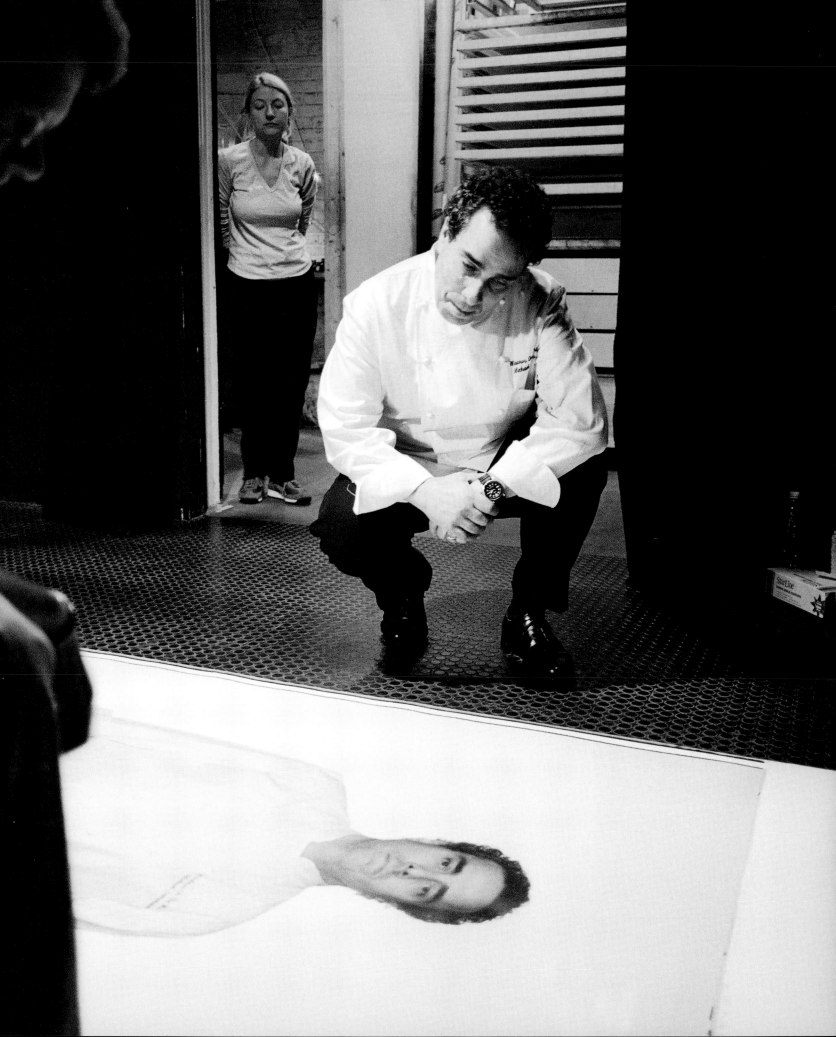

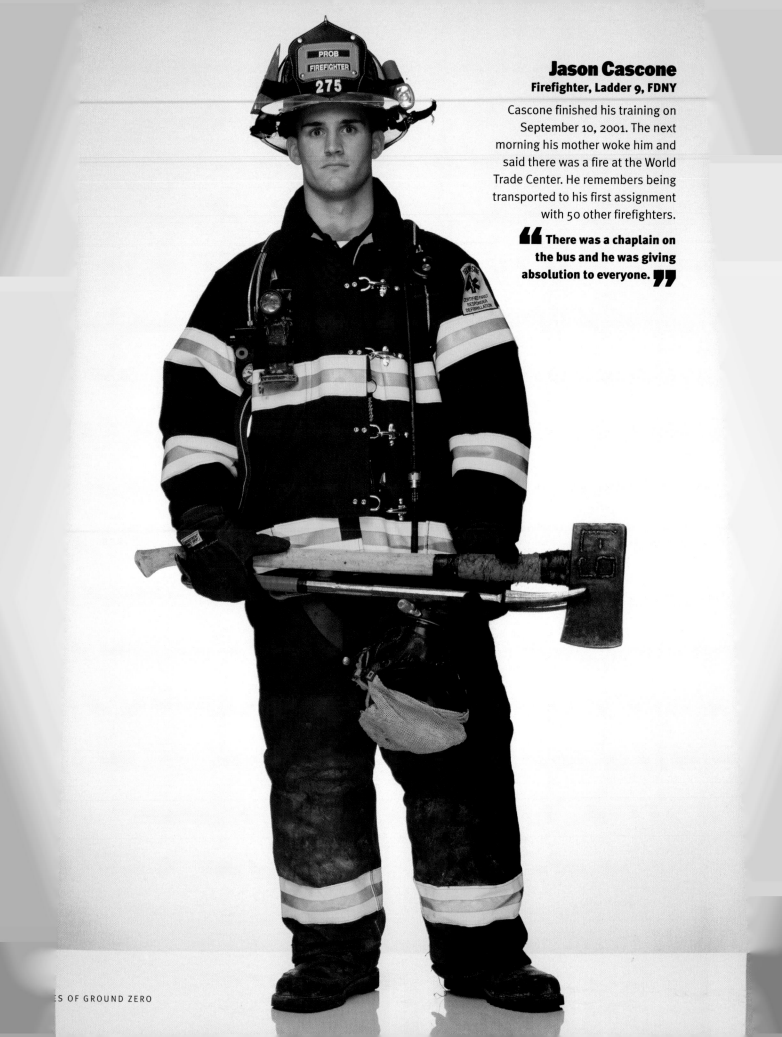

Jason Cascone
Firefighter, Ladder 9, FDNY

Cascone finished his training on September 10, 2001. The next morning his mother woke him and said there was a fire at the World Trade Center. He remembers being transported to his first assignment with 50 other firefighters.

❝ There was a chaplain on the bus and he was giving absolution to everyone. ❞

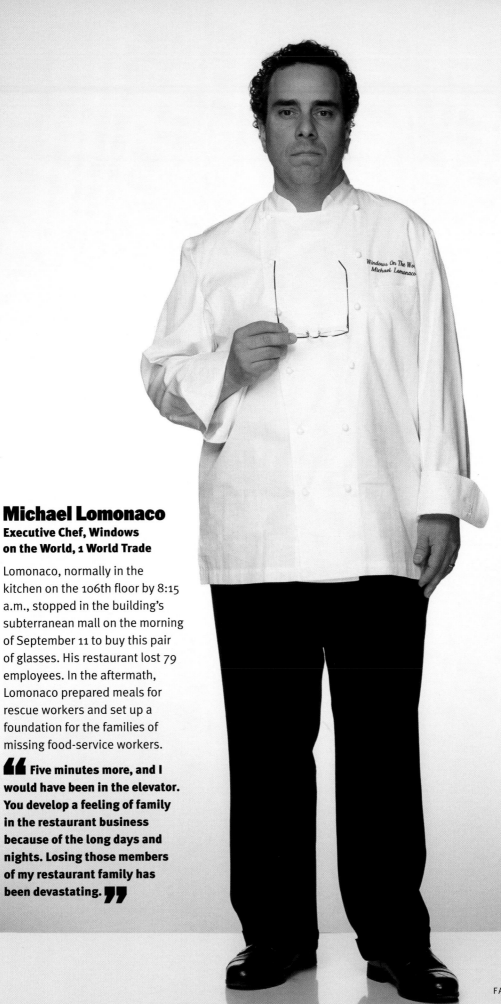

Michael Lomonaco
**Executive Chef, Windows
on the World, 1 World Trade**

Lomonaco, normally in the kitchen on the 106th floor by 8:15 a.m., stopped in the building's subterranean mall on the morning of September 11 to buy this pair of glasses. His restaurant lost 79 employees. In the aftermath, Lomonaco prepared meals for rescue workers and set up a foundation for the families of missing food-service workers.

❝ Five minutes more, and I would have been in the elevator. You develop a feeling of family in the restaurant business because of the long days and nights. Losing those members of my restaurant family has been devastating. ❞

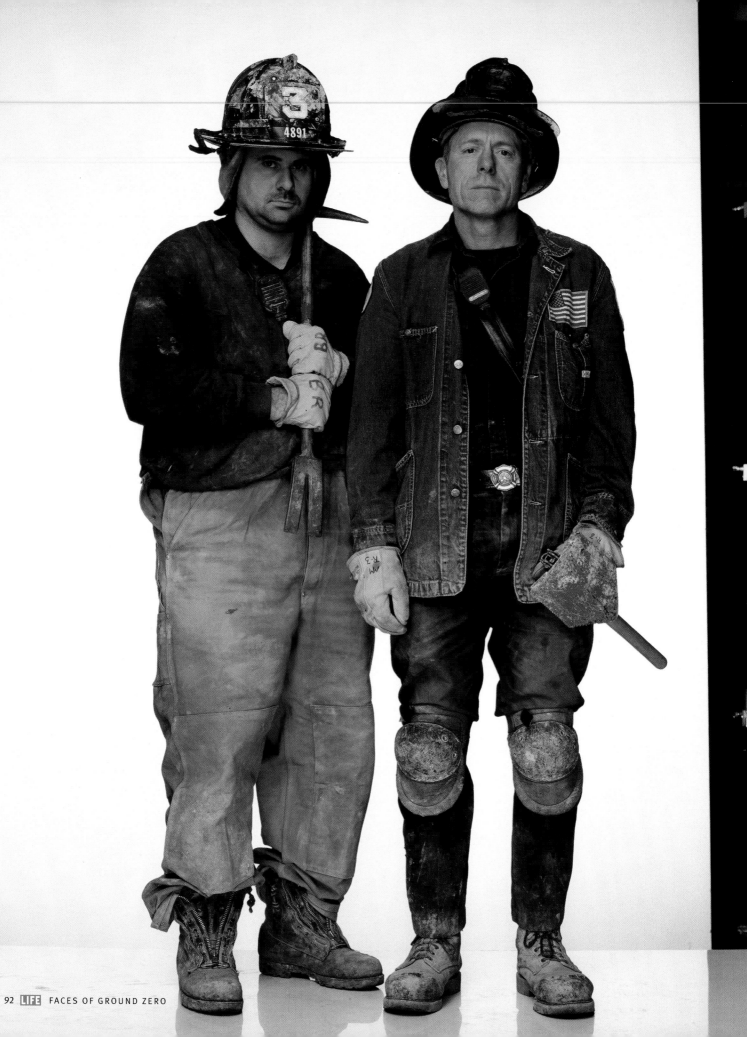

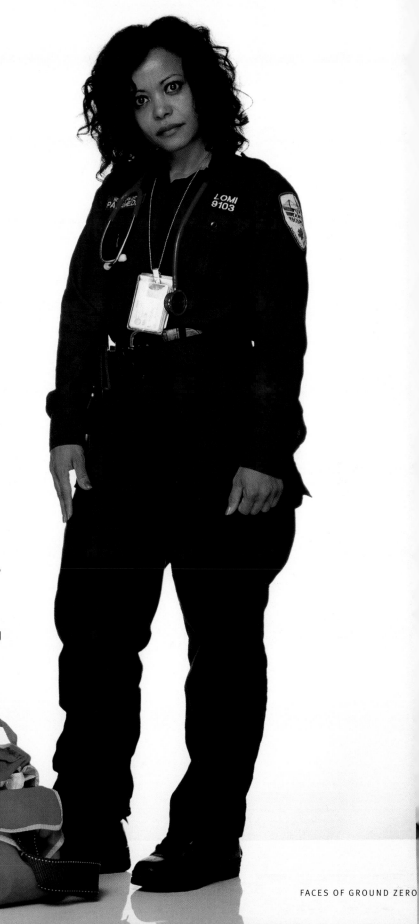

Billy Ryan
Mike Morrisey
Firefighters, Rescue 3, FDNY

When the attack came, each was home and got a call to come in. They arrived at the site just after the second collapse.

" I tried to get overtime the night before but signed up too late," said Morrisey. "It would have happened to me. Eight men in my house alone were killed, and I know of many more." Said Ryan: "Two tables of people at my wedding are not here anymore. I'm tired of burying my friends. "

Juana Lomi
Paramedic, NYU Downtown Hospital

She and her partner dashed to the scene. They survived the collapse of both towers, then they went to work.

" It was an overwhelming feeling of fear, horror—and not being able to do more. There were hundreds of people that needed to be treated. I was at risk of losing my life, but I had to stay and help other people. "

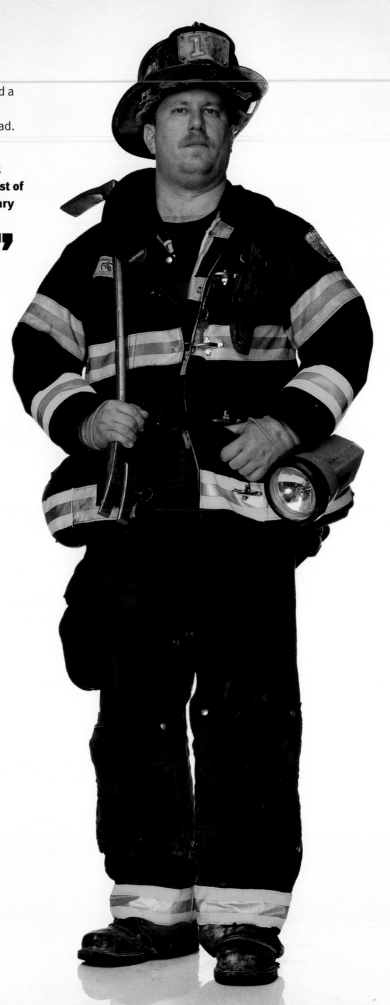

Chris Calamia
Firefighter, Squad 18, FDNY

Calamia was home preparing to attend a college class when the towers were struck. He went straight to work instead. Squad 18 lost seven members.

❝ I wish they were back. That's all I can say. I'm not a big word-guy. Most of us aren't. We don't have the vocabulary to properly express this kind of loss. To call it sorrow just doesn't cut it. ❞

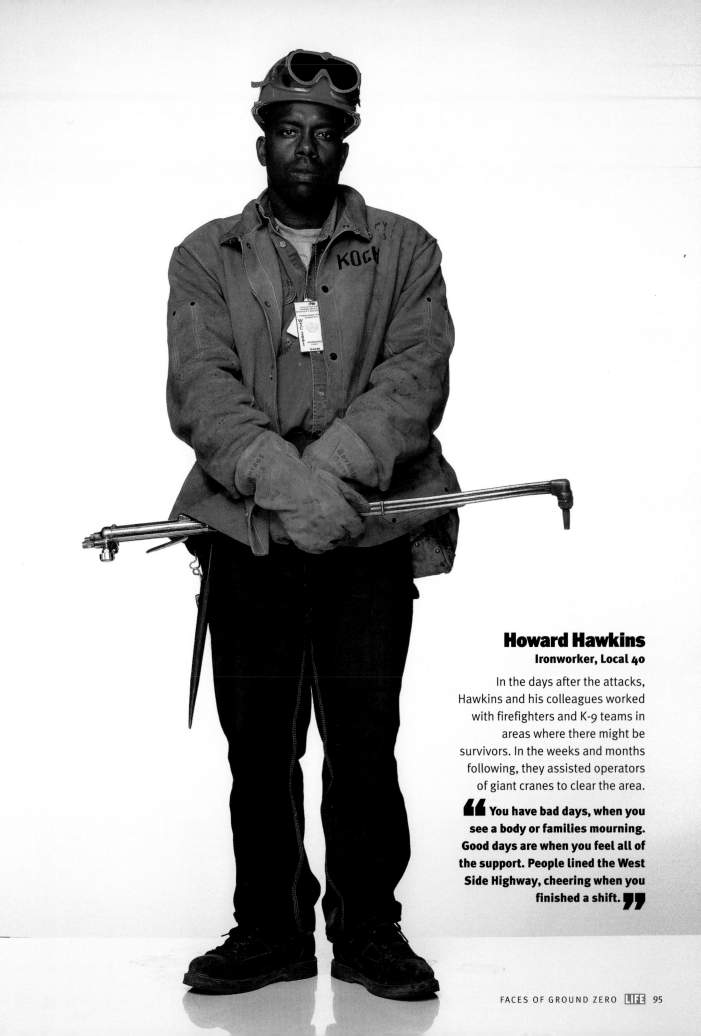

Howard Hawkins
Ironworker, Local 40

In the days after the attacks, Hawkins and his colleagues worked with firefighters and K-9 teams in areas where there might be survivors. In the weeks and months following, they assisted operators of giant cranes to clear the area.

❝ You have bad days, when you see a body or families mourning. Good days are when you feel all of the support. People lined the West Side Highway, cheering when you finished a shift. ❞

Martin Duffy
Ironworker, Local 40

He worked 12-hour shifts, seven days a week at Ground Zero. During his time off, Duffy, who lives in South Jersey, slept at a relative's in Staten Island or at a barracks set up at a nearby hotel.

❝ I'm just thankful that I can help some families get closure over the loss of their loved ones. God bless them. ❞

Andrew V. Sforza
Joseph G. Proscia
Firefighters, Engine 54, FDNY

They lost their firehouse colleagues at the World Trade Center.

❝ I can still hear the words from the company covering 54 Engine," recalled Sforza. "'They are there and no contact yet.' We all had great hope and believed they would come home. I still hear them in crowds and see their faces on the runs. It's hard to accept that 15 of your brothers aren't coming home. ❞

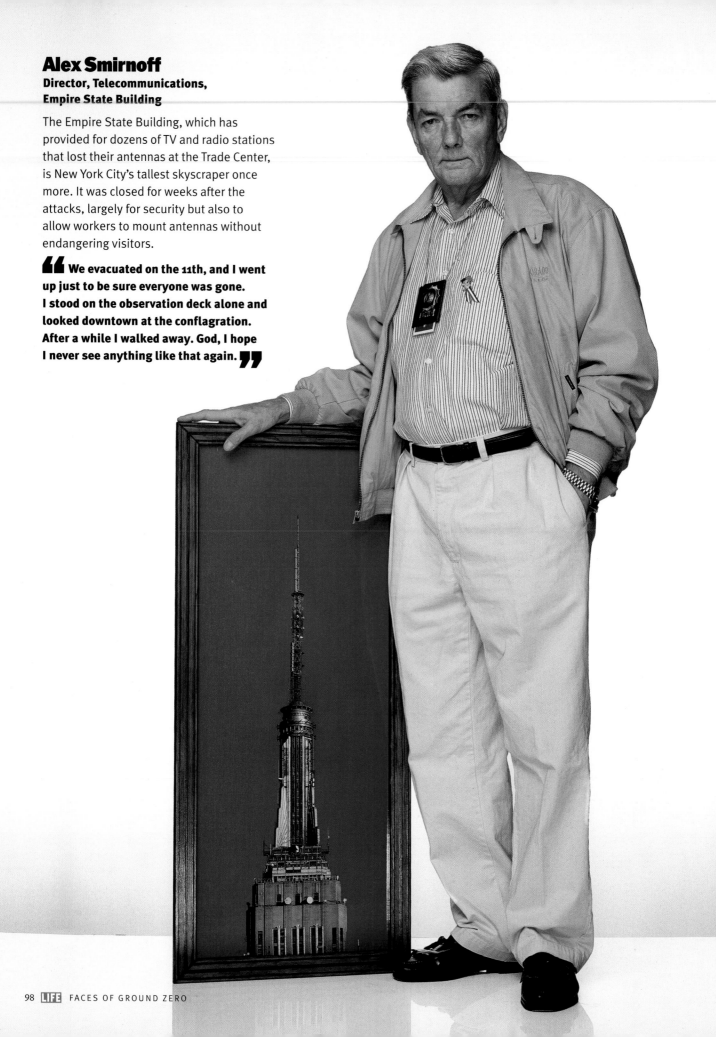

Alex Smirnoff
Director, Telecommunications, Empire State Building

The Empire State Building, which has provided for dozens of TV and radio stations that lost their antennas at the Trade Center, is New York City's tallest skyscraper once more. It was closed for weeks after the attacks, largely for security but also to allow workers to mount antennas without endangering visitors.

❝ We evacuated on the 11th, and I went up just to be sure everyone was gone. I stood on the observation deck alone and looked downtown at the conflagration. After a while I walked away. God, I hope I never see anything like that again. ❞

Tom Silliman
President,
Electronics Research, Inc.,
Chandler, Indiana

Silliman installed antennas on the Empire State Building and other skyscrapers for TV and radio stations that lost their signals when their World Trade antennas were destroyed.

At midnight, I'm on an ice shield of the Empire State Building, 1,250 feet above the city with my bag of tools, working. It's peaceful, but I look downtown and see the work lights and the smoke— still smoke after six weeks. It brings tears to my eyes every night.

Geoffrey Heineman
**Managing Partner,
Ohrenstein and Brown**

Heineman arrived early at his office, on the 85th floor of Tower No. 1, so that he could make it home for his son's 11th birthday party later in the day.

There was a big bang, an explosion. I came out of my office and said, 'Let's round up the people.' It took us an hour to get down. My thoughts and prayers are with those who weren't as lucky as I was to get out.

James Kirby
Richard Riccardi
**Firefighters,
Ladder 6 and Ladder 4, FDNY**

As firefighters did their jobs clearing rubble and searching for bodies, they often had others on their minds.

My sister worked in Building 5. She made it out," said Kirby. "But my brother, Chris, had a three-day construction job on the 107th of Tower 2. He's gone." Said Riccardi: "My house lost 15 guys. They're in the back of my mind the whole time. They're my extended family. This is still the greatest job on earth.

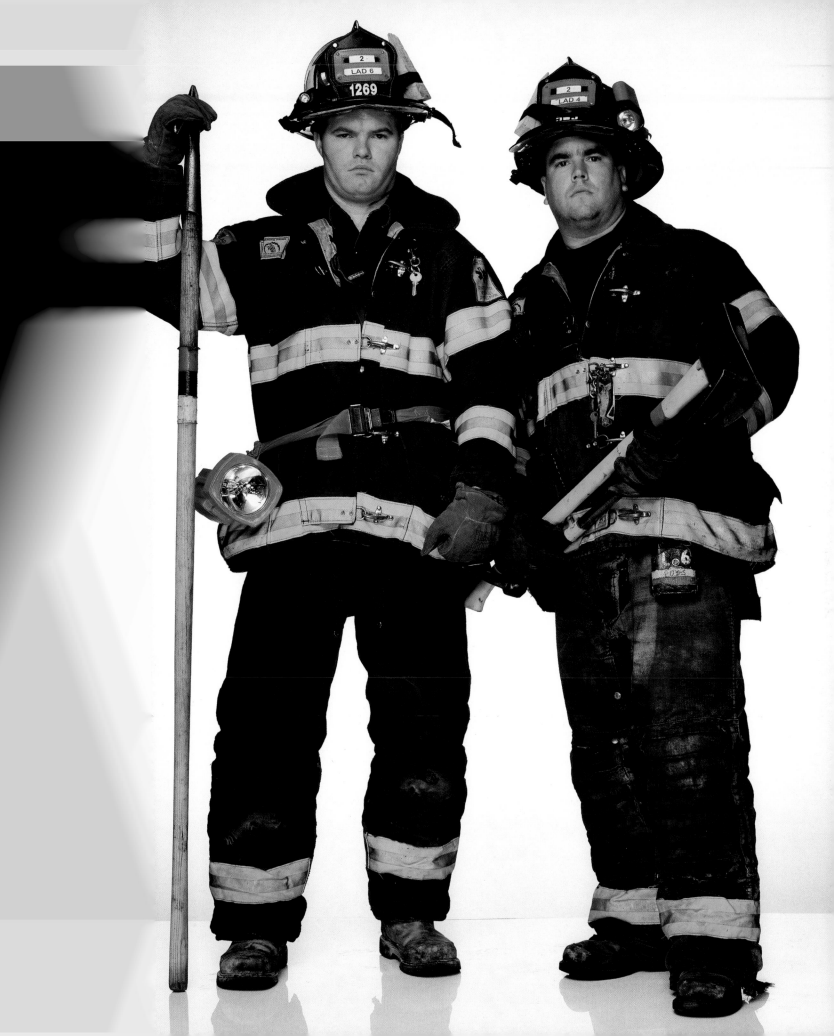

Elizabeth McGovern
Terry McGovern

Daughters of Ann McGovern, a claims analyst at Aon who was killed; Terry is the mother of infant Liam

Elizabeth was working at Merrill Lynch in the World Financial Center on September 11 and walked down 40 flights to safety. Ann worked on the 93rd floor of Tower No. 2 and was last seen waiting for an elevator.

❝ She was on the 72nd floor," said Terry. "There was a line. The group ahead of her made it out. I hope she was killed instantly when the second plane hit. My mom was quite a character. She loved golf and she loved Liam. Now she's cheated out of being part of his life. ❞

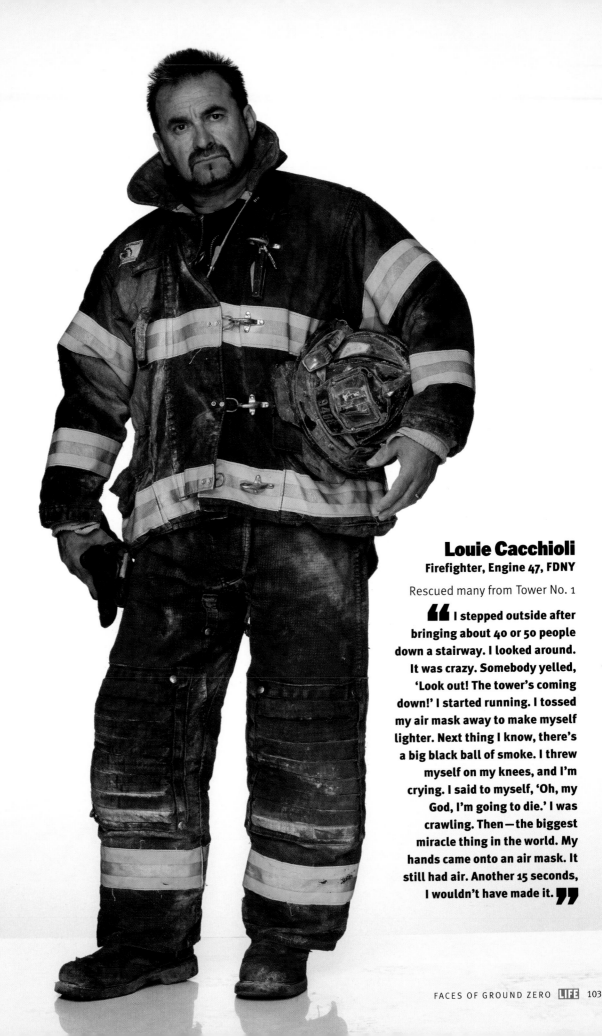

Louie Cacchioli
Firefighter, Engine 47, FDNY

Rescued many from Tower No. 1

❝ I stepped outside after bringing about 40 or 50 people down a stairway. I looked around. It was crazy. Somebody yelled, 'Look out! The tower's coming down!' I started running. I tossed my air mask away to make myself lighter. Next thing I know, there's a big black ball of smoke. I threw myself on my knees, and I'm crying. I said to myself, 'Oh, my God, I'm going to die.' I was crawling. Then—the biggest miracle thing in the world. My hands came onto an air mask. It still had air. Another 15 seconds, I wouldn't have made it. ❞

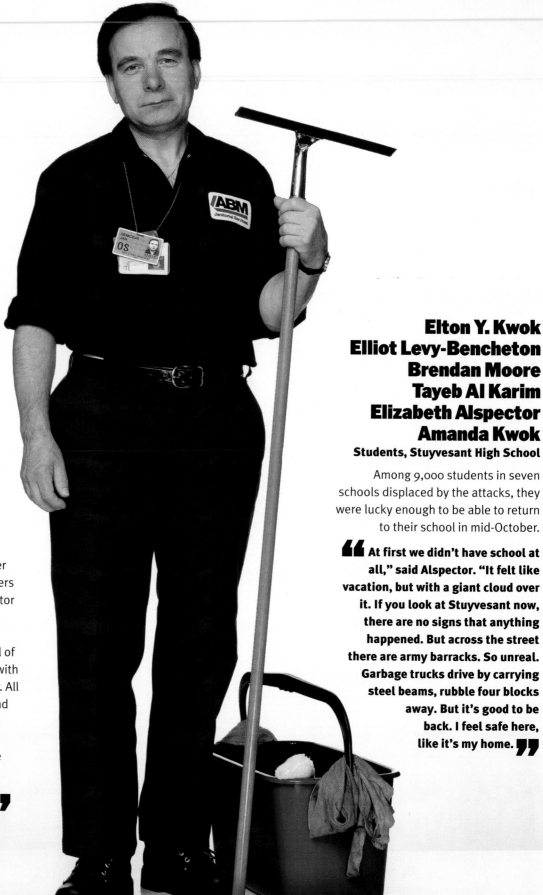

Jan Demczur
Window Washer

When the plane struck Tower No. 1, Demczur and five others became trapped in an elevator 50 floors up. Demczur pried open the door with his squeegee. Faced with a wall of plasterboard, he went at it with the metal blade of his wiper. All of the trapped took turns and finally made a 12-by-18-inch hole. They crawled out, astonishing firefighters. The escape took 95 minutes.

❝ I can't talk about it. ❞

Elton Y. Kwok
Elliot Levy-Bencheton
Brendan Moore
Tayeb Al Karim
Elizabeth Alspector
Amanda Kwok
Students, Stuyvesant High School

Among 9,000 students in seven schools displaced by the attacks, they were lucky enough to be able to return to their school in mid-October.

❝ At first we didn't have school at all," said Alspector. "It felt like vacation, but with a giant cloud over it. If you look at Stuyvesant now, there are no signs that anything happened. But across the street there are army barracks. So unreal. Garbage trucks drive by carrying steel beams, rubble four blocks away. But it's good to be back. I feel safe here, like it's my home. ❞

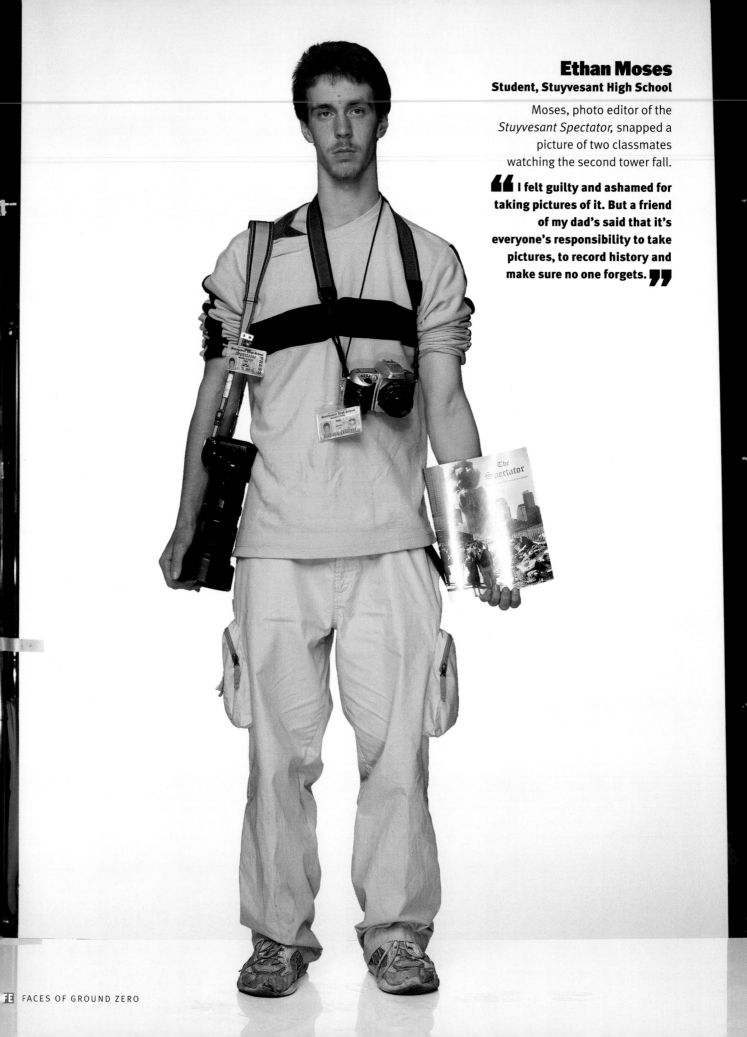

Ethan Moses
Student, Stuyvesant High School

Moses, photo editor of the *Stuyvesant Spectator,* snapped a picture of two classmates watching the second tower fall.

❝ I felt guilty and ashamed for taking pictures of it. But a friend of my dad's said that it's everyone's responsibility to take pictures, to record history and make sure no one forgets. ❞

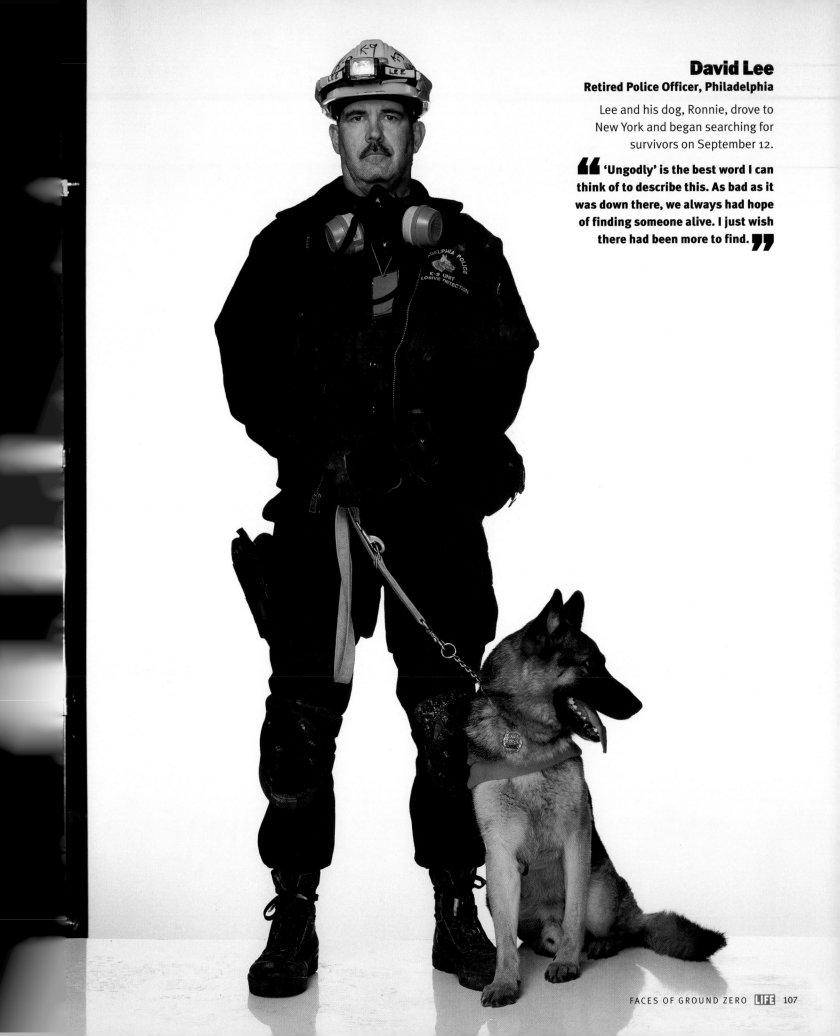

David Lee
Retired Police Officer, Philadelphia

Lee and his dog, Ronnie, drove to New York and began searching for survivors on September 12.

“ **'Ungodly' is the best word I can think of to describe this. As bad as it was down there, we always had hope of finding someone alive. I just wish there had been more to find.** ”

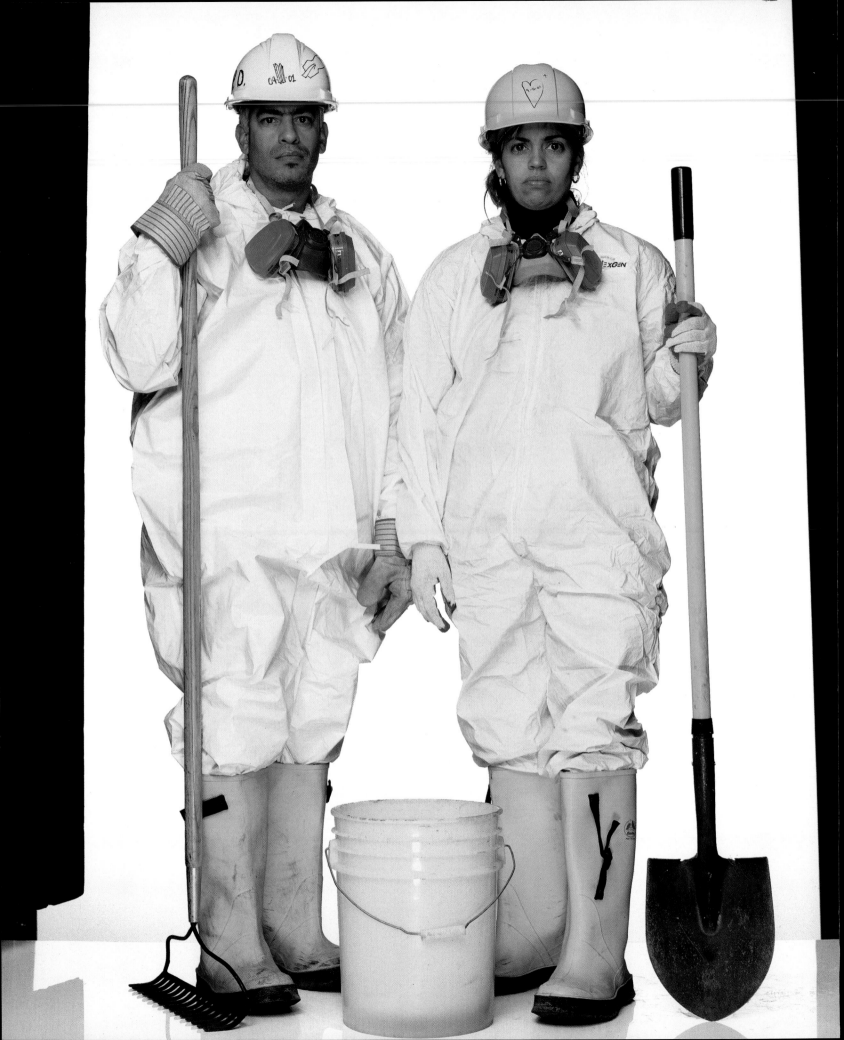

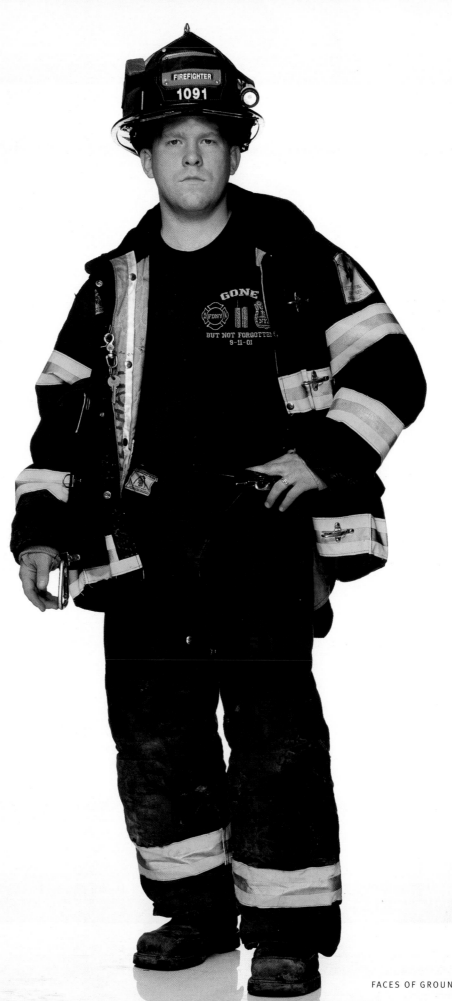

Donald Sanchez
Jacqueline Zayas
Detectives, 52nd Precinct, NYPD

Sanchez and Zayas searched through rubble at Fresh Kills landfill in Staten Island, looking for items that could help identify victims.

❝You dig for hours, sifting through mounds of mud and twisted metal," said Sanchez. "It's so impersonal, until you come across a lock of hair, a shredded skirt or a photo ID. Then the horror screams out at you and you feel the pain of those lost lives all over again. ❞

Daniel Feltham
Firefighter, Engine 33, FDNY

He was headed for an emergency command station soon after the planes struck the towers. Feltham, who had been a firefighter for less than two years, stopped at his grandparents' house to say his goodbyes "in case something happened." He worked in the recovery efforts on September 11.

❝I wanted to be a fireman since I was four years old. It's always been the kind of job you'd want your kids to follow you and do. But I would never ever want my kid to go through this. It's made me feel I would not want my kid to be a fireman. ❞

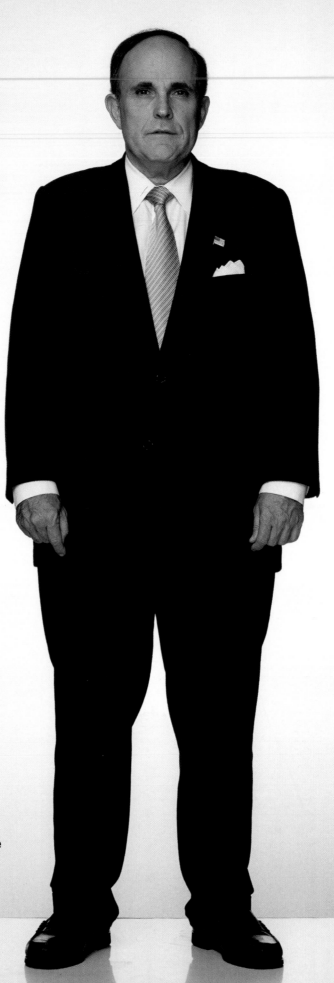

Rudolph W. Giuliani

Mayor of the City of New York on September 11, 2001

Hearing of the attack, he rushed to the scene and took control.

❝ New Yorkers conducted themselves as bravely as people did during the Battle of Britain. In the 1940s they were bombed every day, and still people went about their living and showed a great example of bravery and courage to the rest of the world. If we maintain a steady way of life, we will be a great example to the rest of the country and the rest of the world. ❞

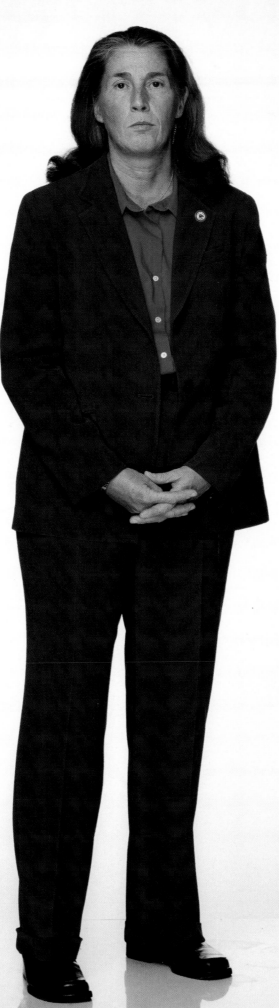

Patti Varrone
Detective, NYPD, Personal Security for Mayor Rudolph W. Giuliani

Varrone took the cell-phone call alerting the mayor of the attacks. She was with him at the scene and later became trapped by smoke in a nearby building where the mayor was trying to set up a command post. Maintenance men helped them escape through an underground tunnel.

❝ In the streets, people recognized the mayor and asked us where to go. We just said, 'North.' Everyone was afraid and covered with dust, but the amazing thing was that they were still stopping to help each other. A lot of civilians did heroic things that day. ❞

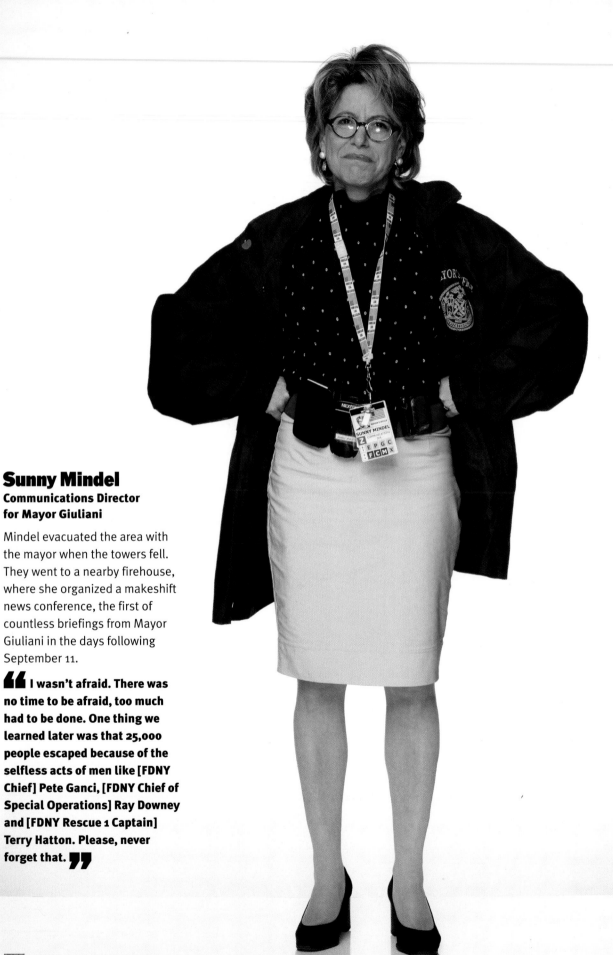

Sunny Mindel
**Communications Director
for Mayor Giuliani**

Mindel evacuated the area with the mayor when the towers fell. They went to a nearby firehouse, where she organized a makeshift news conference, the first of countless briefings from Mayor Giuliani in the days following September 11.

❝ I wasn't afraid. There was no time to be afraid, too much had to be done. One thing we learned later was that 25,000 people escaped because of the selfless acts of men like [FDNY Chief] Pete Ganci, [FDNY Chief of Special Operations] Ray Downey and [FDNY Rescue 1 Captain] Terry Hatton. Please, never forget that. ❞

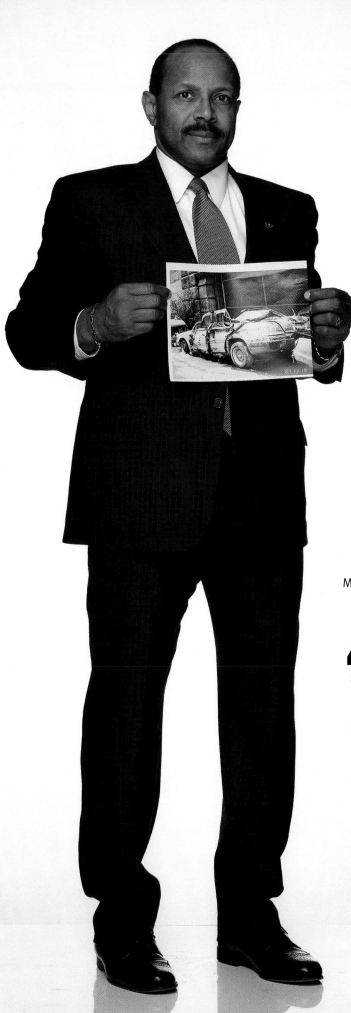

Herbert Miller
Chauffeur Attendant
for Sunny Mindel

Miller received a call to meet Mindel at the World Trade Center. He got out of his car to look for her. Three minutes later it was crushed by falling debris.

" After that, I was covered in soot from head to toe. I started walking uptown and, about 15 minutes later, ran into Sunny and the mayor. I embraced her. I was so happy to see her, and she was happy to see me. "

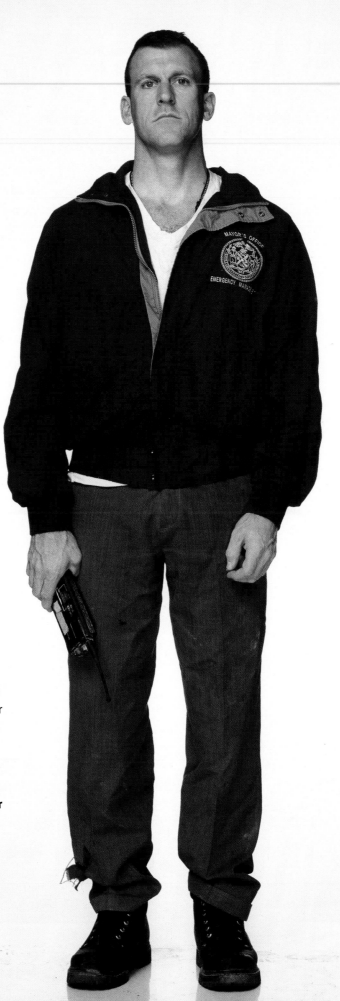

Tim Brown
Supervisor of Field Operations, Mayor's Office of Emergency Management

Brown coordinated emergency efforts between city, state and federal agencies with a two-way radio. He was on the sidewalk of 2 World Trade when it began to come down. He and others sought shelter in the nearby Marriott Hotel, which collapsed around them.

❝ I said my prayers and was waiting to get crushed, but then it just stopped. Outside, a firefighter yelled, 'This way!' So we joined hands and made a human chain and went through the dust cloud towards the voice. ❞

Kenneth Holden
**Commissioner of the
NYC Department of Design
and Construction**

Normally, Holden directs the
building of city sewers, water
mains, streets and libraries. In the
wake of September 11, he became
responsible for demolition,
excavation and debris-removal
at Ground Zero.

**❝ By the end of 2002, the site
will be cleared to ground level, but
then it will take nine months to
excavate the basements and shore
up the slurry walls. Even after
months of working on it, to see this
magnitude of destruction in such a
small space is just very sad. ❞**

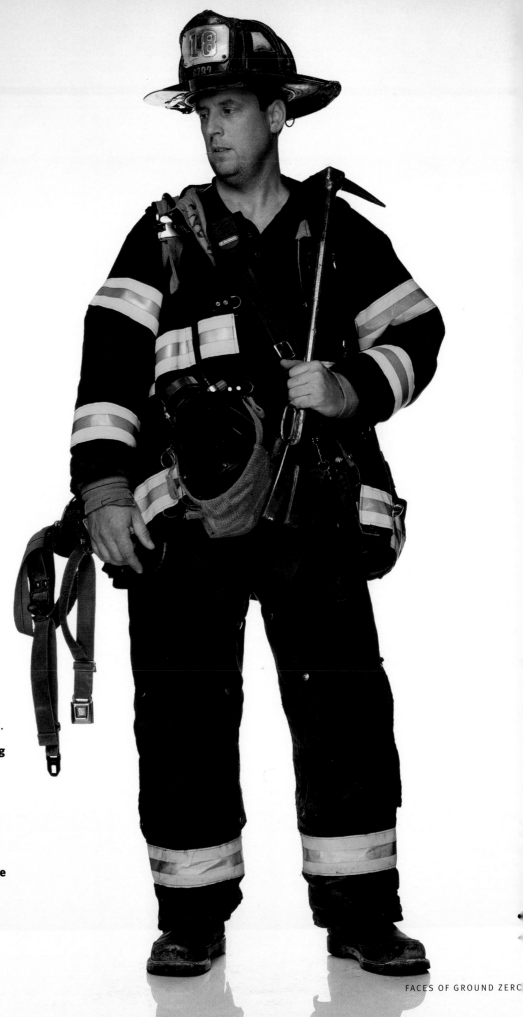

Georgia Faust
Dikko Faust
Polly Faust
Esther Smith
Tribeca family

On the 11th, Esther was at their Duane St. apartment, Dikko at their bookbinding studio and the girls in school. They were among the tens of thousands rendered temporarily homeless by the attacks.

❝ After the second plane hit, we picked up the kids and walked away with nothing," said Esther. "Friends took us in. After 13 days, we finally came home. ❞**

Kevin Scanlon
Firefighter, Squad 18, FDNY

As soon as the second plane hit, Scanlon left his home and headed for the scene. He found chaos and destruction beyond belief. Squad 18 lost seven men.

❝ There was nobody handing out orders, so I just picked a spot and started searching. Anyone who has second thoughts about our country's retaliation should just look at the list of names — nearly 4,000 innocent people. We have to fight back. ❞

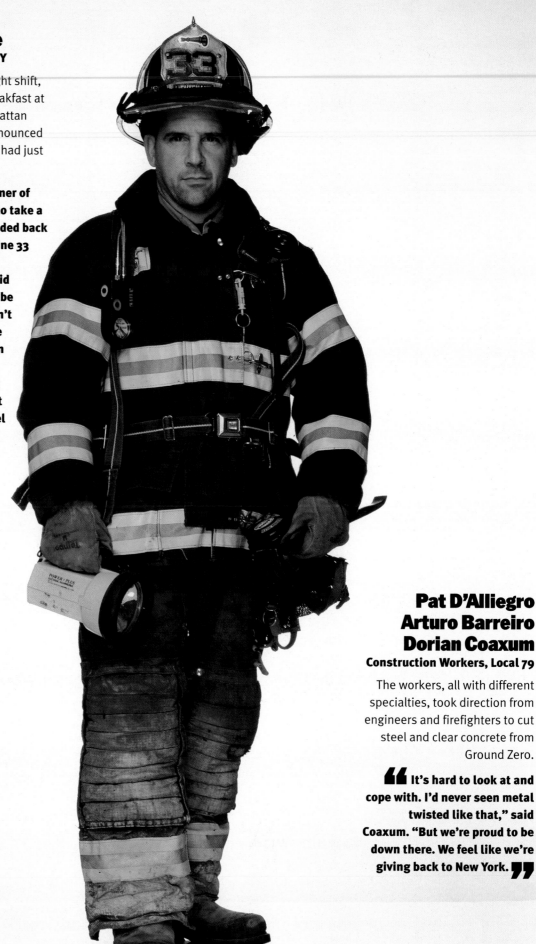

John Baldassarre
Lieutenant, Engine 33, FDNY

Having just come off the night shift, Baldassarre was having breakfast at his firehouse in lower Manhattan when a fellow firefighter announced that the World Trade Center had just been hit by a plane.

❝ I went down to the corner of Great Jones and Lafayette to take a look at the impact. As I headed back to the firehouse, I saw Engine 33 responding to the alarm. I approached the rig and said to Lieutenant Pfeifer, 'Kev, be careful down there, it doesn't look good.' Then they drove past me. With the exception of Richard Conte, the chauffeur, the guys on that crew—Kevin Pfeifer, Robert King Jr., David Arce, Michael Boyle, Robert Evans and Keithroy Maynard—never came back. ❞

Pat D'Alliegro
Arturo Barreiro
Dorian Coaxum
Construction Workers, Local 79

The workers, all with different specialties, took direction from engineers and firefighters to cut steel and clear concrete from Ground Zero.

❝ It's hard to look at and cope with. I'd never seen metal twisted like that," said Coaxum. "But we're proud to be down there. We feel like we're giving back to New York. ❞

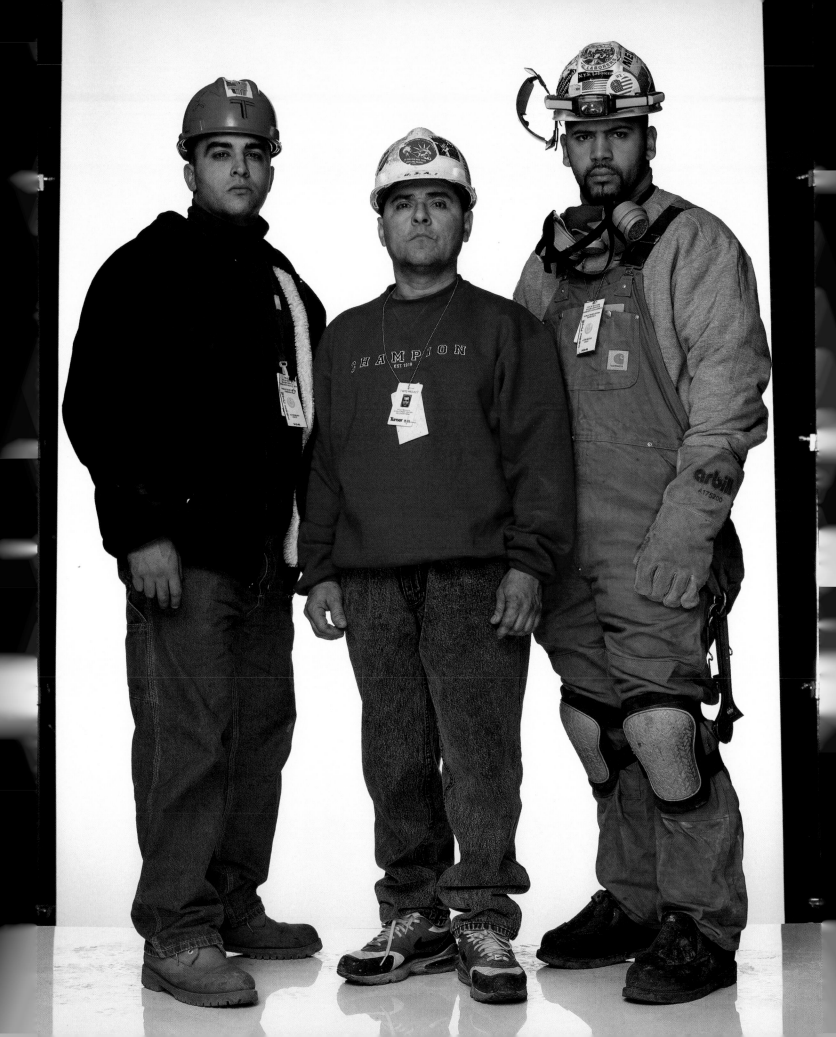

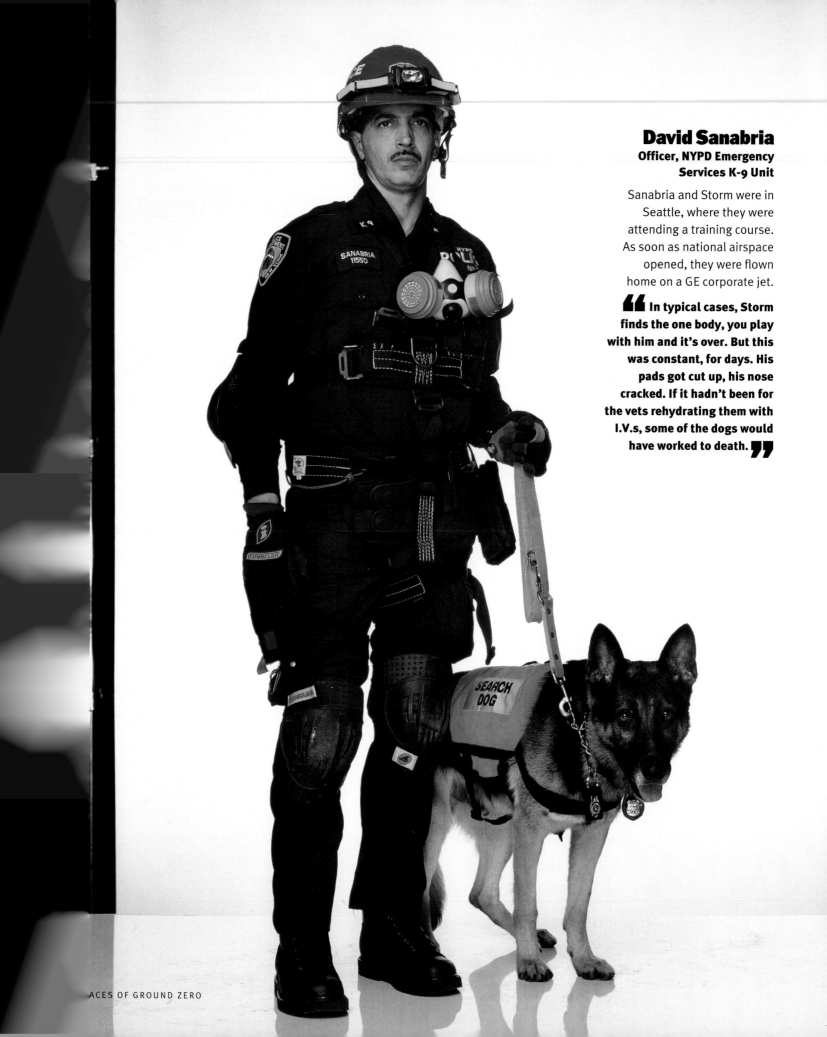

David Sanabria
Officer, NYPD Emergency Services K-9 Unit

Sanabria and Storm were in Seattle, where they were attending a training course. As soon as national airspace opened, they were flown home on a GE corporate jet.

" In typical cases, Storm finds the one body, you play with him and it's over. But this was constant, for days. His pads got cut up, his nose cracked. If it hadn't been for the vets rehydrating them with I.V.s, some of the dogs would have worked to death. "

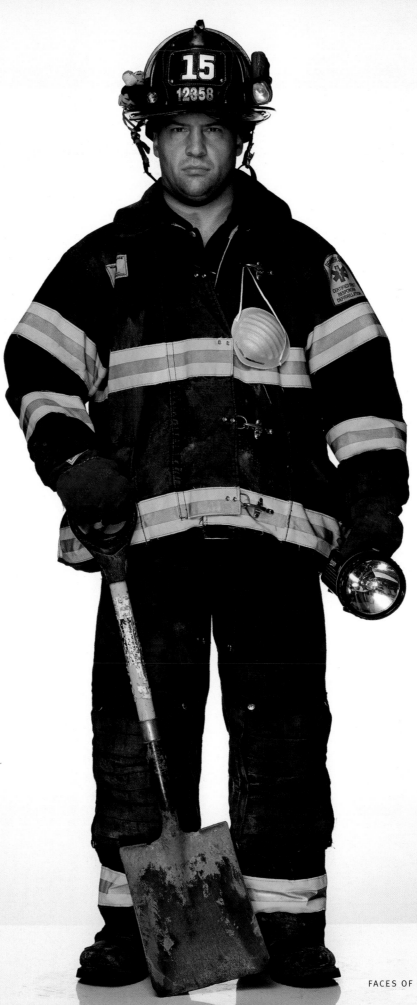

Rocky Raimondi
Firefighter, Engine 15, FDNY

His shift finished, Raimondi left his firehouse at 8:35 a.m. and was driving to Rockaway Beach, Long Island, to go surfing.

❝ I was on the Brooklyn Bridge when the planes hit, and then got stuck in traffic on the Brooklyn-Queens Expressway while I was trying to turn around. When the first building collapsed, I heard the news on the radio. I broke down and cried right there in my car. I thought all my guys had been wiped out, but they lucked out. They were on the 17th floor of Building 1 and got out as fast as they could when they heard Building 2 collapse. They said they had about a minute to spare. It was like a family reunion when we saw them alive. ❞

Paulette Floyd
Disaster Mental Health Worker, American Red Cross

Floyd, a social worker, took several weeks off from her regular job to work as a Red Cross volunteer, providing grief counseling and support for survivors, families, rescuers and others impacted by September 11.

❝ I wanted to be there to help the victims and the workers and the volunteers to express what they were feeling, rather than cleaning it up into what they 'should' be feeling. At some point everyone needs someone to talk to. ❞

Chris Fischer
John McGinty
Firefighters, Engine 9, FDNY

Neither was on duty the morning of the 11th. Both worked in the recovery effort.

❝ I found lots of shoes, for some reason. Just random shoes," said Fischer. "It was very strange. Maybe they were from under people's desks." Said McGinty: "There were huge pieces of steel twisted like pretzels, but there was no glass. These were two 110-story towers of glass and you couldn't see any glass. You couldn't see any phones. You couldn't see one piece of a computer. Everything was completely pulverized. ❞

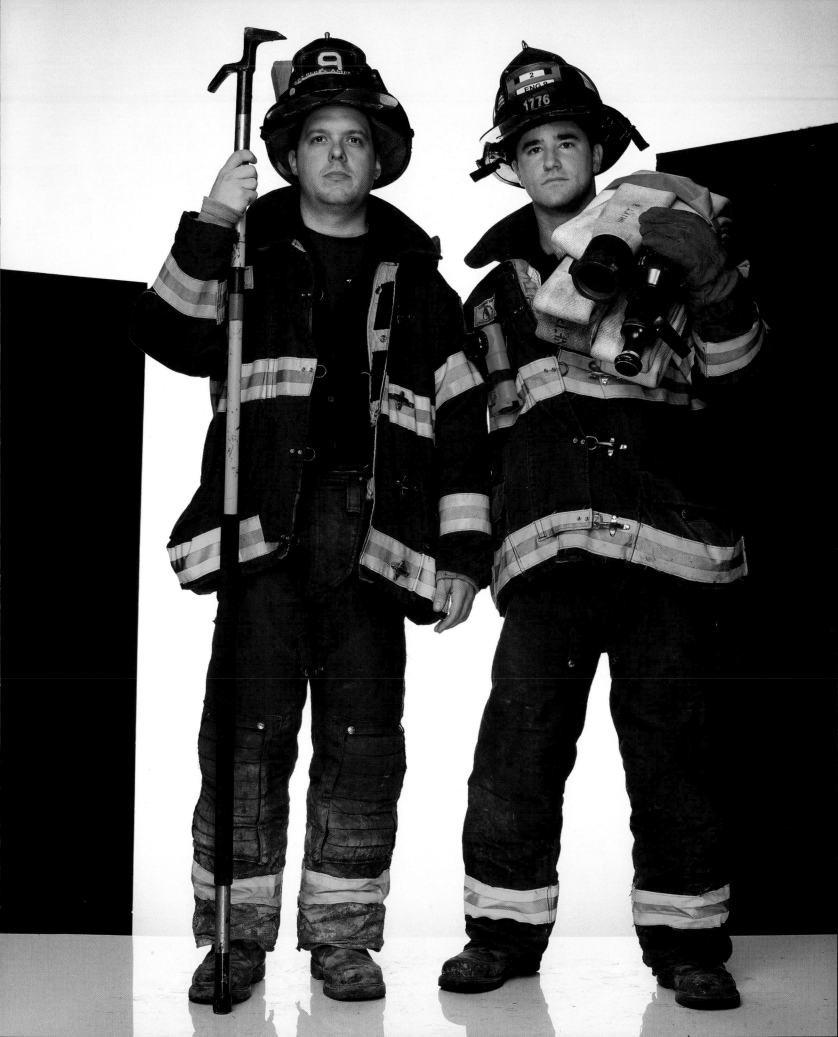

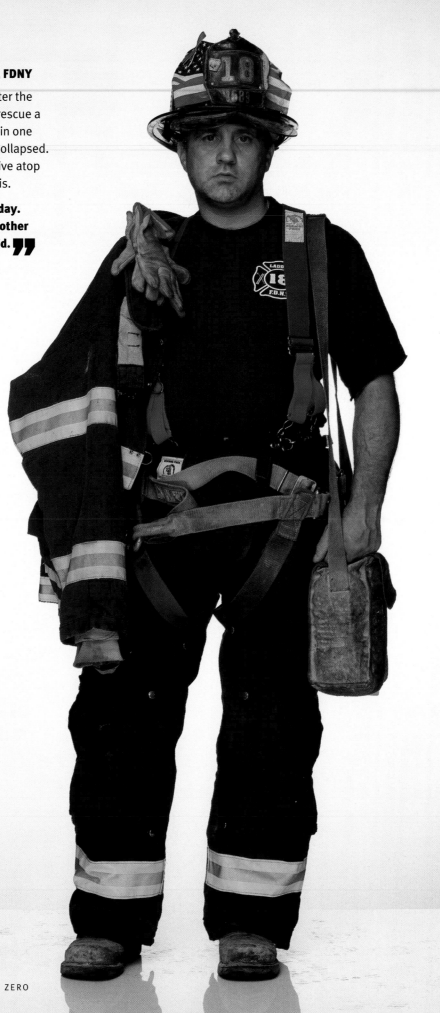

Ron Lattari
Firefighter, Ladder 18, FDNY

More than 36 hours after the attack, Lattari helped rescue a woman who had been in one of the towers when it collapsed. She was discovered alive atop a 200-foot pile of debris.

❝ That was a good day. We thought we'd find other survivors. We never did. ❞

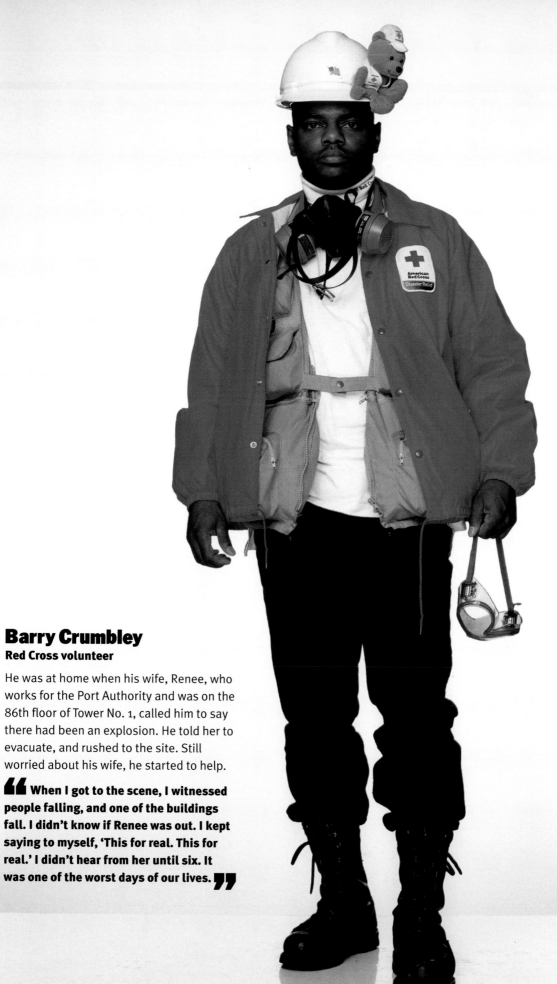

Barry Crumbley
Red Cross volunteer

He was at home when his wife, Renee, who works for the Port Authority and was on the 86th floor of Tower No. 1, called him to say there had been an explosion. He told her to evacuate, and rushed to the site. Still worried about his wife, he started to help.

❝ **When I got to the scene, I witnessed people falling, and one of the buildings fall. I didn't know if Renee was out. I kept saying to myself, 'This for real. This for real.' I didn't hear from her until six. It was one of the worst days of our lives.** ❞

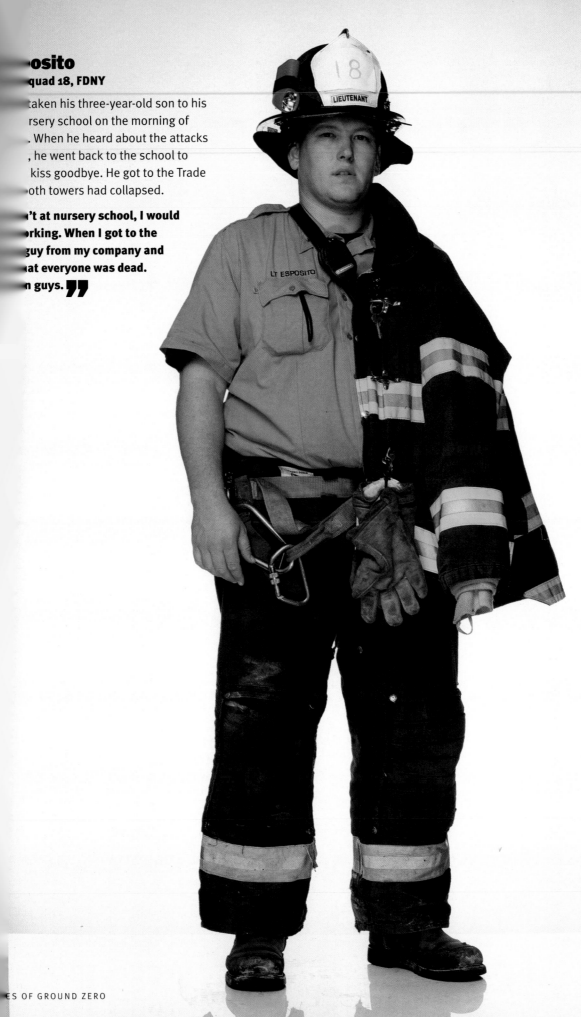

posito
quad 18, FDNY

taken his three-year-old son to his
rsery school on the morning of
. When he heard about the attacks
, he went back to the school to
kiss goodbye. He got to the Trade
oth towers had collapsed.

**'t at nursery school, I would
rking. When I got to the
guy from my company and
at everyone was dead.
n guys. "**

Audrey Valentine
Raul Figueroa Jr.
Morgue Detectives, NYPD

As police detectives assigned to the New York City Medical Examiner's office, Valentine and Figueroa are liaisons between the M.E.'s office and the NYPD. Figueroa was at the World Trade Center when the first tower collapsed. Valentine was stationed at 520 First Avenue, the office of Chief Medical Examiner Dr. Charles Hirsch, awaiting the arrival of bodies.

" Any disaster in which six or more people die, we know we have to go to the site and set up a temporary morgue," explained Valentine. "When the south tower collapsed, the car carrying the staff of the M.E.'s office was crushed. The people in the car, including Dr. Hirsch, saw it coming and ran for their lives. They escaped in time but were hurt by the flying debris. "

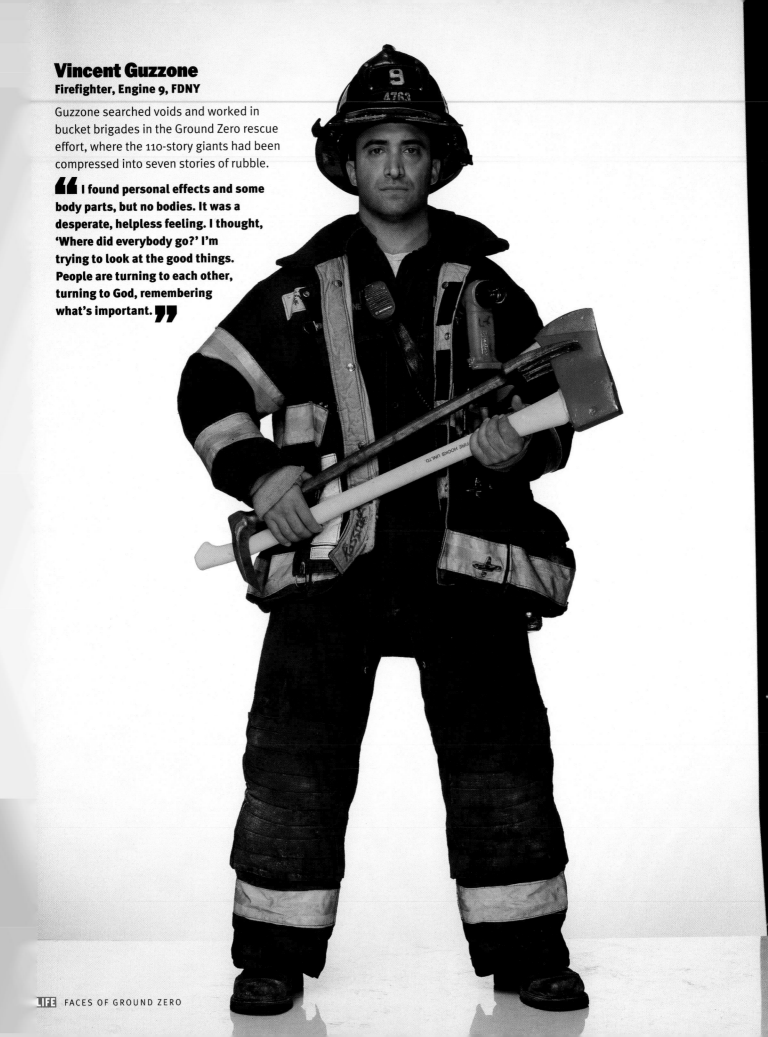

Vincent Guzzone
Firefighter, Engine 9, FDNY

Guzzone searched voids and worked in bucket brigades in the Ground Zero rescue effort, where the 110-story giants had been compressed into seven stories of rubble.

❝ I found personal effects and some body parts, but no bodies. It was a desperate, helpless feeling. I thought, 'Where did everybody go?' I'm trying to look at the good things. People are turning to each other, turning to God, remembering what's important. ❞

Mickie Slattery

**Paramedic, Critical Care Team,
Jersey City Medical Center**

Slattery and her ambulance crew
were eating breakfast at the
Jersey City waterfront when they
witnessed the attacks on the
World Trade Center. She, Pablo
Lopez, EMT, and Bob Casey, R.N.,
later cared for victims being brought
to the pier. Another colleague who
was with them, David Lamange, a
Port Authority police officer and
part-time paramedic, left the
waterfront to go to the Trade Center.
He was killed at Ground Zero.

**❝ People came over on barges,
ferries, private boats, coast
guard cutters. There were even
people who were swimming across.
We had such an influx of people
and then, all of a sudden, it
stopped. We kept waiting for more
survivors. We were hoping they
would find people trapped in the
rubble, but that never happened.
We worked at the waterfront for
a week, but other than rescue
workers with small scrapes and
cuts, we never had anybody else
after that first afternoon. ❞**

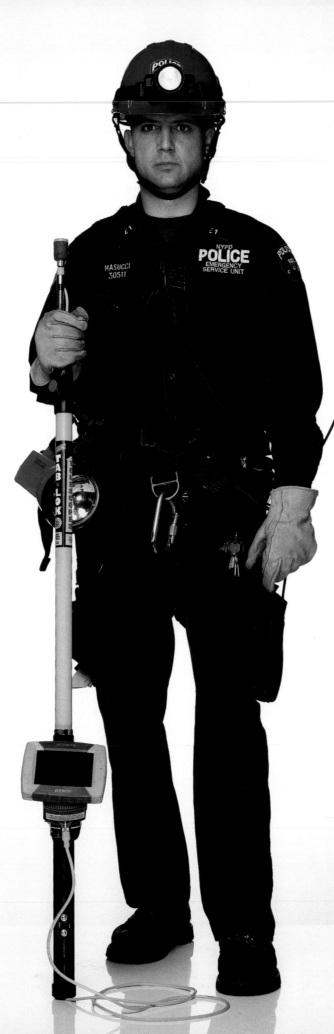

Robert Masucci
Officer, Emergency Service Unit, Truck 1, NYPD

Masucci was mobilizing a block away when the first collapse knocked him off his feet. He had prepared to go in again when the second tower came down. Finally, he searched the rubble using tools like this pole camera, which allowed him to look in voids for survivors.

❝ At times, we had to stop searching because of the fires. It felt like my skin was melting. The devastation was shocking. We all thought we'd die in the collapses. Those of us who didn't went on autopilot. We broke down into teams and started our search. ❞

Sonnett "Sonny" Francis
Michael Farrell
Patrolmen, Fire Patrol 2, FDNY

Patrol 2 was shorthanded that Tuesday, and only firefighters John Sheehan and Keith Roma were able to respond to the alarm. When their off-duty brethren, including Francis and Farrell, heard the news, they raced to the scene. One point hit home: Roma, 27, was missing.

❝ I miss Keith," said Farrell. Added Francis: "He was the guy you knew you could rely on. He was one of the good ones. I just hope that this is the worst our generation ever sees. ❞

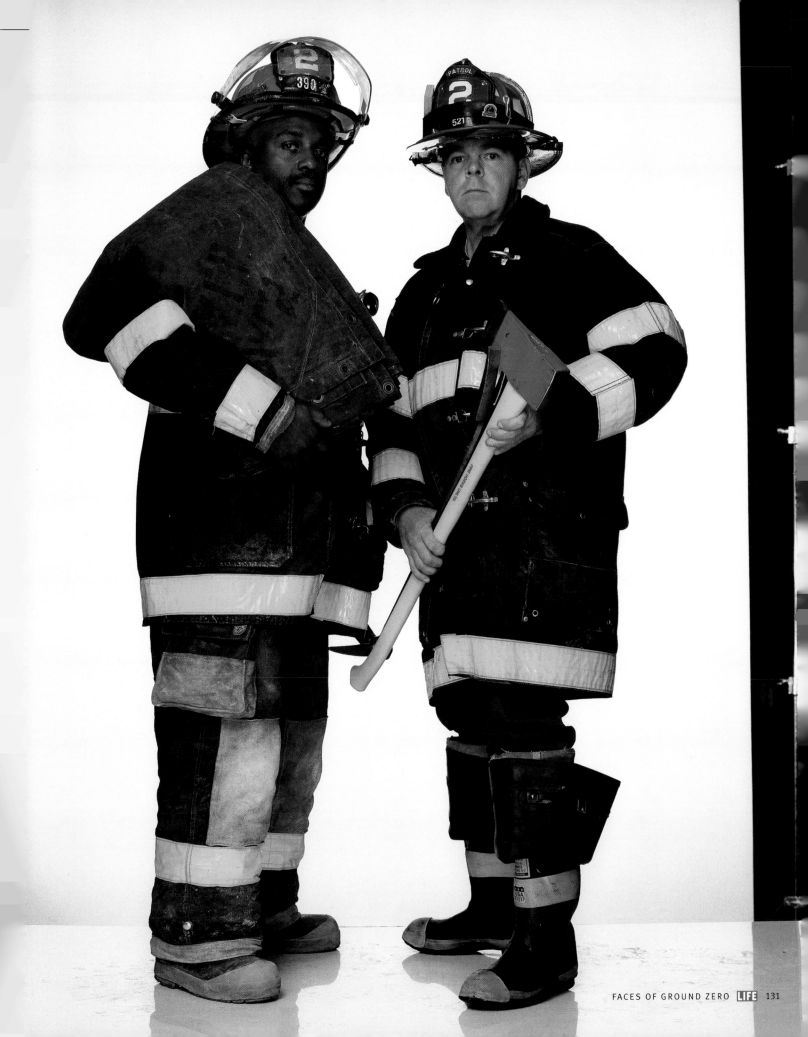

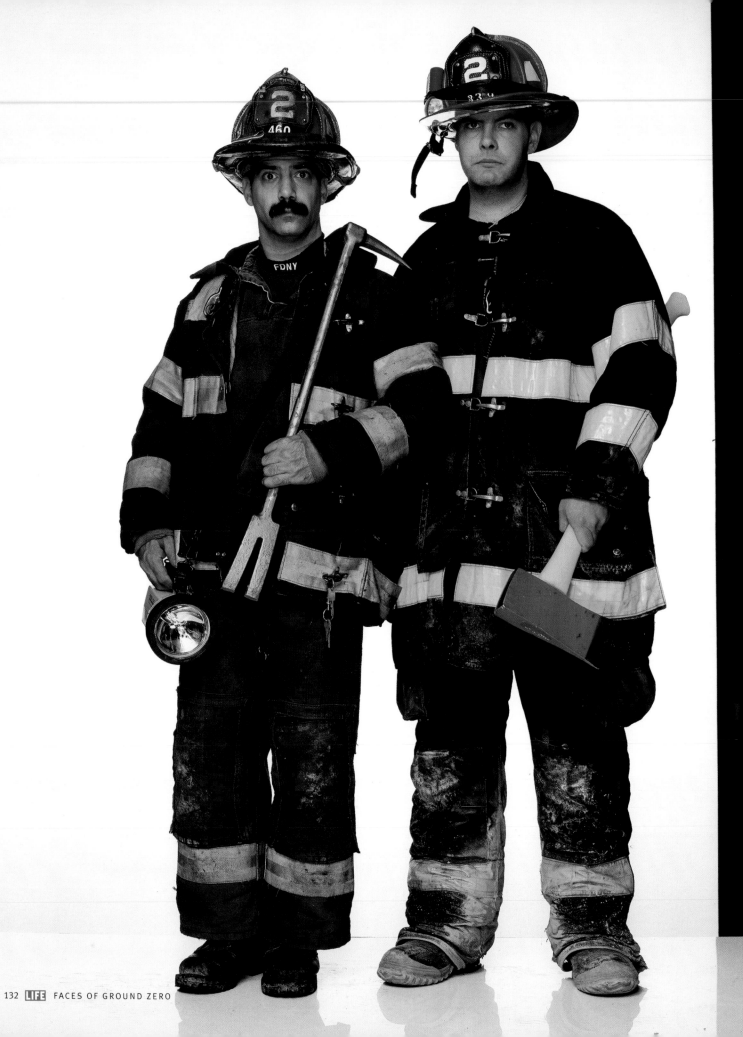

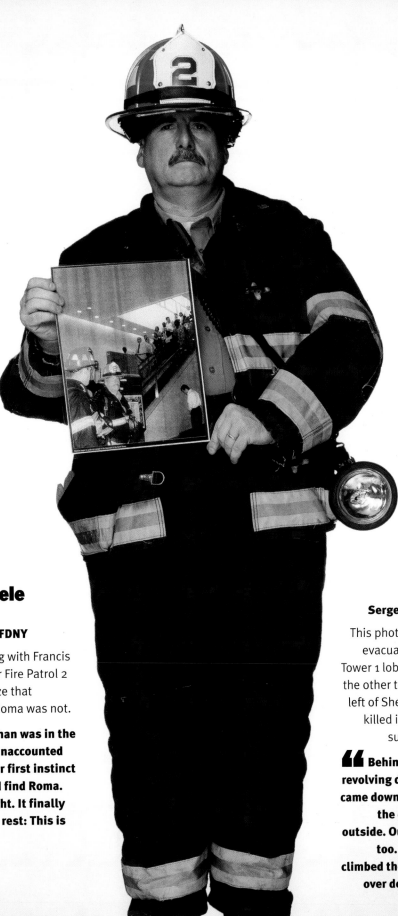

Anthony Emanuele
Michael Ryan
Patrolmen, Fire Patrol 2, FDNY

Emanuele and Ryan, along with Francis and Farrell and their other Fire Patrol 2 colleagues, came to realize that Sheehan was safe—but Roma was not.

❝ We heard that Sheehan was in the hospital and Roma was unaccounted for," said Emanuele. **"Our first instinct was to find survivors and find Roma. I dug for four days straight. It finally hit me when I stopped to rest: This is messed up. ❞**

John Sheehan
Sergeant, Fire Patrol 2, FDNY

This photograph was taken by an evacuating office worker in the Tower 1 lobby eight minutes before the other tower came down. To the left of Sheehan is Roma, who was killed in the collapse. Sheehan suffered a fractured hand.

❝ Behind the photographer is a revolving door. When the building came down, I was two steps inside the door and Keith was just outside. Our whole area collapsed too. I grabbed a civilian. We climbed the escalator and crawled over debris out a window. ❞

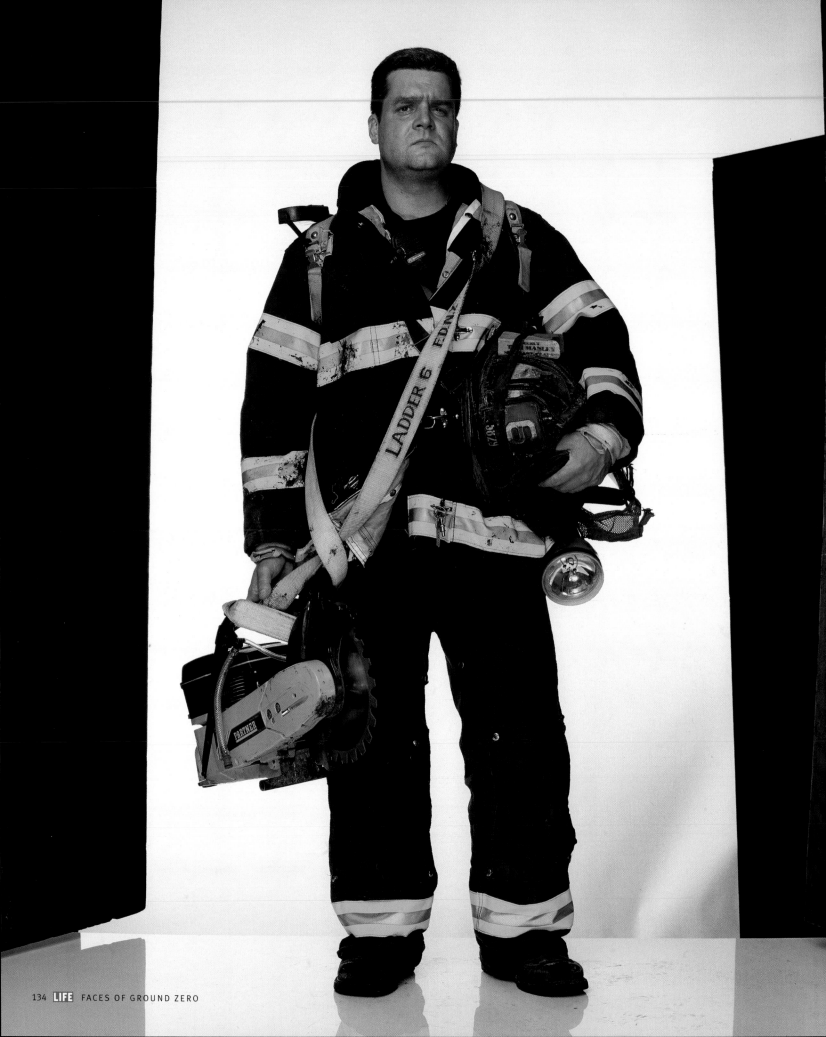

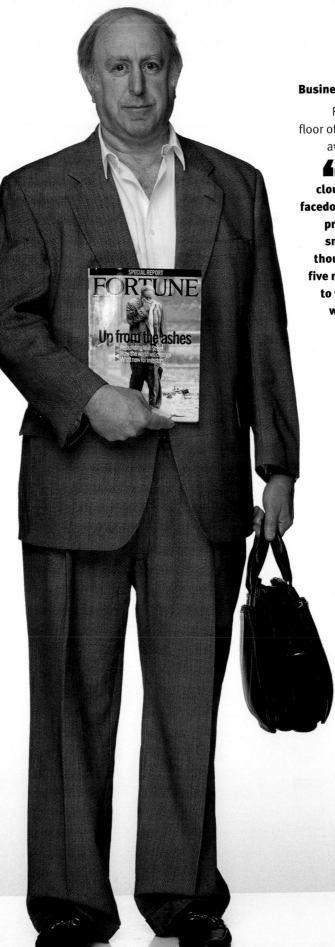

Ed Fine
Business and Financial Consultant

Fine evacuated from the 78th floor of Tower No. 1 and was a block away when Tower 2 collapsed.

" I started running, but the cloud was coming too fast. I lay facedown in the street and heard a priest praying next to me. The smoke and ash were so thick I thought I would suffocate. After five minutes, it was clear enough to walk. That's when the photo was taken. I had no idea. "

Steve Gaudet
Firefighter, Ladder 6, FDNY

Gaudet arrived at the scene just after the collapses. He took equipment from wrecked fire trucks and put out car fires. Then he learned that six men from Ladder 6 were trapped alive in a tower stairway.

" There was a chief telling us not to go in, that we'd lost enough men. Nobody listened. We made our way around to where we heard they were, but we couldn't get to them. World Trade 7 was about to come down, so when we heard they were out, we bailed. "

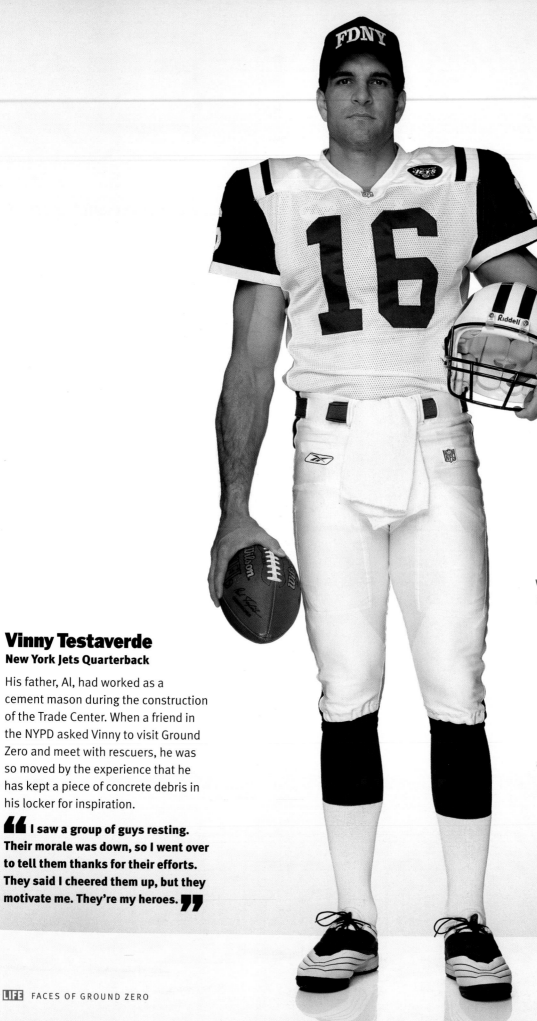

Larry Sullivan
Anthony Cavalieri
Firefighters, Rescue 5, FDNY

Firefighters from the Staten Island–based Rescue 5, which would lose 12 men, took the Staten Island Ferry to Manhattan. Sullivan and Cavalieri's ferry was halfway across New York Harbor when the second tower collapsed. The boat was halted in a cloud of ash. When it reached the terminal, civilians waiting to evacuate cheered the firefighters on.

❝ There was so much smoke and dust, we didn't know what we were up against," said Cavalieri. "It looked like all of downtown Manhattan was being bombed. This was the first time in my 12 years with the department that I was truly scared. When we got there, it was worse than I could have imagined. ❞

Vinny Testaverde
New York Jets Quarterback

His father, Al, had worked as a cement mason during the construction of the Trade Center. When a friend in the NYPD asked Vinny to visit Ground Zero and meet with rescuers, he was so moved by the experience that he has kept a piece of concrete debris in his locker for inspiration.

❝ I saw a group of guys resting. Their morale was down, so I went over to tell them thanks for their efforts. They said I cheered them up, but they motivate me. They're my heroes. ❞

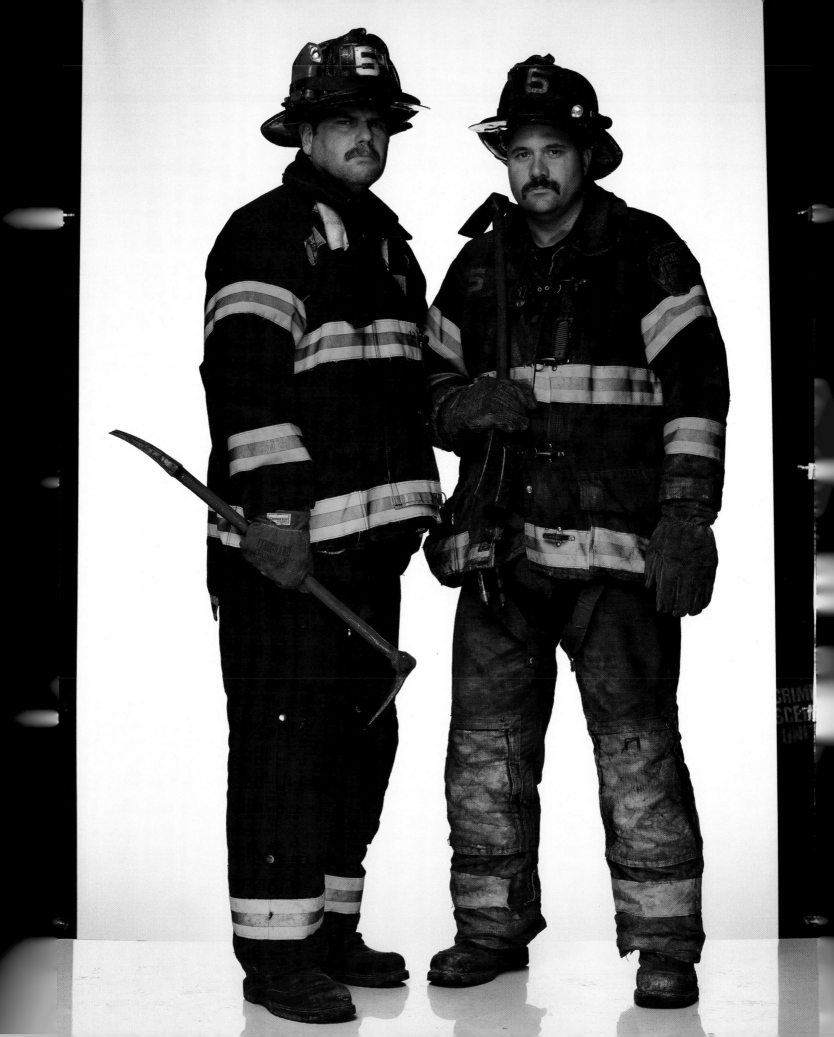

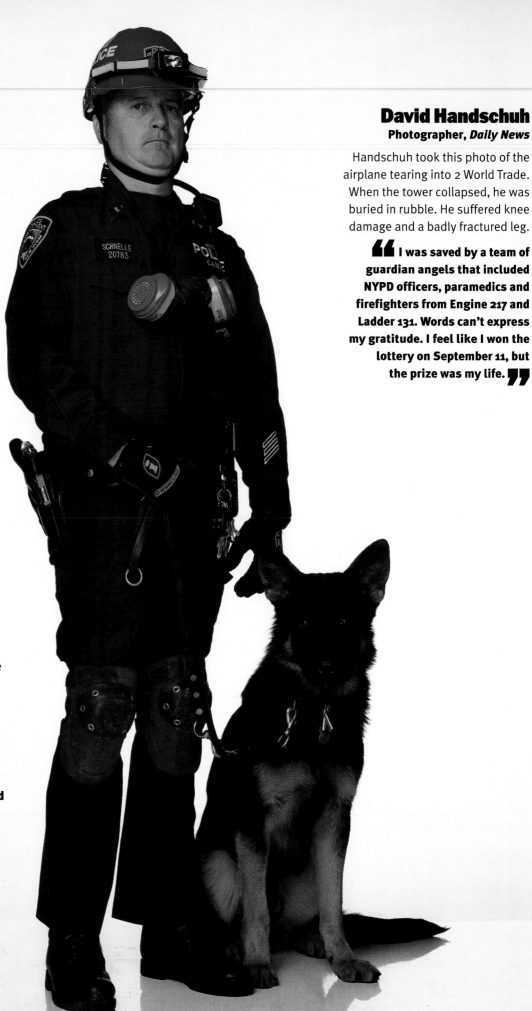

David Handschuh
Photographer, *Daily News*

Handschuh took this photo of the airplane tearing into 2 World Trade. When the tower collapsed, he was buried in rubble. He suffered knee damage and a badly fractured leg.

❝ I was saved by a team of guardian angels that included NYPD officers, paramedics and firefighters from Engine 217 and Ladder 131. Words can't express my gratitude. I feel like I won the lottery on September 11, but the prize was my life. ❞

Robert Schnelle
Police Officer, NYPD Emergency Services K-9 Unit

Schnelle and his former canine partner, Zeus, worked in the search and recovery efforts after the Trade Center bombing in 1993 and the 1995 bombing of the Oklahoma City federal building. On September 11, he and his rookie partner, Atlas, were the first NYPD canine unit at the Twin Towers, arriving shortly before the first tower collapsed.

❝ Atlas and I searched but we didn't find anybody alive. He took a beating that first day. He had only finished his training in April and had been on the streets for maybe four months. He got on-the-job training. But you can't train any dog—or any person—for what happened at the World Trade Center. ❞

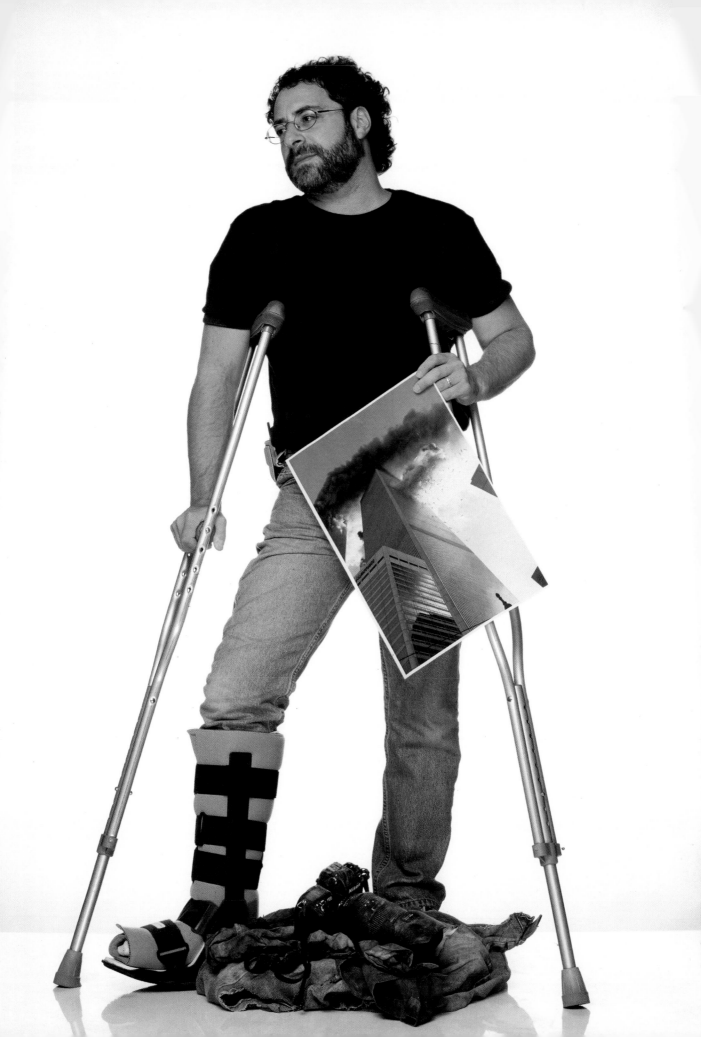

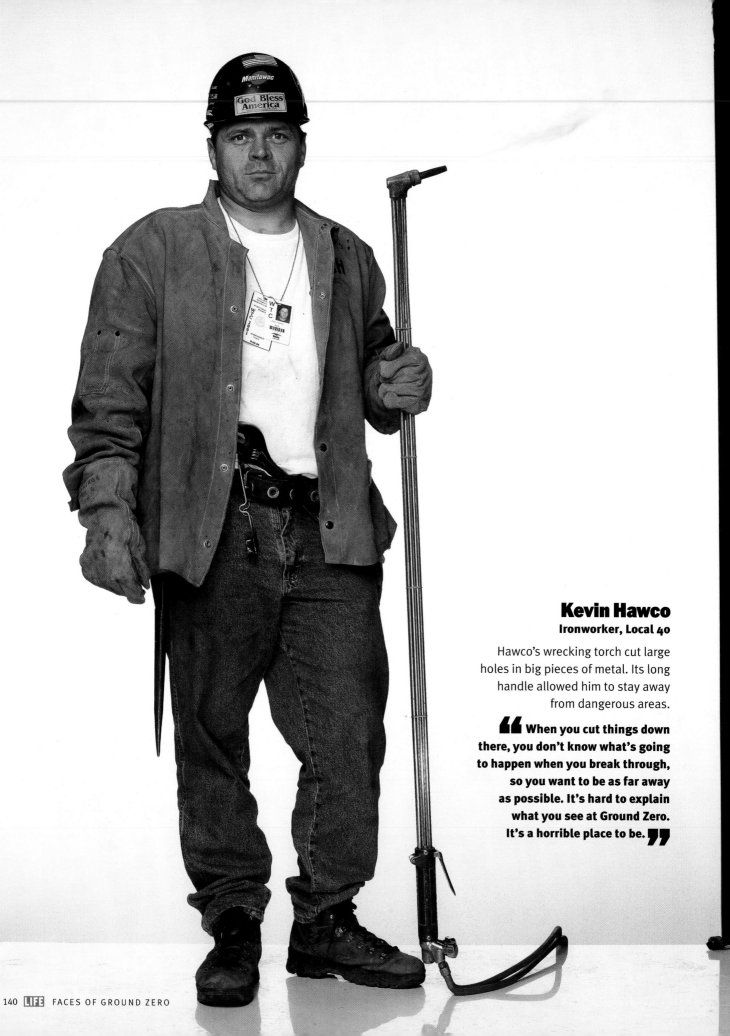

Kevin Hawco
Ironworker, Local 40

Hawco's wrecking torch cut large
holes in big pieces of metal. Its long
handle allowed him to stay away
from dangerous areas.

**" When you cut things down
there, you don't know what's going
to happen when you break through,
so you want to be as far away
as possible. It's hard to explain
what you see at Ground Zero.
It's a horrible place to be. "**

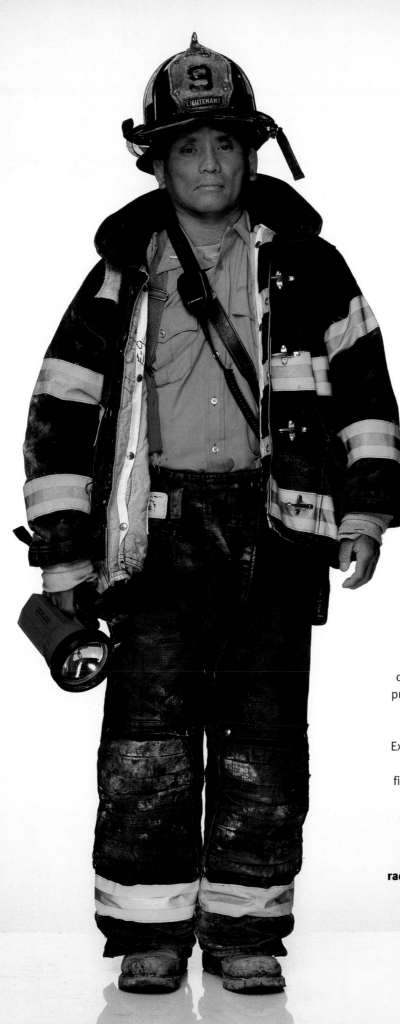

Jacob Chin
Lieutenant, Engine 9, FDNY

When the recall came, Chin, concerned that traffic would delay his driving into Manhattan, put on his dress uniform, grabbed his badge and asked his wife to drive him to the Long Island Expressway, where he got out and hitchhiked to his Canal St. firehouse. Members of his house, which also includes Ladder 6, survived the collapse of Tower 1.

❝I thought I was going to hear my colleagues die on the radio. When they got out, I kissed every single one of them.❞

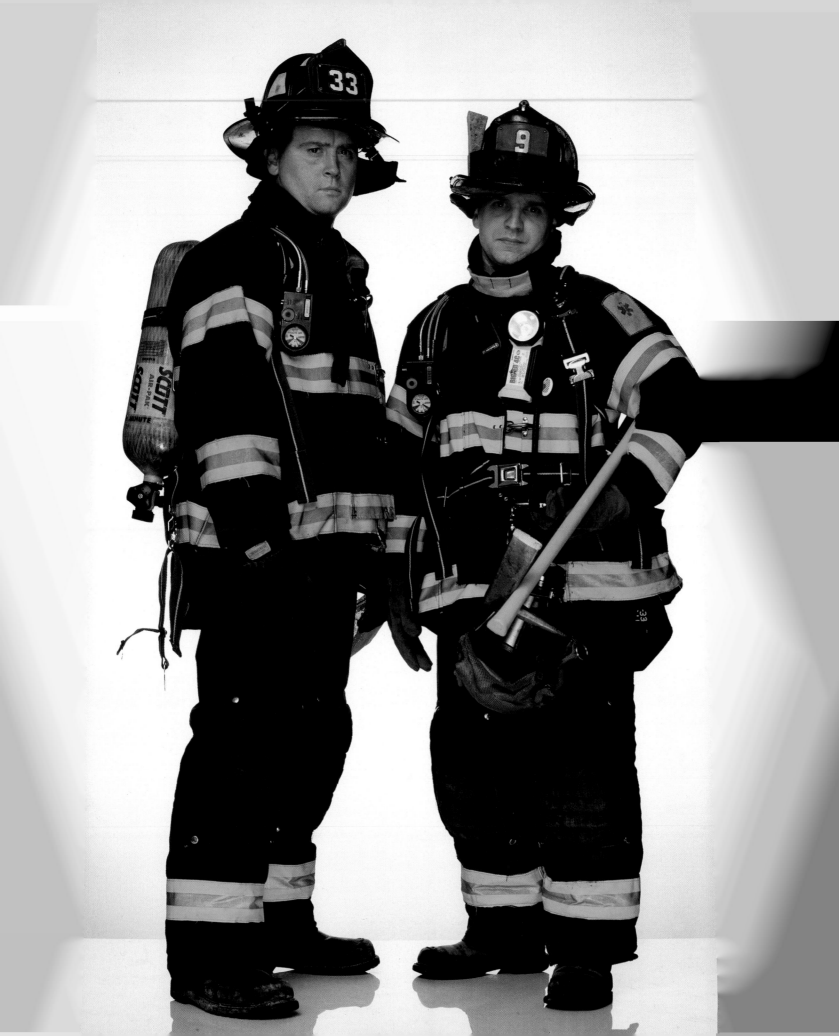

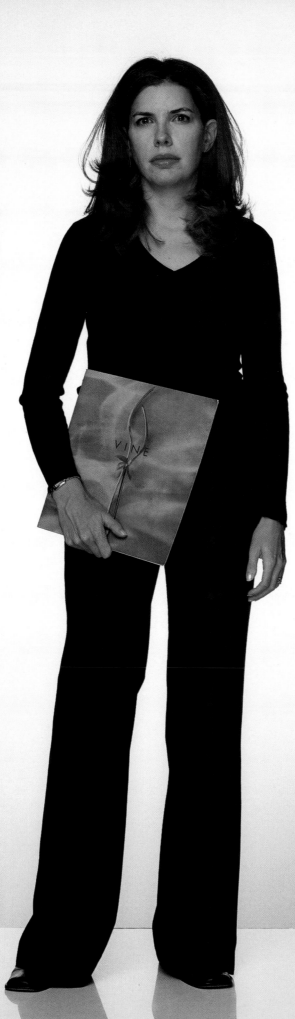

Gerald Dolan
John Kazan
Firefighters,
Engine 33 and Ladder 9, FDNY

On the morning of September 11, Kazan was visiting his parents in western New Jersey; Dolan was on vacation in Cancún.

❝ In Mexico all the Americans wanted to be together. I was the only New Yorker. People just wanted to give their support. I'll never forget those people," said Dolan, who, because all air travel was suspended, couldn't get to Ground Zero until the weekend. As Kazan sped toward the city from New Jersey, he watched the towers burn and then collapse. **"At first I truly thought that by the time I got there the guys would have the fires out and I'd just be helping clean and put out the last bit of flames. Who knew? ❞**

Julie Menin
Owner of Vine, a restaurant
on Exchange Place

Menin founded Wall Street Rising, a civic group working to restore the beauty and vitality of downtown.

❝ Together, I know we will be able to rebuild our community and emerge stronger than ever. ❞

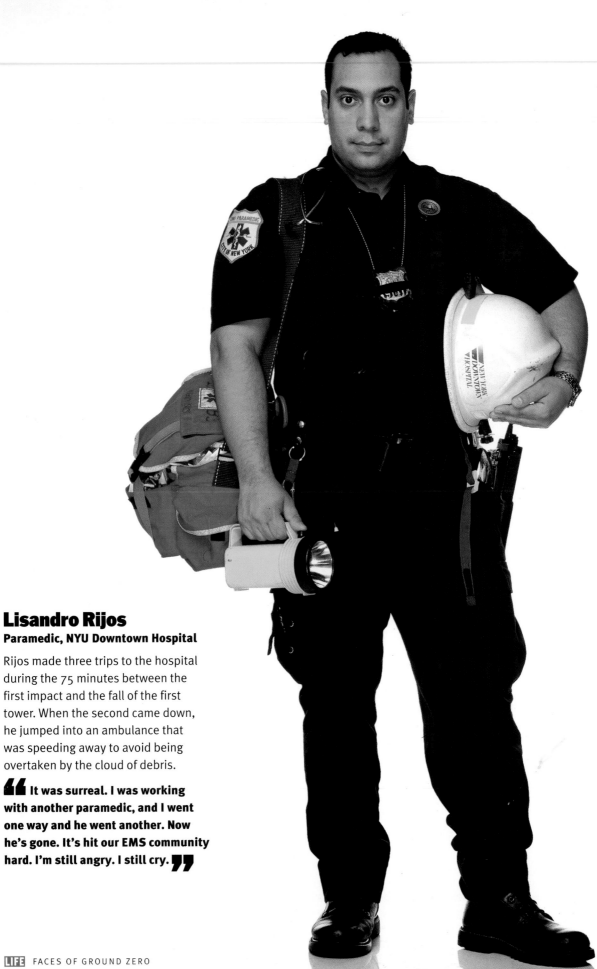

Lisandro Rijos
Paramedic, NYU Downtown Hospital

Rijos made three trips to the hospital during the 75 minutes between the first impact and the fall of the first tower. When the second came down, he jumped into an ambulance that was speeding away to avoid being overtaken by the cloud of debris.

66 It was surreal. I was working with another paramedic, and I went one way and he went another. Now he's gone. It's hit our EMS community hard. I'm still angry. I still cry. 99

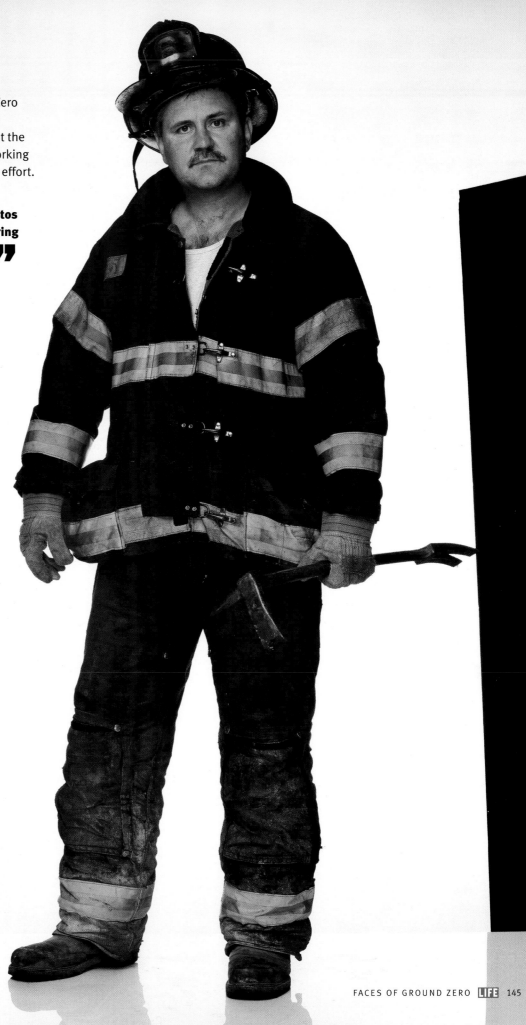

Tommy Lane
Firefighter, Ladder 6, FDNY

By the time he made it to Ground Zero from his home in Long Island, both towers were down. Lane then spent the next four weeks amid the ruins, working daily 12-hour shifts in the recovery effort.

"They say our lungs might be tattered from this, from the asbestos and other stuff in the air. I'm hearing it's taking 10 years off our lives."

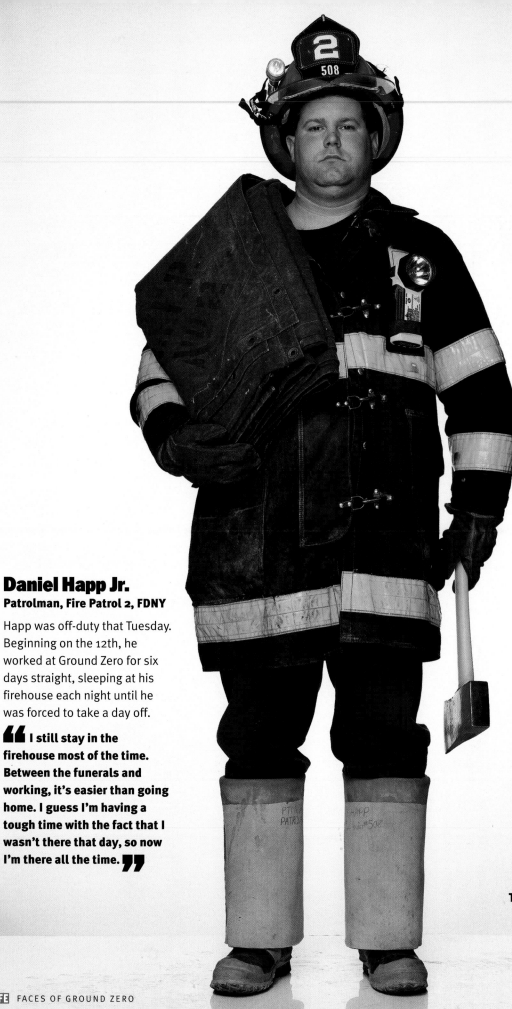

Daniel Happ Jr.
Patrolman, Fire Patrol 2, FDNY

Happ was off-duty that Tuesday. Beginning on the 12th, he worked at Ground Zero for six days straight, sleeping at his firehouse each night until he was forced to take a day off.

❝ I still stay in the firehouse most of the time. Between the funerals and working, it's easier than going home. I guess I'm having a tough time with the fact that I wasn't there that day, so now I'm there all the time. ❞

Stephen Maggett
Raymond Murray
Officers, Port Authority Police Department

Manning the police desk in Building 5, Maggett and Murray took emergency calls. They watched surveillance-camera monitors and saw debris pelting the World Trade Center plaza. After taking cover when the towers fell, they then helped evacuate their building.

❝ I took four calls from a girl on the 106th floor of Tower 1," said Murray. "And one from a guy reporting that there was a second plane about to hit. I felt helpless. There was nothing we could do. ❞

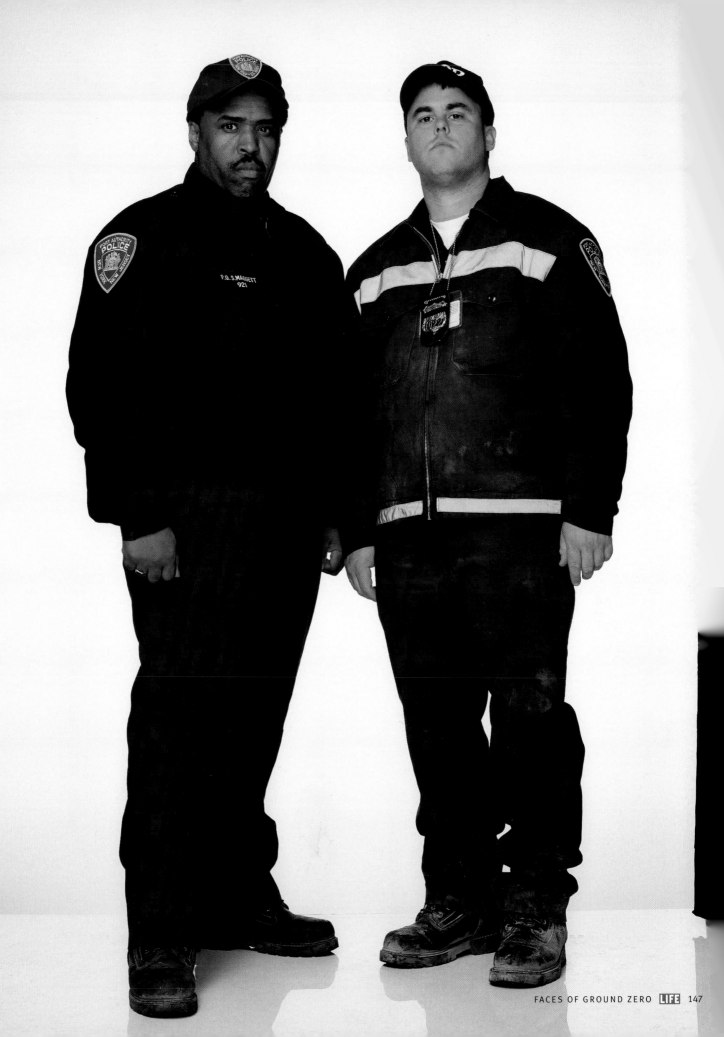

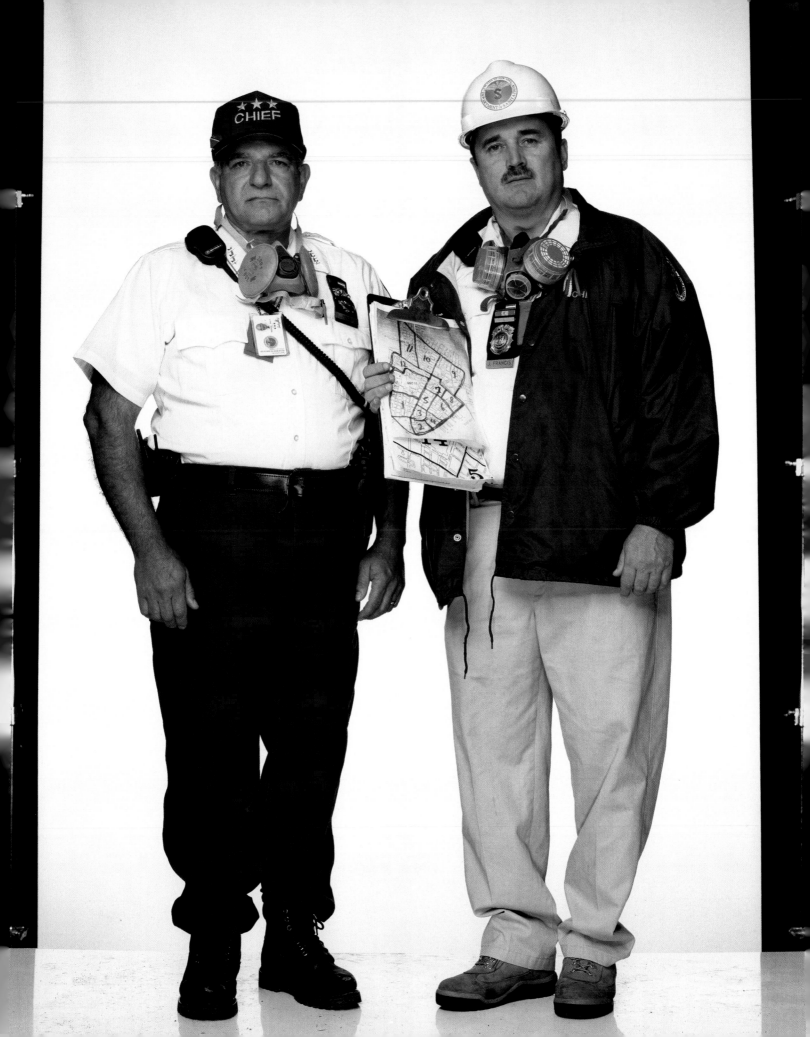

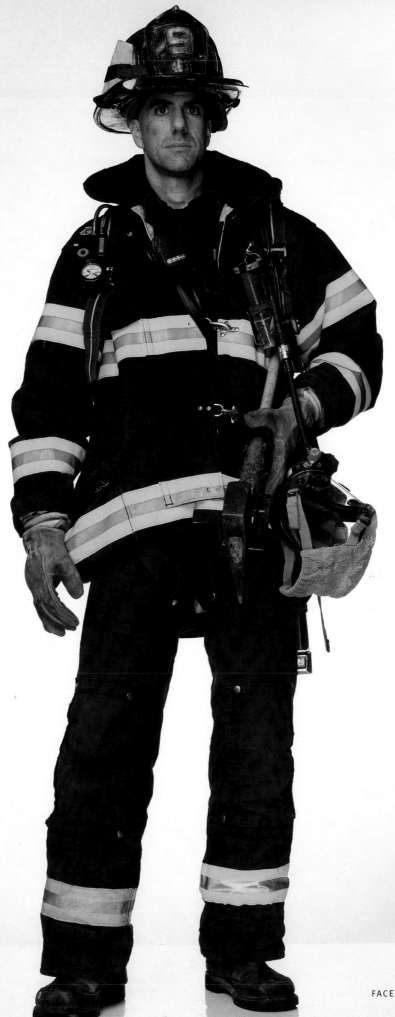

Anthony Punzi
John Francis
**Chief and Deputy Chief,
NYC Department of Sanitation**

The department used mechanical sweepers, flushers, collection trucks, hoses, brooms and shovels to remove paper, dust and debris from lower Manhattan.

❝ Early on, there were six to 10 inches of ash on streets around Wall St.," said Francis. "Our people worked hard in tough conditions. We wanted to get the place in shape to provide some sense of normalcy. ❞

Gary Nybro
Firefighter, Ladder 9, FDNY

Nybro, who was off-duty, reported to the Staten Island command post and manned a triage center, waiting for dead and wounded to arrive.

❝ I stood there for two hours, but no one showed up. I took the ferry and went to our firehouse. The survivors were just making their way back. That's when I found out that 10 of our own guys didn't make it. I worked with them every day. They've left an incredible void. ❞

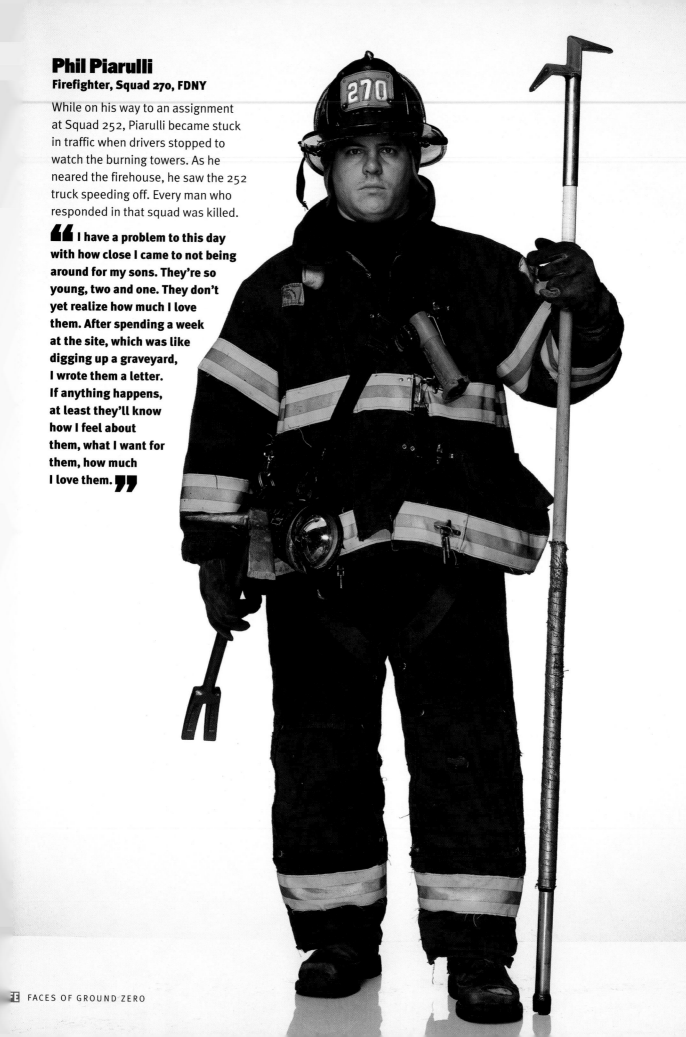

Phil Piarulli
Firefighter, Squad 270, FDNY

While on his way to an assignment at Squad 252, Piarulli became stuck in traffic when drivers stopped to watch the burning towers. As he neared the firehouse, he saw the 252 truck speeding off. Every man who responded in that squad was killed.

❝ I have a problem to this day with how close I came to not being around for my sons. They're so young, two and one. They don't yet realize how much I love them. After spending a week at the site, which was like digging up a graveyard, I wrote them a letter. If anything happens, at least they'll know how I feel about them, what I want for them, how much I love them. ❞

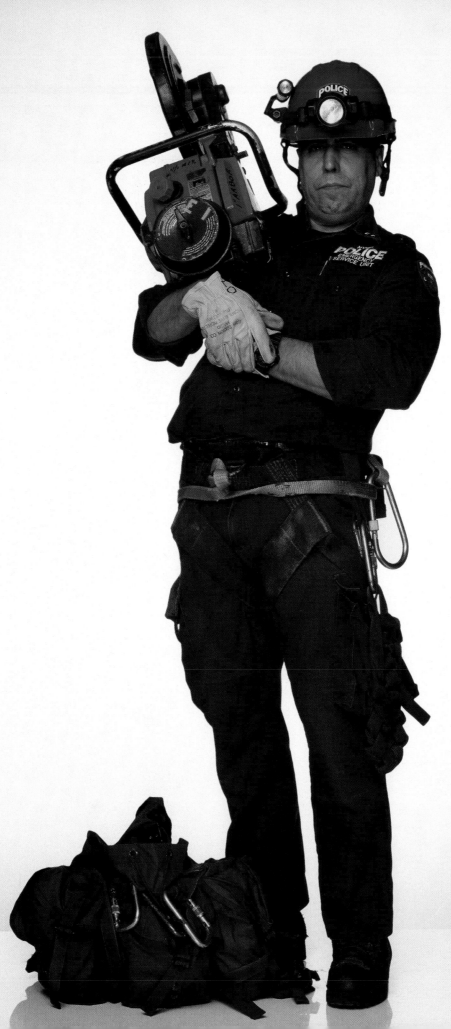

Larry Olivetti
Officer, Emergency Services Unit, Truck 1, NYPD

Olivetti worked in the Ground Zero search-and-rescue effort with "all sorts of tools," including shovels, a saw and an acetylene torch.

❝ I'd worked in building collapses before, but the buildings were three or four stories. Nothing like this. You hear all the clichés — that you have to be down there to understand the scale, that words can't describe it. Well, all the clichés are true. It took days for the reality of this thing to sink in. It still hasn't sunk in that our unit lost 14 guys. ❞

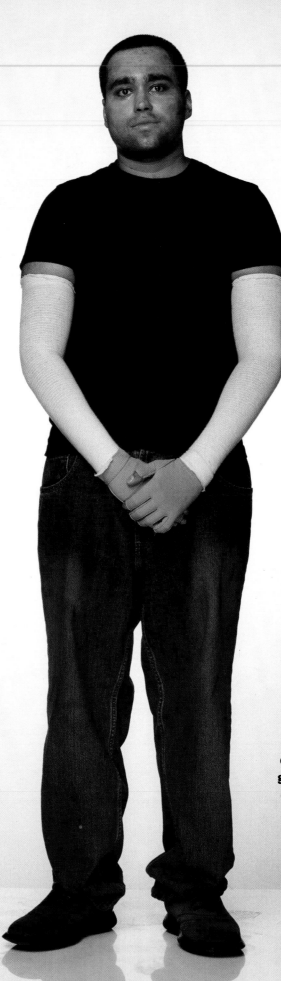

Manu Dhingra
**Securities Trader,
Andover Brokerage**

He was outside an elevator door on the 83rd floor of Tower No. 1 when the first plane hit. Burned over 40 percent of his body, he was rushed to the Weill Cornell Burn Unit.

❝ On the way down, I really wanted to sit, but my co-workers lied to me: 'We're almost there.' People looked at me and grimaced. I thought, 'What kind of life am I walking down to?' But I'm the lucky one. I went back and visited the other patients, fighting for their lives, as often as I could. I hoped to inspire them. ❞

Donald T. Gromling
Timothy Hayes
Pilots, NYPD Aviation Unit

Theirs was the first helicopter on the scene after Tower No. 1 was hit.

❝ We saw the second plane," said Gromling. **"Peculiar. 'Where's this guy going?' He went right under our helicopter. His wings rocked three times, banking left and right. I prayed this was a bad dream. It impacted." Said Hayes: "I advised ground units to shut down airports, then continued to give reports about the conditions of the towers until they fell. ❞**

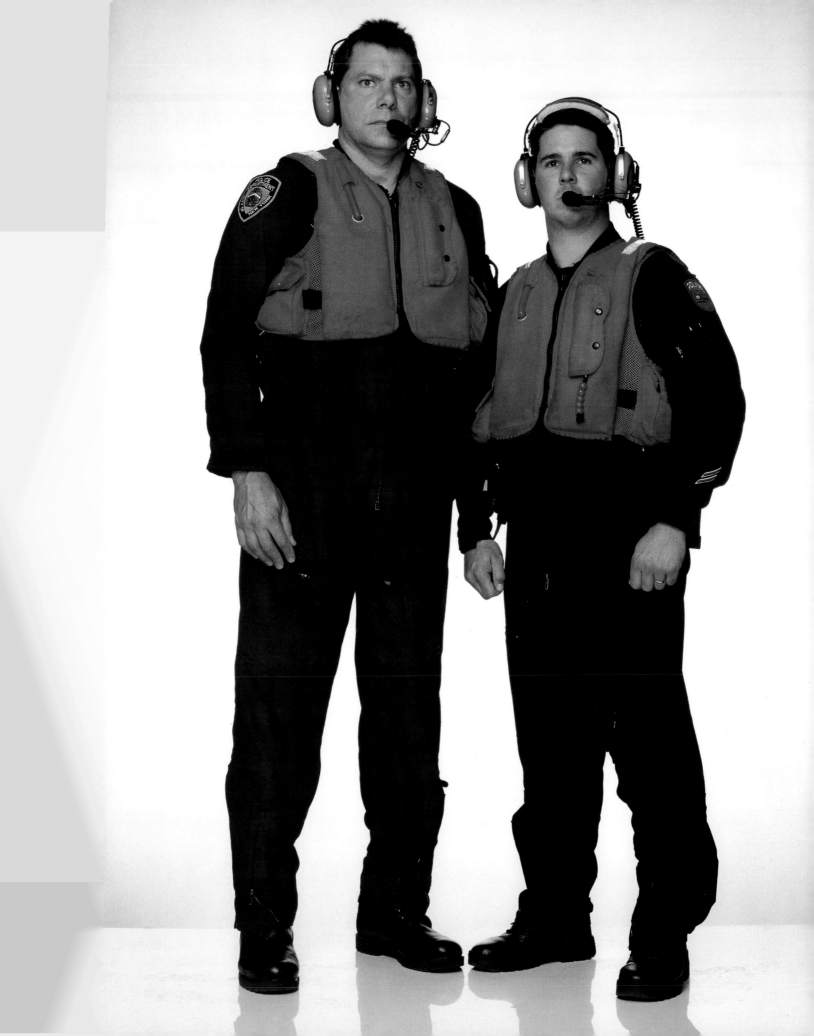

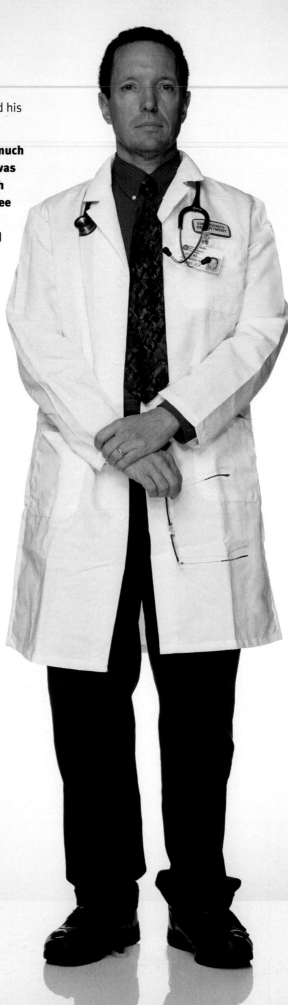

Dr. Antonio Dajer
Assistant Director,
NYU Downtown Hospital Emergency Room

In the 12 hours after the attack, Dr. Dajer and his staff treated 350 patients. Five died.

❝ You think you're ready for it, but it is much too fast. And when you see a woman, who was normal just 15 minutes earlier, come in with burns over her entire body, you just can't see any justification for it. You get a sense of how fragile and temporary life is. ❞

Michael Price
Peter Blaich
Firefighters, Engine 9, FDNY

Price set up hoses at the rig while Blaich and others climbed the Tower 1 steps. Blaich received an order to descend after the first collapse and ran when the second tower came down.

❝ It was a plume of black death chasing me," said Blaich. "I got hit by debris and was ready to curl up and die, when Price pulled me under a tow truck. Every now and then we'd just touch each other. I felt so alone out there. ❞

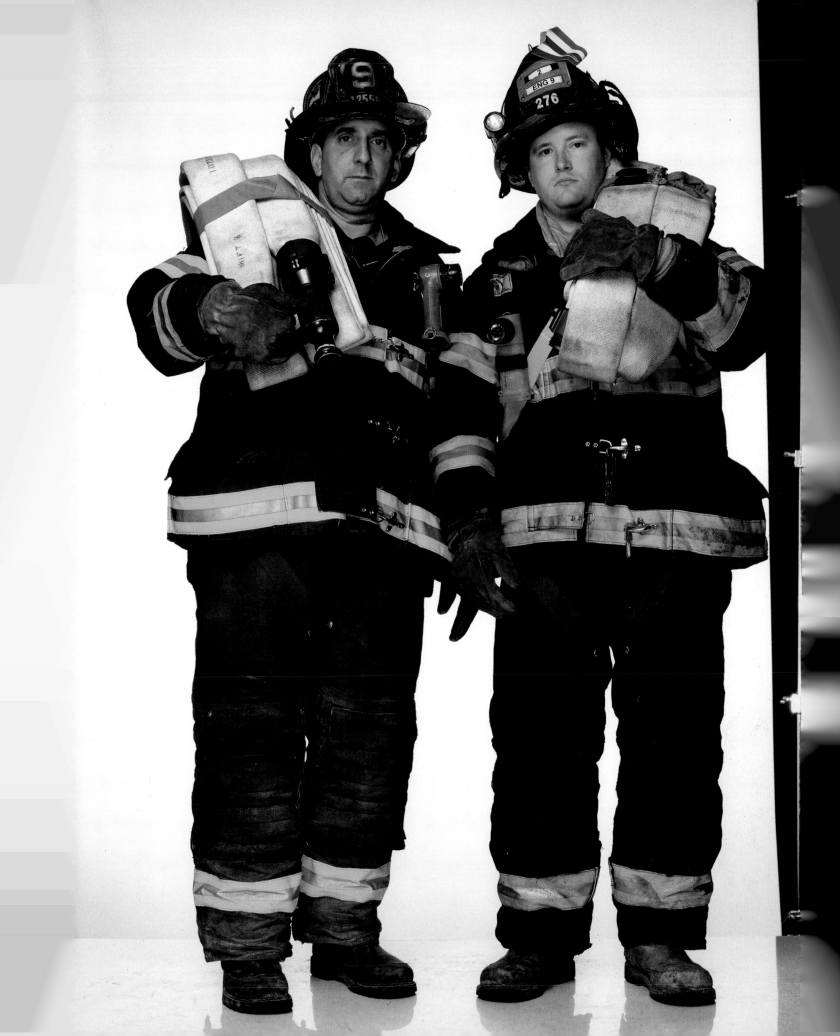

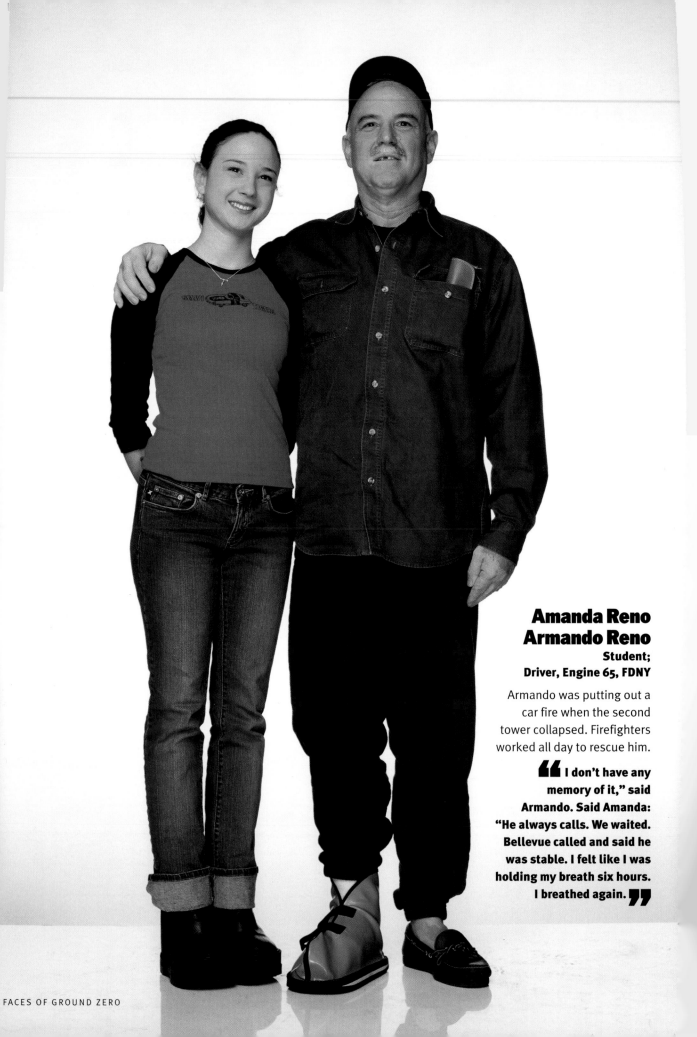

Amanda Reno
Armando Reno
**Student;
Driver, Engine 65, FDNY**

Armando was putting out a
car fire when the second
tower collapsed. Firefighters
worked all day to rescue him.

**❝ I don't have any
memory of it," said
Armando. Said Amanda:
"He always calls. We waited.
Bellevue called and said he
was stable. I felt like I was
holding my breath six hours.
I breathed again. ❞**

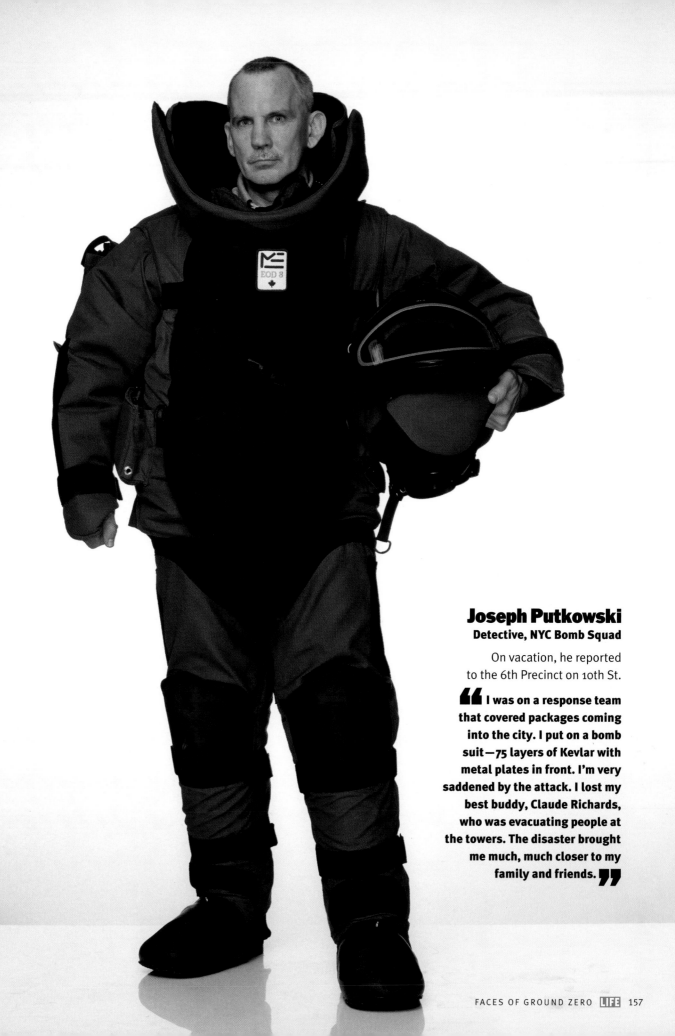

Joseph Putkowski
Detective, NYC Bomb Squad

On vacation, he reported to the 6th Precinct on 10th St.

❝ I was on a response team that covered packages coming into the city. I put on a bomb suit—75 layers of Kevlar with metal plates in front. I'm very saddened by the attack. I lost my best buddy, Claude Richards, who was evacuating people at the towers. The disaster brought me much, much closer to my family and friends. ❞

Tom Franklin
Staff Photographer,
The Bergen Record

Ground Zero was evacuated that Tuesday afternoon before the collapse of 7 World Trade. When Franklin made his way back, he saw firefighters raising Old Glory.

" It was unceremonious and fast. The atmosphere was so serious that no one paid attention to what others were doing. I knew right away that I had a great image of hope, bravery and patriotism, like the photograph of the Marines raising the flag on Iwo Jima. "

Richard Gleason
Patrick Gleason
Peter Gleason
Firefighters, FDNY,
Engine 47; Battalion 14;
and retired

Patrick was working when the alarm came in. His brothers Richard, who was off-duty, and Peter, who was retired, geared up to join in the effort.

" After retiring I went to law school. A professor there, Kit Chan, had an office on the 79th floor of Tower 1," said Peter. "After the first plane hit, I called and told him to get out of the building. He called the next day to thank me for saving his life. He did, however, say he was a little confused, since six months earlier over lunch we spoke about what to do in the event of a high-rise fire, which is to stay put while the fire is extinguished. "

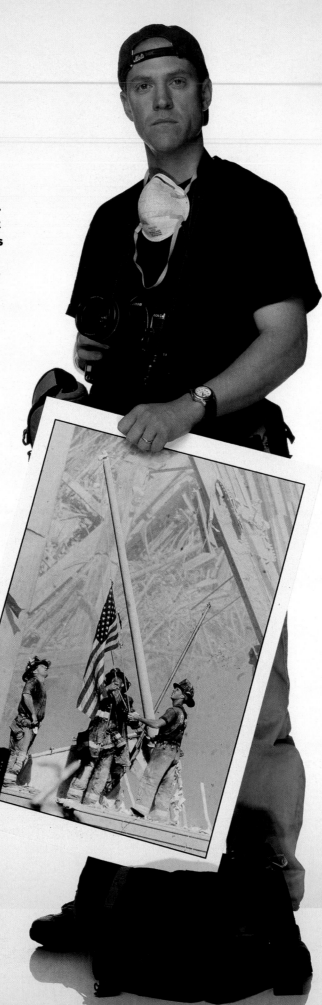